River of Contrasts

maji cruz

RIVER BOOKS
Sponsored by
 the River Systems Institute
at Texas State University
Andrew Sansom,
General Editor

*A list of books in this series is available
at the end of the book.*

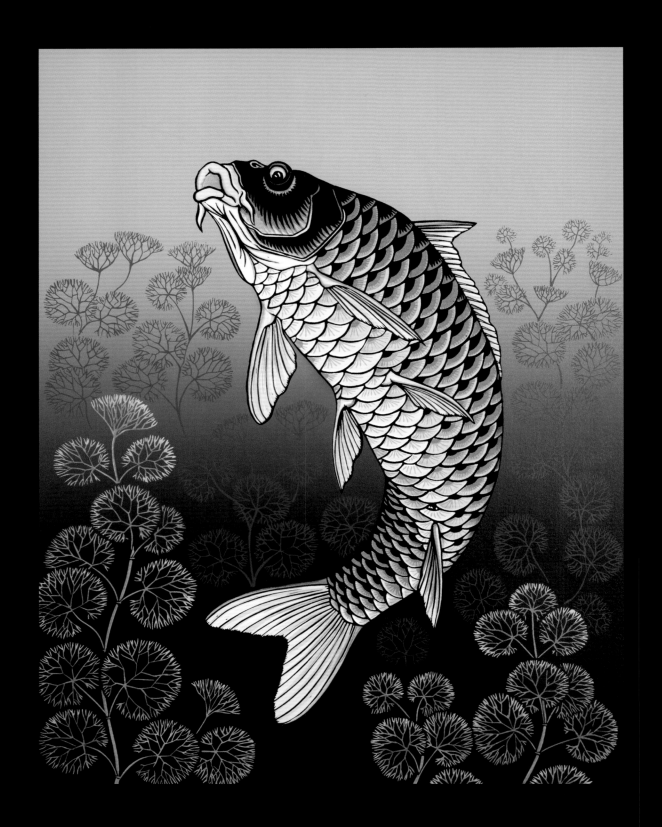

River of Contrasts
THE TEXAS COLORADO

Margie Crisp

Foreword by Andrew Sansom

TEXAS A&M UNIVERSITY PRESS COLLEGE STATION

LIBRARY OF CONGRESS CATALOGING-IN-PUBLICATION DATA

Crisp, Margie, 1960–

River of contrasts : the Texas Colorado / Margie Crisp ; foreword by Andrew Sansom.—1st ed.

 p. cm.—(River books)

 Includes bibliographical references and index.

 ISBN-13: 978-1-60344-466-8 (flexbound : alk. paper)

 ISBN-10: 1-60344-466-1 (flexbound : alk. paper)

 ISBN-13: 978-1-60344-747-8 (e-book)

 1. Colorado River Valley (Tex.)—Description and travel. 2. Colorado River Valley (Tex.)—History.

 3. Colorado River (Tex.)—Description and travel. 4. Natural history—Texas—Colorado River

Valley. I. Title. II. Series: River books (Series)

 F392.C6C75 2012

 976.4—dc23

 2011024353

For my husband, Bill
and in memory of my mom,
Margaret Campbell Bamberger

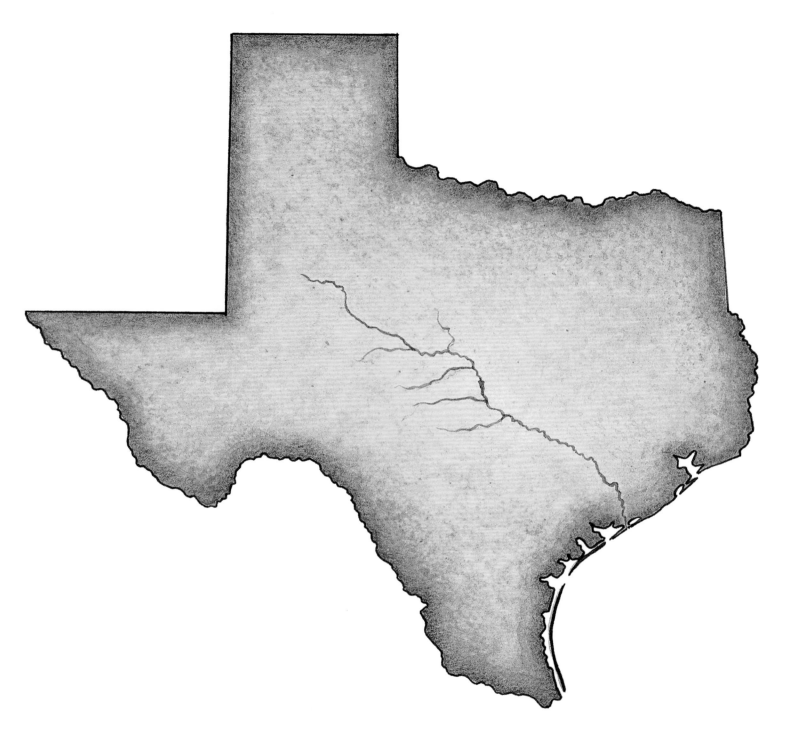

The Colorado River's course in Texas

Contents

Foreword by Andrew Sansom ix

Preface xi

Acknowledgments xv

1. Early Spring on the High Plains: Headwaters 1

2. Impounded on the Rolling Plains 31

3. River Revealed: Cross Timbers and into the Llano Uplift 67

4. Another Colorado: The Highland Lakes and Lady Bird Lake 101

5. Living Downstream: East Austin through the Blackland Prairies 145

6. Into the Gulf (almost): Gulf Prairies and Matagorda Bay 173

Notes 207

Further Reading 211

Artwork 215

Index 219

Although I grew up on the Brazos, the Colorado is my river now.

I have the good fortune of living just a few hundred feet from Lady Bird Lake, the most downstream of the Highland Lakes on the Colorado River, named for one of our most beloved first ladies. The lake sits in the heart of the Texas capital, and I am on it in one way or another every weekend. I have a Labrador retriever and a Jack Russell terrier who love to swim. I take them down to Red Bud Isle below the dam that forms Lake Austin where they would gladly jump into the lake for hours to retrieve their training dummies. Or maybe we go to the hike and bike trail along the lake in downtown Austin with thousands of other walkers, runners, cyclists, and dogs. Sometimes I rent a rowing scull from one of the docks or paddle my own canoe past the mouth of the creek that is fed by fabled Barton Springs and brings clear, cool water into the lake.

Lady Bird Lake is the result of a great force of nature. The Colorado's reaches here in Central Texas have been called "Flash Flood Alley" because of the frequency of intense, often violent storms. About every decade we get a big one, including a storm in 1915 that killed thirty-five people along Waller Creek in Austin. According to the *Austin American Statesman*: "Whole sections of the city were submerged for hours. Houses were washed away, cows, horses, chickens, and other fowl careened down the Shoal and Waller Creeks to join the human corpses that had gone swirling before them to the bosom of the Colorado." In the face of these recurring disasters and following two unsuccessful attempts to tame the river, six reservoirs known as the Highland Lakes were built in the Hill Country in the 1930s and, 40s upstream of Austin to stem the floods. Lady Bird Lake in 1960 was the seventh and last.

The Highland Lakes also brought the promise of hydroelectric power to the Hill Country, which, prior to World War II, was one of the poorest regions of the United States. Overgrazing by cattle, sheep, and goats in less than a century had eroded the soil of this once-lush savanna, destroying its productivity

and exhausting the area's economy. From its bleak prospects and demoralized citizens arose one of the nation's most effective politicians, Lyndon Baines Johnson. Johnson grew up on the Pedernales, a tributary of the Colorado, and graduated in 1930 from Southwest Texas State Teachers' College (now Texas State University and the sponsor of the series this book joins, River Books).

After teaching for a while in South Texas, the young politician joined the New Deal and walked door-to-door in the Hill Country, talking often-destitute people into signing up for electric power produced by the Lower Colorado River Authority, which was modeled after the Tennessee Valley Authority on another of America's great rivers.

Today, the fate of the longest river that begins and ends in Texas is largely in the hands of Austin politicians who will decide whether, after all the claims are made on its waters, some of the vital resource it carries will stay in the river and flow into Matagorda Bay for the benefit of the coastal environment that depends on it. The efforts to protect the Colorado are aided by the art and eloquence of Margie Crisp in these pages, which capture her passion for the river she also calls her own, and by the commitment and financial support of the Trull Foundation of Palacios, Texas, where the great river meets salt water.

Thanks to them and many others who have fought for the Colorado through the years, folks like me will continue to have the privilege of walking along its banks and plying its waters. I'm grateful to them for my river.

—Andrew Sansom
River Books General Editor

Preface

This project began simply enough with short canoe and kayak trips down the Bastrop County section of the Colorado River. The trips were just for fun. My husband, Bill, and I might cast a line out for bass or slip into the current to cool off on hot, bright afternoons. I'd watch birds, trail my hands in the water, duck under the boughs of sweeper trees, and watch the river unspool before me. One warm fall day, on such a pleasure jaunt, someone—I don't recall who—mentioned the peculiar fact that from November to March, the river's flow is composed primarily of wastewater from Austin's sewage treatment plants. I remember recoiling a little from the water dripping off my paddle. As I peered over the side of my kayak into the cool, clear ripples, two thoughts occurred to me. The first was, "This came out of someone's toilet?" The second was, "Doesn't the same water flow from the headwaters all the way to the Gulf of Mexico?" It had never occurred to me that a river could be used up, much less recycled through a city's sewers.

When I started my trips exploring the river, I expected the Colorado's character to remain constant from its headwaters to the Gulf. I was mistaken. The Colorado, I learned, has many faces. As it travels from its inception at the tattered hem of the Great Plains in northwest Texas, it flows (barely, in some places) southeast through multiple regions. The river's character changes to reflect the geology, land use, climate, and temperament of the regions through which it travels. At times the river seems like the consummate traveler who takes on the dress, customs, and mannerisms of the country he or she visits. As droughts thin the flow into narrow streams and expose the streambeds and lakebeds, the river reveals different faces, and there are other dramatic personality shifts as the waters wildly rise and fall with storms and floods.

The Colorado does not have a singular identity, but what it does have is character—deep down, tested Texas character: intractable but loveable, unpredictable but depended upon, and celebrated but often ignored. The Colorado

is many things to many people but it is never the same river twice—not in time, place, or perception.

An angler casting flies for white bass under the limestone cliffs and fern-filled grottos of the river near Bend would not recognize the deep, slow muddy loops in Wharton County as the same body of water. Nor would the sailboat owner enamored of the blue depths and broad expanse of Lake Travis equate those cool waters with the warm, shallow stream of orange liquid above E. V. Spence Reservoir. Lady Bird Lake in the heart of Austin bears little resemblance to the salty, thin trickles at the edge of the Caprock escarpment.

The river I discovered has sections of beauty, but it has also been sucked dry, corrupted by dams, polluted by industry, and gouged by hundreds of gravel pits; it has miles of stripped banks that are more akin to trashy suburban streets than a natural ecosystem. The more I learned about the Colorado and the oft-contentious issues that surround its shores and water, the more I wanted to know. I gorged on history, read accounts on fragile, faded pages, followed threads through the tangle of the Internet, pestered experts with my questions, and brazenly wrangled invitations to ranches, homes, preserves, and personal sanctuaries. Along the banks of the Colorado, people welcomed me, shared their stories, their passions, regrets, and concerns. In these people and their lives, I discovered an antidote to the feelings of despair I felt about the desecration and destruction of the river. The many individuals and groups who work, mostly without recognition, to preserve tracts of land both large and small, to restore grasslands, riparian zones, bottomland forests, to lure people onto the river in canoes, and to teach our children about our river have emboldened me to believe in the future. I hope that by meeting these people, readers will be inspired to participate—whether by the simple act of conserving household water, or by working to restore a piece of land, or even by launching a kayak or canoe to splash in the waters of the Colorado River.

After many years of ambivalence about where my home lies, I've found certainty in over 800 miles of pushing, shoving, and looping curves running from the brink of the Great Plains to the rich waters of Matagorda Bay and the Gulf of Mexico. Now I carry this contentious river with me, along with a flood of issues, conflicts, and water wars. Gar, bream, carp, hellgrammites, caddisflies, naiads, snakes, frogs, algae, and herons clog up my veins. Scratch me and I bleed red. Ask me and I bleed river water.

This book is my attempt to share the Texas Colorado River I discovered.

A river of contrasts: beautiful and devastated; dammed and free running; neglected, and often abused; and yet celebrated by the people who live along its banks. In a tempestuous land, this erratic stream is the foundation of our farms, cities, industry, and homes. The Colorado River's floods, droughts, dams, and the ongoing battles over who owns the water and how we should use it have shaped our culture, our state government, and ultimately, how we view the river itself.

This is our story.

Acknowledgments

Five years ago, upon hearing about my Colorado River explorations, Shannon Davies told me, "That sounds like a book." With her encouragement and guidance, I embarked upon an extraordinary journey. Her unflagging enthusiasm, advice, and support buoyed me even when I faltered. Thank you.

The easy generosity of the people I have met along the river continues to amaze me. For every person mentioned in the book, easily a dozen others contributed stories, history, contacts, interest, and hospitality. River people invited me to their ranches, their homes, and into their lives. This book would be nothing without their stories.

I am deeply indebted to the biologists, bird watchers, botanists, ecologists, farmers, fishermen, geographers, geologists, historians, hydrologists, kayakers, ranchers, writers, zoologists, and friends who contributed to my understanding of the river, its history, functions, and needs. I specifically want to acknowledge the many Colorado River Municipal Water District and Lower Colorado River Authority employees who cheerfully answered my questions about their work and the river.

The encouragement of my family and my friends kept me going and made this project a heck of a lot more fun. My sister, Frances Sharp, contributed daily with her patient listening and perceptive responses. Jeffrey Greene recognized my love of language long ago and encouraged me to write. My aunt, Mary Weiss, bolstered my flagging energy with her joy of life and love of science. My brother Chris, and my nephews, Eli and Gabe, reminded me just how much fun it is to fish for bream, get muddy, and find cool stuff with nets. My stepdad, J. David Bamberger, is a continual source of inspiration and proof that one person can make a positive difference in the world. My mom shared this journey with me when she could and when unable, eagerly awaited reports from the field. Her skills as a naturalist and her experiences as an environmental activist and educator profoundly influenced the project. Jason Sharp provided much needed camaraderie as well as assistance with the

research. Milton Burton's wit and insight were invaluable; David Haynes' tactful trimming of extraneous punctuation was crucial; Priscilla and Jeremiah Jarvis made this a better book with their careful reading and responses; and Kay Queen and Doran Williams generously loaned me their Marfa adobe as a hideaway. Kevin Anderson and his thoughtful conversations provoked me into thinking about the river in new ways. Rusty Ray's enthusiasm and knowledge about soil conservation inspired me and reminded me that everything starts from the ground up.

Dick and Joanne Bartlett and the Thinking Like a Mountain Foundation earned my eternal gratitude for giving me a desert sanctuary to think about water and the river exactly when I needed it.

Thanks to Tom Druecker and Margie Simpson of Slugfest Printmaking Workshop in Austin for creating such a dandy place to make art. Sandrine Molnar and Daniella Valero deserve special acknowledgment for their talent and help with the artwork. Sandrine's artistry greatly improved the maps.

Without question, my husband Bill deserves the ultimate recognition for making this book possible. Over the five years I have worked on this project he has proved his enduring good nature time and again. With humor and patience, he has tolerated the researching, frequent absences, and distraction of the writing process. Above all, I simply could not ask for a better companion on the river or off.

A final doff of the hat goes to all the individuals and groups—past, present, and future—who devote their time and energy to protecting and preserving the Colorado River of Texas. Thank you.

River of Contrasts

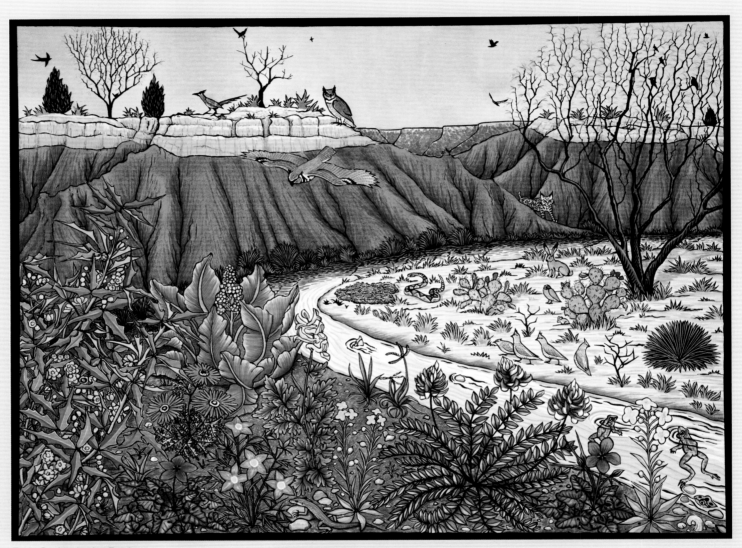

Early Spring in the Basin

1: Early Spring on the High Plains

HEADWATERS

EARLY SPRING ON THE HIGH PLAINS in the Texas Panhandle is gray and brown. Dull clouds press down on the unrelenting span of plowed cotton fields. Gusts of wind blow yellow dust clouds that dissipate on the iron-gray horizon. Occasional farmhouses disrupt the monotony with brief flashes of trees, fences, yards, and the accumulated detritus of life scattered and revealed in the open. There is no place to hide.

I feel particularly small in this great expanse, the tail end of the Great Plains. Even though I am barreling along at ridiculously high speeds, this breadth of space gives me the hallucinatory effect of being stationary.

I am in search of a river. The first Spanish explorers named this area the *Llano Estacado,* or Staked Plains; early Anglo explorers called it the Great American Desert or the Sahara of North America. In the midst of this arid terrain, I hope to find the headwaters of the Colorado River, more than 850 miles of wholly Texas waterway. Reportedly, it begins in the hidden canyons and seeps on the edge of the Llano Estacado just below the Caprock Escarpment.[1]

This is not the river that carved the Grand Canyon; it is another Colorado River. The Texas Colorado runs southeast across the state from the High Plains, across the Rolling Plains, and into the Llano Uplift's granite heart where it is

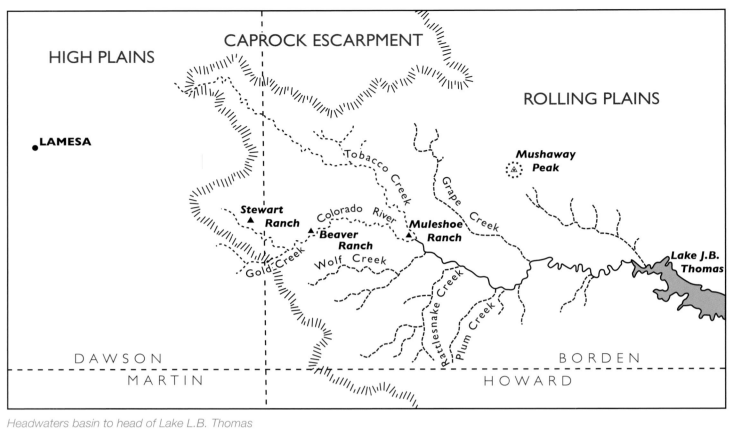

HIGH PLAINS

CAPROCK ESCARPMENT

ROLLING PLAINS

•LAMESA

Tobacco Creek

Mushaway
Peak

Stewart
Ranch

Colorado River

Beaver
Ranch

Muleshoe
Ranch

Grape Creek

Gold Creek

Wolf Creek

Rattlesnake Creek

Plum Creek

Lake J.B.
Thomas

DAWSON

MARTIN

BORDEN

HOWARD

Headwaters basin to head of Lake L.B. Thomas

slowed by the dams of the Lower Colorado River Authority's Highland Lakes. The lakes extend through the city of Austin, and then the river, unencumbered by dams or reservoirs, pours across the Blackland Prairies and into the Gulf Prairies and Marshes to mix its fresh waters into the saltwater of Matagorda Bay and, eventually, the Gulf of Mexico.

Trace the river's course upstream from Matagorda Bay, and you follow the history of Anglo settlement. Settlers gradually penetrated the wilderness and established towns in the region stretching from Stephen F. Austin's original colony between the banks of the Colorado and the Brazos Rivers and upstream to the town of Waterloo—which became the city of Austin and the state capital. Moving through the Hill Country, across the Rolling Plains, and into the High Plains, the landscape gets drier and, as the river narrows, farms and ranches huddle in the river valleys to tap into the river's life-giving waters.

Sixty miles from Lubbock and south of the town of Lamesa, I turn east onto gridded section roads to look for the edge of the Caprock Escarpment. The landscape is so vast that ranches are described in square miles, called sections, not acres. The roads surrounding Lamesa form such perfect right angles and parallel lines that a map of the area looks like graph paper. Driving the dirt and gravel section roads is easy (though no one has wasted money on road signs), but my truck erases all behind me in an enormous plume of dust. When I stop to check the map, the cloud envelopes me so that I am blind and blanketed with a layer of fine grit. With my finger firmly planted on the map at my presumed location, I creep across the county map along the ruler-straight roads. Every inch of land is plowed except the road base, bar ditches, and oil pump sites. Bales of harvested cotton squat at the edge of roads. Dirty fluff is drifting like old snow in the ditches and catches in the weeds straggling at the verges. The late afternoon light breaks through the flannel of the clouds to lie long and bright against the fingerprint whorls of plowing. At a slower pace, the area becomes surprisingly beautiful. The hypnotic rhythm of the contour plowing becomes a fugue—graceful sweeps of converging lines dissolving and reappearing as I move over the subtly rolling swells. The patterns merge and repeat in variation until I feel like I am in the midst of a giant tapestry of dark wools and silks, a subtle but infinitely varied design in umber, sepia, and gold.

With no more warning than a barely perceptible curve in the road, I am at the top of the Caprock Escarpment. I feel like I have discovered the quintessential Texas landscape: hidden in plain sight, a breathtaking geological formation of such magnitude that it is impossible to comprehend until I am standing at the edge of its palisaded cliffs and looking over land both wildly beautiful and devastated. The earth falls away and reveals itself in eroded ridges of bright red Triassic clay bluffs and secretive draws where the waters collect to form the small beginnings of powerful rivers. The springs and seeps at the edge of the Caprock Escarpment not only give rise to the Colorado River but also other Texas rivers including the Concho, the Brazos, and the Red River. The slopes below me are clothed in mesquite, cedar, prickly pear, yucca, bunch grasses, and broom weed. The scrubby vegetation is a relief after the endless miles of raw soil. Cattle graze between the oil pump jacks that are mindlessly diligent, pivoting up and down, creaking and groaning. Calves step delicately over the pipelines crisscrossing the land between pump jacks and tank

batteries that perch on slopes sliced, smoothed, and leveled. Roads overlay the basin with a net of white gravel that binds oil, land, and water together into an uneasy alliance.

A small road curves over the rim of the Caprock, and I follow the gravel track down into the heart of the basin. In through the open window drift the commingled perfumes of dry earth, honey-sweet blooming agarita shrubs, and the purple-grape smell of lilac-flowered buffalo clover. Occasional whiffs of hydrogen sulfide gas from the oil wells give the landscape a peculiar overtone of burnt matches and scrambled eggs.

The road twists and turns with no regard for compass points or my desires. The oil field roads, well maintained and official looking, meander from pump jack to tank and are not on my maps. The Caprock is behind me, then in front of me, to one side, then the other. I bump along in a cloud of dust and increasing frustration looking for signs, picking the roads that seem most traveled, always heading toward where I think the river should be. I chant a mantra: "Better lost in a new place than bored at home." A gnawing sense of doubt is sprouting and sending tendrils of anxiety curling through my limbs. "Just what the heck am I doing out here?" I ask aloud and try to unclench my hands from the steering wheel as one more road dead ends at yet another laboring pump jack.

The plan that led me to this moment was hatched in a haze of panic. A family crisis had catapulted me into the unfamiliar role of nurse, then, almost as rapidly, spun me back into the suddenly alien territory of my life. As the cancer that nearly took my mother's life subsided into remission, I struggled to extricate my psyche from the twin ruts of worry and fear. Watching helplessly as someone I loved came so close to death caused a seismic shift in the comfortable landscape of my life. I became antsy, itchy, and out-of-sorts. The crisis was over but I couldn't settle down. In my art studio, I spent hours sitting at the drawing table staring at blank sheets of paper while my panic level increased. About that time, my husband, Bill, bought me a kayak to match his. One morning I found myself paddling down the Colorado River in a bright mango-colored kayak in a dense fog. On the belly of the great warm beast of the river, I drifted into memory and back.

In 1976, my free-spirited mother uprooted my siblings and me from an air-conditioned New Orleans house with multiple bathrooms and hardwood floors and planted us in the Texas countryside. The succession of rural farm-

houses we lived in was unremarkable except for the uniformly primitive state of the indoor plumbing (if even present) and a general state of disintegration. We finally settled onto a piece of sandy land forested with thick stands of blackjack and post oak in Bastrop County. Copperheads were abundant, air conditioning a distant memory, and we spent months exploring the surrounding countryside. Someone took my mom and me on a canoe trip down the nearby Colorado River from Utley, around the loop of Wilbarger Bend to the FM 969 Bridge. Unbeknownst to me, on that early summer day filled with sun, the river's gentle murmuring, and the splash of wooden paddles dipping into the slow green current, the Colorado River slipped under my skin.

Thirty years later, I'm paddling the same section of river again. Birdsong pierces the fog, and ghostly shapes of trees swell and break along the bank as I drift downstream. Egrets seem to condense out of the haze, taking flight before me and melting into the white mist. In the milky quiet, a sense of recognition surrounds me; a certainty infuses my limbs as I gently rock in the plastic cradle of the kayak. I see the threads of rivers that run through my life, binding me to place and memory: from the willow-laced and rubble-strewn banks of the muscular Mississippi River hidden behind the levees in New Orleans, to the tea-colored bayous and sugar sand creeks of Louisiana, to the revelation of icy whitewater streams tumbling down Appalachian slopes, and back to the slow green dignity of the Colorado River in Bastrop County, Texas. Yet I knew almost nothing about this river, where it began, the course of its stream across the state, who and what lived along its banks, or where it went after leaving my territory. I found myself paddling into my future, linked to the past, and determined to learn all I could about this river that I'd taken for granted.

Now I am driving in circles in Dawson County looking for a river. I brazenly wave down a dusty pickup. Squelching paranoid fantasies about murderers, I ask the driver for directions to the river. He seems deeply amused and equally perplexed by a middle-aged woman wandering the Jo-Mills Oil Field in search of a line marked "river" on a map. An oil field engineer, he has worked in the area for years. I convince him I am not a common trespasser, and he, suddenly loquacious, recites a string of directions, landmarks, property lines, and names. Overwhelmed, my pencil skids to a stop on my notepad. With a grin, the engineer gets out of the truck, takes me by the shoulders, physically turns me, and points to the Colorado River a few hundred yards away. As we part, he sweeps his gimme cap off his head and shakes my hand, warmly wish-

ing me luck. His forehead and shining pate are as pink and smooth as a baby's bottom—a shock compared to the brown, weathered texture of his face and neck. I stare at the shockingly pale and naked skin. It is a moment of intimacy that leaves me surprised and somehow embarrassed.

I drive a short distance and turn off onto a small road I had bypassed earlier. The road slips down to ford the river in a muddy bottom. A scrawny Western diamondback rattlesnake surges onto the track next to the river. Yanking the emergency brake on and grabbing my camera, I eagerly jump out to chronicle my first wildlife encounter on the river. The skinny, irascible snake has no interest in my literary endeavors or artistic aspirations and immediately rears up and back into a hard "S"-curve of ill-tempered, buzzing defensiveness. As I circle, the snake's head follows, its tongue slowly flicks forward, then curls back over the rostrum, the tips of the forks lightly touching the head scales to collect scent molecules from the air. Assessing danger, the rattler is threatened—and stunningly, venomously, beautiful. The snake uncurls and begins to back away. Intent on blocking its path, I follow. But then, with only a vague image of a diamond-patterned sickle curving toward me, I unexpectedly find myself transported three feet away. I turn back and see that the snake's chin now rests in the muddy ridge of my boot print where I'd been standing. After a few tongue flicks, however, it slowly eases off the road to wind its way through silver winter grasses and disappear beneath the sheltering pads of a low-growing prickly pear cactus. My adrenaline-spurred heart races, and I'm grinning and then laughing at myself, embarrassed by my foolishness and pleased with my self-preservation instincts.

A few feet away, the river hardly seems worthy of the name: under 2 feet in width and just inches deep, the water is silted; heavy mineral encrustations bracket the mud banks, and fine crystals feather the stems of grass and salt-cedar. Although the United States Geological Service (USGS) has designated this small stream as the headwaters of the Colorado River, most of the local people, including the oil field engineer, argue that both Gold Creek and Tobacco Creek—because they run stronger and carry more water during all sea-

sons—would be better choices. Perhaps historically, more water seeped from springs and drained from the watershed to flow down the small channel, and that is why it is labeled the Colorado River.

I walk along the sections of the river closest to the road. The light is fading, and the rattlesnake still irritably buzzes nearby, so I return to the truck. Peering at my scribbled notes, I take the first road that looks promisingly well used. I meander along the oil field roads, making brief forays off the main track onto the small lanes that twist and turn between tank batteries, pumps, pipelines, and abandoned sites.

Oil & Water

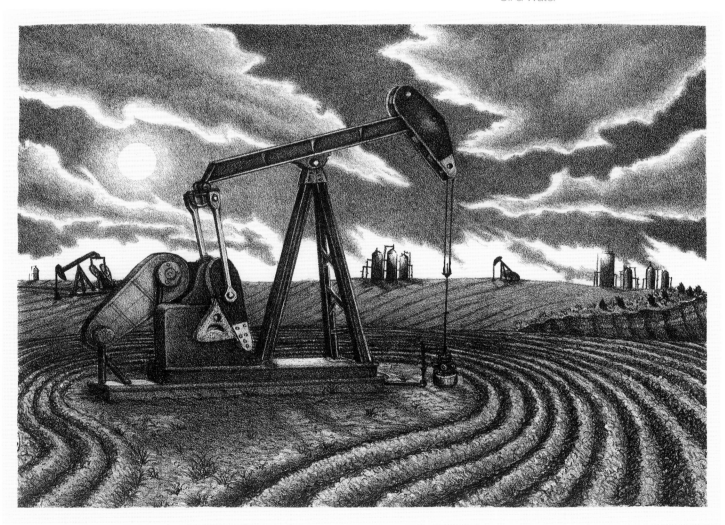

The sky is turning scarlet, and clouds sketch calligraphic figures that glow deep orange, salmon-pink, and hot vermilion as the sun slips through the haze of airborne soil along the horizon. The road twists one direction and then the other. I reach the top of the Caprock, and all the roads look the same—plowed earth to the edge of the barrow ditch, humped loaves of cotton, and pump jacks glowing with small electric lights. The red of the setting sun flashes off my rearview mirror and in a growing alarm I realize I am heading in the opposite direction from the town of Lamesa, dinner, and a bed. I turn the truck around and drive past a drilling rig with lights glowing bright in the dusk. My cell phone rings shrilly and I jump. My seatbelt decides I require protection from an imminent impact and tightens like a boa constrictor around dinner. I snag the phone off the passenger seat; it is my husband Bill, calling to see how the trip is progressing. Between useless tugs at the seatbelt, I tell him in a rising voice that I'm lost; all the roads look the same and keep going the wrong direction. By this point, I am pinned to the seat, holding the cell phone with one hand and trying to steer with my fingertips. "Well," he says in his deep East Texas drawl, "Don't stay out on those oil field roads after dark. You don't want to spend the night out there." "Really?" I reply, my budding hysteria squashed by a sudden wave of irritation. We have a moment of marital silence while we both review the possible directions the conversation could take. Luckily, we are saved from my smart-aleck retort (or a tearful outburst) by the miraculous appearance of an intersection with road signs. After confirming with Bill that the sun does indeed set in the west and that if I want to go north, the sun should be on my left side, I turn the truck toward Lamesa and follow the track to a thin ribbon of asphalt that leads me into the heart of town.

Stewart Ranch

In order to avoid the possibility of having my butt peppered with buckshot— or worse, being called to task by some sort of authority figure—I decide I should call the landowners along the river headwaters before making any more visits. Frank Beaver was not interested in talking to me until he learned I lived in Bastrop County near Camp Swift where he had trained for the U.S. Army's 10th Mountain Division. He agreed to meet me the following morning. Rich and Barbara Anderson invited me out to their ranch for the following

afternoon. Don and Martha Stewart, the owners of the tract of land designated as the geographical headwaters of the Colorado River, cheerfully insisted that I drop by their home in Lamesa that morning for a cup of coffee and a chat.

I step outside the motel to discover that a "Norther" had moved in during the night. The wall thermometer reads 38° F, and the wind whips across the Great Plains with nothing to break its stride or slow it down. I retreat into the room to squeeze myself—in successively tighter layers—into every article of clothing in my suitcase. The result is a swaddled figure reminiscent of an un-coordinated, obese penguin, not an intrepid artist planning to spend the day exploring a river.

The Stewarts' home is full of family photos, Harley Davidson motorcycle models, and the engaging smell of a wood fire. Sitting around the kitchen table with never-empty coffee cups, Don and Martha cheerfully endure my questions about living on the river.

Don has a big droopy mustache, gray and white hair, and blue eyes in a weathered and kind face. He is laconic but assured when he does speak. More loquacious than Don, Martha is open, generous, and confiding, but I get glimpses of a core of harder, sterner stuff. Their exchanges are affectionate and tolerant—years of working together have streamlined their conversations. I can only guess at the depths that we skim over as I pry into their lives.

With central heat purring in the background and a coffee pot gurgling on the counter sending up periodic spouts of steam—comforts I tend to take for granted—they tell me about their courtship and marriage. Don tells me, his eyes twinkling, "Martha grew up in the mountains of central Arizona in the town of Crown King. I was working up there for the Forest Service and we met at a Saturday night dance in the summer of '49 and married in the fall. We packed up the car in January and drove here across northern New Mexico then turned south out of the mountains onto the plains. The farther we drove into Texas and the flatter it got, the longer Martha's face got. By the time we got to Lubbock she looked downright miserable." Martha breaks in, "I'd never seen anything so flat! Growing up in the mountains, I never imagined such a place existed!" Don raises an eyebrow at the interruption but continues, "She didn't say a peep, but I could tell she was wondering how she could live in such a bleak place with no trees, no creeks, no up and down." Martha nods her head in agreement. "Then we came over the edge of the Caprock and drove down into the basin here." Martha whispers to me, "It is still a thrill to drive

off the Caprock." Don finishes up, "By the time we got to the house, she was smiling. She said to me, 'I can live here.' Up to that point, I'd been afraid she was going to turn around and run home to Crown King."

They both beam at me. Martha tells me that neighbors were doubtful that she was tough enough to make it as a rancher's wife. "They didn't know where I grew up," she says conspiratorially. At the homestead, they had running cold water in the kitchen from a hand-dug well. They bathed in a washtub and used an outdoor privy. Martha, laughing, says of her cooking, "I'd cook stuff that'd make a rabbit slap a bear!" Don reminds her of the jelly she used to make from wild plums growing on the ranch. She reminds him of when he got bucked off a horse into prickly pear cactus. She makes me copies of a ranch house photo from 1951 when they moved in, and another of Don on a horse named Fibber McGee.

In the early years, the river ran and flooded with regularity. Now it rarely has water unless they get a good rain. Don says that over thirty years of taking more out of the Ogallala Aquifer than gets puts back by rain has taken its toll. Their four kids played on the creek (the Colorado River) and swam in the pools. When the creek was up, whether anyone could drive in or out was the question. Don and Martha managed to survive twenty-seven years of early morning school buses, spring floods, fall floods, summer droughts, rattlesnakes, and a contaminated well. Though they moved to Lamesa years ago, Don, Martha, and their children still think of the "Poverty Flats" ranch as home. Don is on his way out to check on some new cattle and offers to show me around the ranch.

Three draws on the Stewart property drain off the Caprock Escarpment into the river. The gradual slopes create a gentle basin—unlike the dramatic drop-offs to the north and south. The rolling terrain is dressed with thick grasses, scrubby cedar, and broom weed that Don refers to as "turpentine weed." When asked about the name, he tells me it is highly flammable, takes over the grasses, and cattle won't eat it. The delicate gold stems and dried leaves, which I had been admiring, lost some of their appeal, but I could imagine the glorious yellow blooms covering the area in late summer. The lack of mesquite trees in the upper basin is surprising, and Don explains it is a result of a voluntary partnership with the government's Conservation Reserve Program to prevent erosion of topsoil and protect the river from excessive runoff of soil. Twenty years ago, the area had been root-plowed to destroy the cedar and mesquite

thickets and then seeded with native grasses. A few cedar trees have returned to the area, but a thick carpet of native grasses, including sideoats grama, black grama, green sprangletop, and blackwell switchgrass blankets the slope.

Driving along the maze-like roads between pump jacks, tank batteries, and ranch sites, ridiculous numbers of northern bobwhite and scaled quail dash across the road in front of the truck. We park at the old homestead, and Don invites me into the house. It has a dusty, neglected smell, but it is a relief to get out of the bitter wind.

In the living room, a bookshelf displays an impressive collection of stone tools, projectile points, beads, and metates (hollowed stones for grinding grain) that the Stewarts have unearthed over the years. On the wall, a framed collection of carefully labeled dried grasses is a testimony of the Stewarts' allegiance to native grasses.

Don turns on the taps to check the water flow. He tells me that brine from nearby oil wells contaminated the original well. The first thing they noticed was leaves dropping from the trees around the house and in their garden. Only after going on a trip and not drinking from their well for a week, could they taste the salt in the water. A hydrologist from Midland tested the well and determined that the source of the chlorides and other contaminants was likely the oil company's unlined, open brine settlement pits to the northeast of the house and well. The Stewarts sued. Exxon, after many years, finally made a cash settlement for the "alleged claim." A deep bitterness creeps into Don's voice as he says the words "alleged claim."

I walk down to the dry bed of the river. Is it a river if it has no water? Isn't a river defined by its flow and by the passing of time?

What I discover is that deep in the washes, in the dry beds, life is thick. Out of the hand-numbing and nose-reddening wind, birds sing and flowers bloom. A rangy grove of wild plums shimmers in the gray afternoon air: tiny white blossoms clinging to thin, tough limbs. Oriole nests hang, tattered, from the plums and mesquites. Agarita is blooming—small yellow bells tucked beneath evergreen holly-spiked leaves. Even in the cold air (and with a runny nose) their honey-rich fragrance draws me in. Buffalo clover sends curling wisps of grape Kool-Aid scent into the air. Covered in soft silvery hair, wooly locoweed has bright purple blooms like the buffalo clover but no discernable scent. I find early blooming bladderpods, which are saffron-petaled members of the mustard family. Yellow-eyed blue gilia flowers stare boldly from under the dry

grasses. It seems that every thorny mesquite has a mockingbird trilling, shrieking, and warbling from the sky-most branches. Their songs overwhelm even the raucous calls of ladder-backed woodpeckers, and the more melodic territorial songs of the burning-red cardinals. Sparrows flit and scrabble through the brush at every turn. I manage to identify white-crowned sparrows and song sparrows only because they stop foraging long enough to vigorously sing from the branches of plums, mesquites, and other brush. Ruby-crowned kinglets fuss at me, and brown towhees lurk in the scrub. A flock of cedar waxwings keens from a bare tree. Feathers smooth and unruffled in the breeze, they pose in a tableau as beautifully composed as a Japanese woodblock print. Sur-

1/5 M. Clyne

rounded by thick grasses and barricaded by seep willow and saltcedar, small pools of water in the riverbed reflect the sky.

I follow the wash downstream and come to what the Stewarts designate the first "permanent" water on the river (though it is actually on the neighboring Miller Ranch). The small seep, or spring-fed pool, of silty water is about 7 feet deep and ringed with faded brown cattails and bright green sedges with a pale, gravel caliche bluff eroding on one side. An unidentified but clearly indignant duck flies noisily away, and a great horned owl silently drifts from the bluff to a leafless tree on the opposite side of the draw as I approach. A spooked least bittern squawks irritably as it flies past me. The owl watches me

as I pick my way along the base of the bluff to a treasure trove of owl pellets filled with curved orange incisors, delicate bones, and dark brown fur. When I pick up one of the pellets, an internal, "Oh yuck, Margie!" in the voice of a friend is so strong that I almost look over my shoulder for her. Years ago, while out on a hike, I had enthusiastically nabbed a pellet from beneath a tree. I showed my friend Elisabeth the tiny bones, hoping she would see the beauty, but she was repulsed. Owls, like other birds of prey, swallow small meals whole or gulp down jagged chunks torn with their sharp beaks. Once the digestible parts of the rodent, bird, or insect have been absorbed, the owl regurgitates a tidy compressed package of fur, feathers, bones, and exoskeletons.

I gently pry apart the bones and grizzled dark fur in the pellet I just picked up. The rodent skulls are perfect, white, and without a trace of flesh. The teeth are still in the sockets and even the jaws are in place. Hundreds of thousands of clean, small bones litter the ground. They are beautiful, delicate, and sad—scattered pale against the red of the clay and dispersing into the dark green shadows of the sedges. Somewhere behind me, a wren is loudly fussing away.

I cannot resist trying to get a closer look at the great horned owl, so I walk around the pool and squelch through the tussocks of sedge pummeled by cattle hooves into a muddy green soup. One misjudged step after another soaks my feet with icy water. Just as I get close enough to see the owl with my underpowered binoculars, it gracefully swoops over me back to its roost on the bluff and out of range again. The owl and I play this game for a few minutes; each time it passes over, I swear it gives me a look of supreme boredom and condescension.

My owl-watching skills exhausted by cold and frustration, I walk downstream. Raccoon, skunk, heron, coyote, and bobcat prints pepper the muddy banks. From this point on, the river has some flowing water, though not as much as in years past, according to the Stewarts. Don told me that the character of the river has changed drastically during his lifetime. He attributes it to the irrigation wells, loss of the grasslands, changes in the runoff patterns of rainwater from cultivation, and an extended drought. I have trouble imagining the river as he remembers it: flowing with water year-round, with tree-shaded holes deep enough for kids to swim in, and pools with eating-sized fish lurking in the depths.

The river slows and widens to become a small wetland. It is almost too cold for frogs, though I do manage to prompt a very sluggish cricket frog into

a half-hearted leap off the bank. The wetlands are impossible to cross without plunging into knee-deep mud, so I climb up a steep bank to circle the marshy areas.

Gopher tunnels and burrows perforate the sandy soil away from the riverbank. My boots break through the crust and I slide ankle deep into the mined land. Chances of seeing a live gopher are slight; they only rarely come to the surface to throw out earth from tunneling or to forage for food.

Wood rat

Barricades of collected cow pies, coyote scat, mesquite branches, joints of cactus, and miscellaneous bits of oil field rubble surround low-growing prickly pears and spiny mesquites. The fortified homes of wood rats, a.k.a. pack rats, look impregnable, but tracks and trails run through the thorny vegetation to succulent prickly pear pads that bear the gnaw marks of prominent front teeth. The rats are relatively safe in their spiny fortresses but for the gopher snakes and rattlesnakes that can enter their warrens with impunity. The idea of a rattlesnake, especially one as irascible as yesterday's, in a burrow beneath the crumbling soil, is unnerving.

I have been hearing the yelps and howls of coyotes all day, but suddenly they sound closer. While I have no desire to confront an entire pack of coyotes, I see them more as rodent control than potential human predator. On our land in Central Texas, my husband and I share our woods, pastures, and walking trails with a pack of coyotes. They seem to prefer our maintained paths to the rougher tracks through the woods, and they regularly mark the ways with scat. This gives me the enviable opportunity to see what food is in season for the coyotes. I know when the Mexican persimmons are ripe and when the mesquite beans are sweet. An armadillo meal leaves small boney plates scattered along the path; cottontail fur is unmistakable, and grasshoppers seem to make up much of the coyotes' summer diet. Coyotes pluck birds of all their feathers before dining on them. Hence, a dinner of fowl leaves a damning trail of plucked feathers. As I make my way from the river back to the truck, I come across a large patch of red and brown feathers drifting under a low tree and catching in the grass. A coyote-shaped spot of flattened grass is clearly distinguishable in the center of the soft feathers. While the distant coyotes sing the sun on its way to the horizon, and with the ominous groaning of a pump jack as backdrop, I scurry to my truck in the rapidly fading light.

Morning is clear and warmer than yesterday. As I head east out of Dawson County and into Borden County, I tilt off the edge of the Caprock Escarpment and move into the aptly named Red Bed Plains. The land opens and spreads into the broad swells of the Rolling Plains. From the edge of the escarpment, I had seen the red Triassic bluffs that give the area its name, but up close, the iron-saturated clay glows from burning orange to almost crimson red in the warm morning sun. The water in the river is a deep orange color from silt and contrasts nicely with the pale gold-green winter grasses and scattered clumps of purple-flowered wooly locoweed that line the banks. The name *Colorado,* which translates from Spanish as "red," "reddish," or "colored," seems perfect for this vividly colored, muddy stream. Yet Del Weniger in his book, *The Explorers' Texas,* writes this about the Colorado:

"However, its waters were always reported limpid and free of sediment throughout most of its length, even though some of its tributaries were found muddy on occasion. Only in its lower reaches was it reported somewhat tinged with color. As one of our explorers had already concluded, this river is therefore misnamed. It is actually grossly libeled by the name."

Weniger attests that the misnaming of the river is evidence of the general state of confusion surrounding early accounts and maps of the streams and rivers. In this section of clay-infused water, though, the name *Colorado* is fitting.

A white pickup truck pulls up on the verge, and Frank Beaver gets out, welcoming me to his ranch. Tall and lanky, in neatly pressed western shirt and jeans, I would never guess he is pushing eighty-four. His manner is direct and open, and, under a dove gray cowboy hat, his face is kind. He clears the truck seat for me, and we are off to see his ranch.

He came to the ranch on July 1, 1936, for a month's work of breaking horses. The owner, Miller, liked him enough to ask him to stay on for a regular job working the five thousand head of sheep. Except for a stint in Italy during WWII wrangling mules and carrying ammunition for the 10th Mountain Division, he has lived on or near the ranch ever since. When he asks, I tell him I think the area is beautiful—but hard. He smiles and nods at my answer. We cut across the riverbed and he points to eroding clay banks and orange water. "River bottom used to be sandy," he says. "Dry spells, I'd come down to the river with a fresno and a team of horses, find a little wet spot in the sand and

dig a hole to water the sheep and cows. Water would seep and slowly fill the hole." I ask, "What is a fresno?" He cannot believe that I have never heard of a fresno and has to spend a couple of minutes teasing me and expressing his surprise (I learn that a fresno is a horse-drawn, box-like implement for scraping and moving soil). He wonders aloud if the sand and gravel hauling had any part in the sandy bed disappearing. During lean times, ranchers—including the Stewarts and the Millers—sold sand and gravel by the truckload for construction: a hard but necessary choice to keep a ranch solvent.

While we are talking about the river, Frank tells me that the river always ran low during the summer, but it was dependable during the winter months. Now, he says, the river only runs when the irrigation pumps on the Caprock are not running. Gone are the smile and the teasing. He suddenly looks his age. He points out a patch of saltcedar. He says, "When we were running sheep, there wasn't a bit a saltcedar here. I think the sheep ate the new shoots, so it couldn't get established." He goes on to tell me that during a bad drought, the owner pulled the sheep off the ranch and later replaced them with cattle. We both look out over the brush and the oil wells. I have gathered that the Miller heirs own the majority of the ranch. Frank has spent his life working on a ranch of which he owns only a small piece outright, leasing the rest from the Miller heirs. He deflects any questions I ask about the oil companies, oil or brine spills, or groundwater contamination. He would rather tell me about his cattle or the many buffalo skulls he has uncovered in the riverbed. We drive into a pasture and when they hear the truck, a group of fat cows and calves comes running and hollering for feed. A trio of young bulls saunters down the road and alertly watches the truck. As soon as he notices the young bulls, Frank apologizes to me but says he has work to do. We have to go find the boy who works for him and get those bulls out of the pasture.

We find Frank's "boy," Eddie, at the old Glen Creek School working hard to mend an old fence. The cedar fence posts, weathered to knife-sharp ridges have barbed-wire strands so rusty they crumble and break. The school's windows are broken and the roof is collapsed. Eddie is an honest-to-goodness cowboy with plaid shirt, tight jeans, platter-sized belt buckle, and a distinctly gap-toothed smile. He doffs his hat at me, and when I wander off to snap photos of the old school, I hear Frank say, "She says she's writing a book on the Colorado River." "Is that right?" I hear Eddie reply. I look back and see the two of them shaking their heads in amazement or bafflement.

Eddie swings back up onto his horse, poses for a photo when Frank insists that I get a picture of a "real cowboy," and then canters off to move the young bulls to another pasture. Frank and I load back into his truck. Now it's time for him to ask me questions: "Are you married? Your husband doesn't mind you going off by yourself? What kind of art do you make?" (Yes; no; prints and paintings of landscapes, birds, and animals.) He asks if there is anything else I'd like to see. I decline, asking instead for permission to hike along the river and take photographs.

When we reach my truck, Frank Beaver parks and gets out to say goodbye. As I drive away, I look back to see him standing tall and courtly, next to his truck. The same smile that has been loitering around the corners of his mouth all morning breaks free into a big grin as he waves goodbye.

I park behind a nearby pump jack and slide down steep clay banks to the river.

The cloven hooves of the sheep and cattle continue and accelerate the ero-

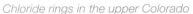
Chloride rings in the upper Colorado

sion and shaping of the land started by the river. The riverbanks are miniature badlands, Lilliputian chasms full of fantastic sculpted formations and layers of colors. The runoff silts the water, and the churning of cow hooves muddies the water further. The grasses are close-cropped by the cattle, and hoof prints pockmark the riverbed. I find half a tiny pearlescent mussel shell. I put it in my pocket and wonder what can live in the shallow waters of the river.

Thick clumps of seep willow line the course of the river where it is contained within its banks. The burnished mahogany red of last year's new branches is surprisingly pretty against the rough gray of the older bark and the clumps of narrow, bright leaves at the joints. Where the river broadens into a small marsh, tough green sedges bunch around the orange water in brilliant green pompon rows. Obviously, cattle don't like their flavor, or they would be mown to root level like the grasses. The scraggly and spiny shrubs that cover most of the area dislike soggy roots and don't venture into the wetlands. The 16-foot-tall bluff behind the marsh is dark red, darker than any other soil or clay I've seen on this trip. Thick layers of pale pink and orange stone topped with rocky, tan caliche and a few hardy shrubs cap its eroded slopes. The red is as rich as hematite, an iron-ore pigment I grind and use in egg tempera painting. The color is browner than a glass of burgundy but has the nuance and tones of a glass of port held up to the winter sun.

Below the little marsh, the stream narrows again and burbles over smooth round pebbles. Each small stone near the water has a ring of white mineral crystals. The stems of grass and sedge all have feathery coats of crystals, and there is a white crust on the drying clay of the bank. I'm too chicken to taste the water or touch the crystals to my tongue to see if they are salt or alkaline. The presence of the oil pump jacks, signs warning about poisonous gases, and mysterious black plastic pipelines running chaotically across the river make me nervous. Early explorers' accounts of the upper Colorado River often intimated that the waters were brackish or salty and, according to the *Springs of Texas* by Gunnar Brune, much of the original spring water issuing from the Caprock was heavily mineralized. Frank Beaver told me that the river used to run clear but always had an "alk-y" taste. The Rolling Plains area is rich with minerals; Permian gypsum and natural salt deposits leach into groundwater. Long-term drought has exacerbated the problem by concentrating chlorides and sulfates in the remaining surface water.

In addition, this area has the added burden of chloride pollution from

the oil fields. Underpinning most of the headwaters basin, the Jo-Mill field in Dawson and Borden counties is one of the seven largest-volume fields in the Spraberry-Dean Sandstone oil fields, part of the rich Permian Basin. When wells are drilled into the tightly packed but porous sandstone of the fields, oil, natural gas, hydrogen sulfide gas, and brine (heavily concentrated saltwater) flow upward. The wells pump up oil and brine and then put the mixture through a separator. From 1954, when the first well was drilled, until 1969, the oil companies discharged the brine into open, unlined dirt pits. The heavy, concentrated saltwater and toxins seeped through the sand and gravel into the freshwater aquifer; during heavy rains, the pits would overflow and wash directly into the river and its tributaries, poisoning the soil along the way. On the Stewart ranch, Don pointed out the site of the settlement pits that contaminated their well water. Although Exxon filled the pits decades ago, the area is almost bare of plants, unlike the tangled grasslands surrounding it. Since 1969, the brine and chemicals used in the drilling process, including highly toxic barium, arsenic, and cadmium, are put in tanks and transported by truck for disposal at approved sites. Yet chloride contamination is an ongoing problem because abandoned, unplugged, or improperly plugged oil wells provide an easy route for brine, oil, and chemicals to migrate into aquifers. In addition, wells with deteriorating metal casings allow brine and oil to seep into surrounding soil, groundwater, and the river.

A pump jack labors above me, and a crude oil pipeline crosses the riverbed, suspended over the eroded banks. I clamber up the bank to go over the pipeline with pounds of sticky clay layered on the soles of my boots. With every step, I accumulate more pebbles, sticks, and dirt until I have a 2-inch-thick platform glued to each foot. I skid back down to the river and skate over to a ledge. While reaching for a rock to pry off the goo, I see, in the soft, orange clay by my hand, bobcat tracks. Each print holds minute and exact impressions of fur and the texture of the skin on the paw pad. The sun glints off the river, and I see a shining trail of water-filled tracks trotting downstream.

Muleshoe Ranch

I stand on the shoulder of Mushaway Peak in northern Borden County looking south across the headwaters basin of the Colorado River. To my right, the

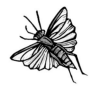

Caprock Escarpment rises long and low, indigo blue against the pale wash of early afternoon sky. Before me, the rolling terrain is sculpted by the creeks that join like the fingers on a hand to form the Colorado River: Gold Creek, Tobacco Creek, Glen Creek, Rattlesnake Creek, Plum Creek, and Grape Creek. Ignoring the few barbed-wire fences and power lines, I begin to mentally erase the tangled brush and the drought-burned pastures before me and dress this landscape in the thick grasses and wooded streams that made up the natural prairies[2] in the eighteenth century and earlier. Grasslands that grew thick and stirrup-tall in good seasons were interspersed with pockets and islands of mixed woods. Numerous historical accounts describe the streams east of the plains of the Llano Estacado as having rich *galeria* forests along the stream bottoms. Del Weniger, in *The Explorers' Texas,* recounts how, in 1854, J. H. Byrne, part of a western railroad expedition, describes the stream banks as "thickly covered with timber—mezquite, hackberry, wild china, plum, willow and scrub oak." Other explorers remarked on the beauty of the area saying, "These rivers are very beautiful because of the large numbers of trees near them, good and palatable water, good watering places, and grass that grows abundantly near the water." With trees arching over the streams, these graceful "gallery forests" threaded the length of the Colorado and its tributaries through the grasslands.

The terminology of the open sea seems natural to this place of open treeless plains and former rolling prairies: waves of grasses and islands of trees, swells of land surging and lapping at the base of the Caprock; I find myself swaying slightly to the imagined currents.

Onto this reconstructed landscape, I imagine the brown wave of a herd of bison cresting the far ridges. Brown shapes fan out over the horizon as they graze, moving slowly and inexorably along. I reject a Hollywood-inspired stampede and substitute a creep-like brown molasses across the prairies, as immense herds move slowly north with the spring. Droves of white-tailed deer browse through the gallery forests and on the verges of the grasslands. Herds of pronghorns, our native "antelope-goat" stay separate from the bison, but they wheel and take flight like flocks of birds, speeding over the grasslands as packs of wolves circle the edges of the herds looking for prey. Fire roars across the landscape, burning out the trees and shrubs sprouting in the grasslands, leaving fertile ash for the grasses and herbs that will reemerge in the seasonal rains. Camp smoke drifts from the canyons at the edge of the escarpment.

Jumano Indians used to live at springs issuing out of the Caprock, but they were pushed out by the Lipan Apaches who made the protected canyons their homes for a century or so. I imagine the slow progression of the Apache bands as they follow the bison herds and periodically stop in fertile areas to plant small seasonal crops. Though the Lipan Apaches tamed the wild Spanish horses and became proficient equestrians, they remained tied to their gardens and vulnerable to the Pentachka, or the Honey-eaters, the largest and best-known Comanche band. The Comanches came cascading across the plains in the early 1700s to claim the territory for their own.

From the west, thousands of sheep move onto the Llano Estacado and down the Caprock herded by Spanish and Mexican *pastores*. The flocks mow the grasses short, and then the sheep and the *pastores* disappear. Their adobe houses and plazas disintegrate into dust. Massive herds of cattle belonging to the Spanish missions now crest the horizon and compete with the bison, deer, and pronghorns. Descendants of the horses left behind or stolen from the Spanish explorers number in the tens of thousands, and they roam across the Llano Estacado and the headwaters.

The herds of bison thin as hunters with rifles slaughter hundreds of beasts at a time. Traders from New Mexico, the Comancheros, make camps at Mushaway Peak to trade in stolen cattle, horses, and people. In the secretive canyons at the edge of the Caprock, they build corrals for rustled livestock and slaves of many colors. The Comanches still follow the diminishing bison and try to hold onto their territory as the game disappears. Settlers move in a wave across the area, cutting the timber as they move and clearing the gallery forests along the streams and river. Barbed-wire fences stretch across the range. Cattle, sheep, and horses crop the grasses of the prairies short but, unlike the roving bison, the domestic herds stay, and their hooves cut into the exposed earth. Plows bite into the soil and turn up the plains of the Llano Estacado from edge to edge. Wells plunge deep into the Ogallala Aquifer to irrigate fields of cotton. Springs at the edge of the Caprock dry up as the straws of the numerous wells lower the water level. Rivers dwindle and stop running except when rains fill their beds. The grasses have disappeared, and in their place, tough mesquite, inedible cedar, and thorny plants grow up into impenetrable brush lands. Oil pump jacks soon dot the land from the Llano Estacado over the Caprock and into the headwaters basins, scattering at the edge of the producing field just over the Borden County line.

This is the land, with its history of plenty and plunder, that Rich and Barbara Clayton Anderson took on the management and ownership of in 1957. Instead of gallery forests along the banks of the Colorado River and its tributaries, the Muleshoe Ranch had thick brush—primarily mesquite—covering much of its forty-eight sections (over thirty thousand acres) and choking the streambeds of the Colorado and the tributary creeks that merge with the river on their Borden County property. While explorers recorded mesquite in the canyons and arroyos of the Llano Estacado and Caprock Escarpment as early as 1808, the density of the thickets of stunted trees in the mid-twentieth century was indicative of destroyed grasslands and depleted soil. Without the deep, penetrating roots of native grasses to hold the earth in place, rain washed away valuable topsoil and compacted what thin dirt remained.

Rich Anderson surveyed his new domain and, he tells me, after an intimate conversation with God about responsibilities, he declared himself a grass farmer first and a cattle rancher second. His plan to clear brush and reestablish native grasses so his cattle would have something to eat was new to the majority of the ranchers in the area. They looked on in amazement as Rich and Barbara started a program that included root-plowing brush thickets with a bulldozer (equipped with a giant rake-like blade to dig out the gnarled trees), aerial spraying with herbicides, seeding the areas with native grass seeds, and building rainwater catchment ponds. With the help of the Soil Conservation Service's Great Plains Conservation Program, their fifty-year battle to wrestle the Muleshoe Ranch—and an additional fifty or so sections of family land—out of brush and back to grasslands has been successful, although thoroughly exhausting. When I'd driven across the highway from Frank Beaver's ranch and entered the Muleshoe, I'd noticed a sudden increase in the diversity of grasses, small shrubs, birds, and other animals. Birdlife was abundant, with roadrunners trotting down the road in front of the truck, songbirds and sparrows in the trees and grasses, watchful kestrels, and red-tailed hawks on the power lines, and even an out-of-place-looking pair of greater yellowlegs and a long-billed dowitcher probing the grassy verge of an old airstrip. A trio of pronghorn antelopes warily regarded me before bounding away. A few scattered mesquites were the largest trees in sight, and each seemed to host a resident mockingbird doing his or her best to out-sing every other bird around. Even in a record drought in dormant early spring, the Muleshoe vibrates with life.

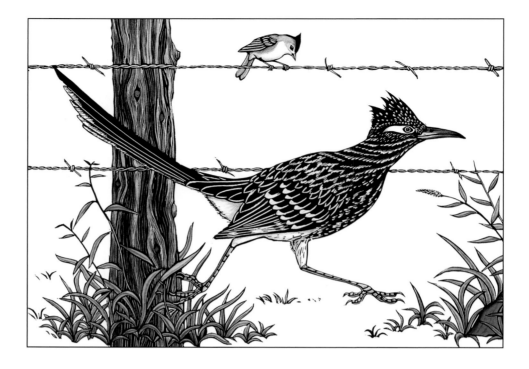

Rich Anderson looks the part of a Texas Rancher: tall, rugged, and imposing; he starts my visit by proclaiming that ranching is a damn hard life. He is defiant, almost proud, when he tells me that he has broken sixteen ribs, worn out both knees and hips and now sports matching sets of artificial joints as well as a fused spine. He quickly adds with a grin that he wouldn't change his life for love or money. His wife, Barbara, is petite, with abundant graying hair that she girlishly pushes behind her ear before speaking. She almost shyly tells me that the Muleshoe, her family's ranch, is probably the largest in Borden County. Assembled at the turn of the century from sections bought from homesteaders and ranchers, it covers over 48 square miles. Between the Muleshoe and other family properties, Rich and Barbara operate and control a total of 100 square miles. The drive from the ranch house at the confluence of the Colorado River and Tobacco Creek to our lookout at Mushaway Peak, a remnant of the Caprock, takes half an hour and includes several well-rehearsed stories about brush clearing and grass farming.

We leave the flanks of the peak, and Rich drives me across the Muleshoe to show me the rangeland. He is justifiably proud of his life and work and supplies me with a steady stream of entertaining anecdotes, opinions, and personal philosophies. Rock-solid in his political beliefs, he takes great delight in mock-

ing what he refers to as the "liberal-environmentalists" and what he considers their rabid zealotry. "Ranchers were the first environmentalists," he announces and then goes on to explain that the historic damage to the rangelands was unintentional. When the explorers and settlers arrived, he tells me, they found herds of buffalo and thick grasses that, depending on the amount of seasonal rain, could be tall and lush. The ranchers fenced the range and stocked their land with numbers of cattle as if every year was going to be a good year for rain. "They didn't understand that the grass wasn't going to come back if they had too many cattle on their land during a drought," Anderson says, watching to see my reaction. "Once the grass was gone, the brush took over." He adds that there are some property owners who don't have the resources to properly manage their land (and a few who can't be bothered), but that most ranchers are dedicated to preserving their ranches, livelihood, and way of life. "And the only way to do that is to be a grass farmer first and a cattle rancher second," he grins.

When he drops me off at my truck, he keeps me a moment longer to deliver smiling but serious warnings not to get lost, snake bit, or to start a range fire. If he had any idea how lost I've been over the last two days, he'd never let me loose on his ranch. Like a kid let out of school early, I have a crazy and exuberant feeling that anything is possible. I walk up an arroyo and slip into a wordless space where the light shimmers, the air is full of expectation and promise, the whispering of grass blades makes my skin tingle, and I can taste the color of the bird songs. I am cross-eyed in love with the warm sun, absurd cotton-ball clouds, and the explosions of small birds that sing tender, pale green notes and flit among the leafless branches. A house wren scolds me vigorously in tones of burgundy and brown then turns her attentions to a mockingbird careless enough to cross her path. A curve-billed thrasher bounds into the top of a mesquite and pours forth in song as varied and colorful as a field of wildflowers. I see turquoise mountain bluebirds and the sulfur-yellow flash of meadowlarks, rusty American tree sparrows, magenta-dipped house finches, and flocks of white-crowned sparrows. When the sun slides behind a cloud, it is as if a curtain is drawn, and the birds hide their bright breasts and crests and still their voices. Then a northern harrier glides past; when she is gone—as if on cue—the sun breaks through, and the birds pop out of the grass to flit and twitter.

The arroyo ends below one of the many rain catchment ponds, or tanks, the Andersons have built around the ranch. I try to sneak up to get a look

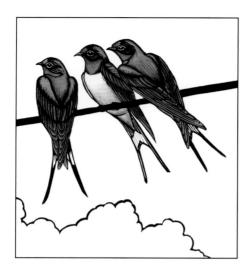

at the birds paddling in the receding water and the shore birds skittering around the 100-foot line of drying and cracking mud. Stealthy birdwatcher that I am, I manage to startle every bird on or near the pond into flight. I finally sit down, prop my weak binoculars on a convenient willow limb, and wait for the birds to settle down again. For the birds I can't identify I make notes of field marks in the hopes of identifying them from the field guide later. I have no trouble recognizing American coots squawking and paddling from one end of the tank to the other. Bufflehead and northern shovelers are unique and easy to recognize. The shrill keening of killdeer is as distinctive as their brown- and black-banded chest. Barn swallows flare their forked tails as they swoop over the surface of the water, the blue of their backs iridescent in the sun.

I decide to eat lunch on the arching limb of one of the willow trees surrounding the pond. Dozens of red-eared slider turtles pop up their heads to watch me from the opaque green water. Battalions of azure and black damselflies hover over the water. A fluorescent green baby bullfrog with luminous yellow eyes glares at me balefully from the water's edge but submerges when I move to stand up. While grabbing binoculars to look at a small, very fast brown bird in a nearby willow, I drop my sandwich into the cow-churned mud. "Oh, Margie!" I can hear the exasperated voice of my mother, my grandmother, and a long line of school teachers. Picking up the bread, I defiantly eat the "cleaner slice," try not to think too much about *E. coli* bacteria and instead consider the poetic and ironic aspects of being surrounded by cow poop on a cattle ranch while eating peanut butter and jelly on only slightly dirty bread.

I sling my daypack over my shoulder and follow the arroyo back to the truck. I scrabble under a barbed-wire fence and, determined to keep my boots dry, start my meander down a dry section of riverbank.

The river disappears behind rocky shoulders. I clamber down overhanging rocks: thick multi-colored layers of stone and sand topped with pink rocks, plastered with the brown bottle-shaped remains of cliff swallow nests. When I slide down to the water's edge, I discover the bluff is covered with beautiful dark red abstractions painted on a pale, sandy background. When rain runs down the face of the stone, it crosses over and mixes with a layer of dark red clay and sand to form a slurry of color that flows and drips to create dendritic patterns like earthen angiograms.

A great blue heron has printed his trident signatures in dark red mud on a pale gray rock at the water's edge where it stood watching and waiting to

stab a fish or frog with its saber-like beak. A few steps farther down river and I see where someone—bobcat or coyote?—had a heron snack, leaving distinctive feathers and one long leg behind. Even I can read these riverbank hieroglyphics, but I wonder what I overlook or do not comprehend. For Native Americans, trappers, scouts, and hunters, their lives depended on an ability to read the mysterious signs of animal tracks, interpret the patterns, and tell the stories. On the riverbank, I easily identify the footprints of frogs, turtles, raccoons, coyotes, and herons. Sparrows and songbirds leave a delicate scribbling at the water's edge, punctuated by the mincing steps of a skunk across a mud flat. I look down and see what look like the tracks of a full-grown iguana. My brain locks up with the possibility of an iguana running around Borden County, but then I recognize the impressions as the tracks of an extra large bullfrog. Now I know what all the herons, coyotes, and raccoons are feasting on—bullfrogs and their tadpoles.

Low ridges run to the river like the veining of a leaf to a central stem; the tips, though, are truncated into exposed small bluffs that form walls on either side of the river bottom. The river corridor varies in width from only ten feet to hundreds of yards wide. The red clay banks seem to resist the forces of erosion and hold firm, while the sandy areas have receded into gentle, open slopes. The river is close to a foot deep in spots and averages five to six feet in width. Mostly it is quiet and slow, and orange with suspended clay. Its banks are thick with seep willow, saltcedar, mesquite, sedges, and cropped grass clumps. If the area weren't braided with cattle trails, I could not get near the river. Periodically, the channel of the river narrows, and the current bumps against the banks, threading its way through trailing grasses—gurgling and doing its best impression of a babbling brook.

Because it has been at least an hour since lunch, I plop down in a bare sandy patch close to a twisted mesquite for a snack. I am quite fond of mesquites, though, as German scientist Ferdinand Roemer quipped in 1846, "To find shade under a mesquite tree is like dipping water with a sieve" (Roemer, *Roemer's Texas*). According to Roemer, early settlers regarded the presence of mesquite trees as a sure sign of fertile soil, and livestock relished the grass that grew luxuriantly under the trees. At the time, he observed, "Mesquite trees never form a continuous forest, but are found singly, scattered in the prairie." Today, mesquites are labeled water hogs and scorned. But tough and drought-resistant, mesquites can thrive in depleted soil that nothing else will survive

in, produce abundant food for wildlife, provide excellent habitat for nesting songbirds, and improve the soil by fixing nitrogen. I've had sweet, nutty mesquite tortillas made from the bean pods and admired the hard, durable wood used in furniture and floors. Like other Texans, the mesquite is thorny and a bit of a nuisance, but durable and steadfast.

As I continue my walk, I notice a few spring flowers are just starting to send out their first blooms on the dry hillsides above the river. Tucked beneath the pale gold of the winter grasses, bonsai versions of prairie verbena hug the ground, growing no more than 2 inches tall. The scrambled egg yellow of frilled puccoon looks odd clinging so close to the ground. A small purple tansy aster blooms on a slope, and I notice the ground is thick with plants and unopened buds. Dozens of a small yellow flower are scattered in with the asters and verbenas. I don't try to identify it beyond recognizing it is a "comp" (in the Compositae, or sunflower, family). The delicate and spiny dried leaves of desert holly flutter like pale flags at the base of shrubs. I've never seen the blooms—only last year's leaves staking the new growth. Sand asters are white with tiny yellow ray flowers and distinctive spines at the tip of each leaf; yellow bladderpod blossoms tremble at the ends of stalks. Corydalis, or scrambled eggs, teeter on their stems next to purple-faced stork's bill geraniums. A clump of bitterweed in full yellow bloom is tucked along the warm south side of an arroyo. The mesquites haven't started budding out, but the branches of javelin bush are obscured with clusters of translucent, pale yellow flowers. Earlier that day, while I sat with the Andersons in their home and we lamented the effects of the ongoing drought, Barbara suddenly left the table. She returned, handing me a well-worn copy of *Wildflowers of the Western Plains* by Zoe Kirkpatrick. With her eyes shining at the memory, Barbara pointed out some of the eighty-seven different wildflowers she identified on a morning walk one perfect spring morning a few years ago. I try to imagine what this area would look like in a good year, with enough rain for the plants to flourish but not so much that it would wash them away. It would be beautiful. In the midst of my wildflower reverie, I realize the sun is surprisingly low in the sky. I conclude that if I walk very fast and don't stop to look at birds, plants, rocks, tracks, or insects, I can make it back before dark. I almost make it, but a low-flying owl distracts me and leads me into a maze of gullies and washes. The owl melts into the twilight, so I stumble through the fading light back to the river and upstream to my truck.

The headwaters of the Colorado River do not issue from dramatic and massive springs like the San Marcos or the Comal Rivers but instead begin as small trickles of water in a heavily utilized land. Contour plowing of the croplands of the Llano Estacado helps prevent excessive soil runoff and erosion, but it has changed the drainage pattern for the river headwaters basin. With an annual average rainfall of 20 inches—or less—area crops need groundwater irrigation. Pumping and depletion of the Ogallala Aquifer beneath the Llano Estacado has dried up the many small springs that used to seep from the canyons and breaks of the Caprock and feed the river. Natural gypsum and salt deposits, along with oil field activities and poor agricultural practices, have contaminated the groundwater and the surface water of the river with concentrated salt and toxins. Cattle and sheep clamber down the riverbanks and expedite erosion and soil runoff.

In spite of these obstacles and because of the vision of local landowners and the work of the Natural Resources Conservation Service (NRCS) programs, there is live water in the river. The Stewarts and the Andersons (and their children) are dedicated to preserving ranching as a way of life, and they work hard to be conscientious stewards of the land. A soil scientist at the NRCS proclaimed the Stewart Ranch a conservation showcase and wished for more landowners with their commitment and enthusiasm. In 1993, the National Cattlemen's Association recognized the owners of the Muleshoe Ranch for their dedicated conservation with the prestigious Environmental Stewardship Award.

When the Andersons began their grasslands restoration on the Muleshoe Ranch, the river was intermittent and only ran during rain and in the wet season. Now, they proudly report, there is year-round live water in the Colorado River. These two families leave a generous bequest to their children and the people of Texas. The river may not flow as much as in years past, and it may be thick with soil churned by the hooves of cattle, but water that originates in the headwaters basin of the Colorado River starts a journey that lasts more than 850 miles. As the Colorado River winds its way through cities and towns, it will be impounded for reservoirs, dammed and released for hydroelectric-generating plants, and it will touch the bodies and lives of millions of Texans on its way to the Gulf of Mexico.

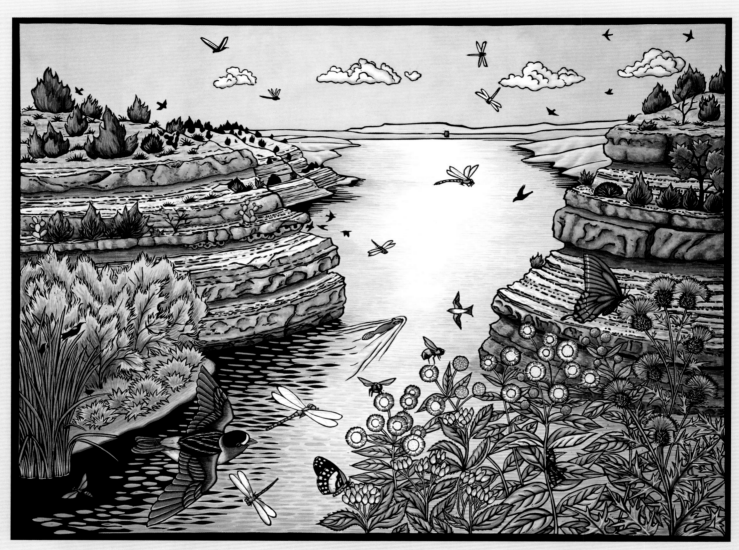

Reserved Beauty

2: Impounded on the Rolling Plains

Lake J. B. Thomas

Destiny proudly poses for my camera, a grinning gap-toothed eight-year-old with wind-tangled black hair. Behind her, the orange waters of Lake J. B. Thomas whip themselves into small brown waves. She squints in the sun. The shutter clicks, and with a quick wave she scrambles down the steep rocks returning to her sister and their game of throwing rocks into the water. Her father uncaps a jar of the newest and best stinkbait for catching catfish. The girls squeal and hold their noses while the sleek muscular dog in the back of the pickup sniffs the air appreciatively. The two girls, their dad, and his best friend drove over from Big Spring for a day of fishing but even with the pungent bait, the catfish aren't biting. I bring over my road map, and together we trace the path of the Colorado River from our position at Lake J. B. Thomas, down to the E. V. Spence Reservoir, and then to the O. H. Ivie Reservoir. The river runs through the Rolling Plains ecoregion,[1] the southern end of the Great Plains, a land of deep clays, dry former prairies, and woods. It is bordered on the west by the Caprock Escarpment and the High Plains, on the south by the Edwards Plateau, and on the east by the Cross Timbers and Prairies ecoregion. With an annual rainfall of 20 inches, most of the area is desert-like rangeland

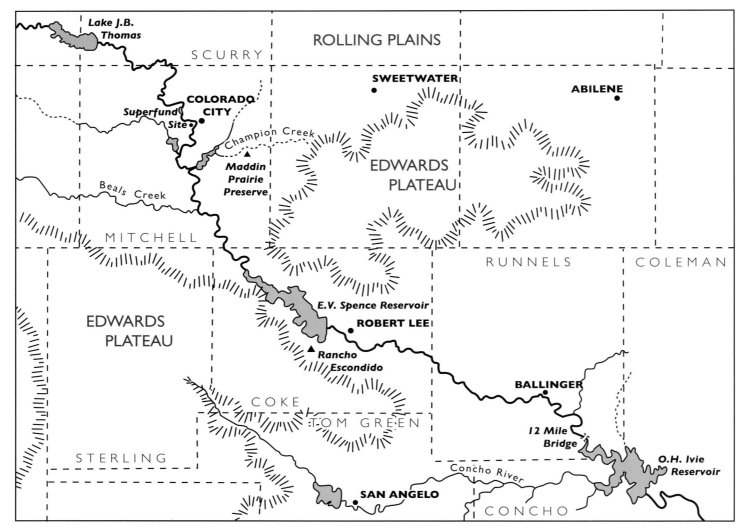

Lake J. B. Thomas to O. H. Ivie Reservoir

locked in an unrelenting battle with woody brush, struggling croplands, and the ubiquitous oil industry.

Lake J. B. Thomas is the first of three main channel impoundments that the Colorado River Municipal Water District (CRMWD) owns and manages. Built in the early 1950s during the heyday of dam construction, engineers designed the reservoir to catch storm and floodwaters that otherwise, in the words of a local rancher, "would run downstream and go to waste." In a parched and drought-prone land, it insulted and enraged people to watch precious water slip away down river.

That morning, I'd impulsively stuffed my truck full of gear, lashed a kayak

in the back, and pointed the vehicle north and west out of Central Texas toward the Rolling Plains. I was unprepared for the desolation of the lake and the surrounding landscape: bare rock shores, turbid orange-brown water, and baking sun. At the water's edge, thick cushions of saltcedar needles coat the rocks. A fisherman in a perilously low-riding boat is pulling up jug-lines. I yell out the standard, "Catch anything?" He never looks up but calls out over the wind and waves that he has pulled nearly 900 pounds of catfish out of the lake in the last year. The gunwale of the boat dips down to the lake surface as he leans over and hauls in a line tied to an old Clorox bottle. At the end is a big catfish, its fat white belly slack and pearlescent in the sun. I look out and see dozens of white bottles bobbling throughout the nearby coves.

In 1952, when the dam for Lake J. B. Thomas was completed, people in the member cities of the district—Snyder, Big Spring, and Odessa—celebrated. The CRMWD not only built the dam, they also drilled a well field in Martin County for groundwater and installed over 115 miles of pipeline to deliver water to their customers.

The first indication that things might not work out as planned was the lake's refusal to fill. A year after the dam was sealed, Texas was in the throes of a massive drought: the drought of record for the state. But the drought-busting rains of the early 1960s produced more than enough rain to fill the lake. Water sheeted off the hills, trickled into washes, flowed through streams, and rushed down the riverbed. The rainwater washed across the drought-ravaged rangelands carrying soil and debris into the reservoir, foreshadowing the tons of silt that continue to plague the lake. Lake J. B. Thomas has only been full three times in its more than fifty years—and all three of those times were between 1960 and 1962. During the time when folks believed that the lake would not only fill, but also stay full, a real estate boom sprouted vacation properties along the bluffs ringing the perimeter. With the current lake measuring less than 15 percent of capacity[2], the few remaining homes overlook a lakebed choked with saltcedar, seep willow, and grasses. Constant demand, limited supply, extended droughts, and a serious overestimation of runoff amounts have kept the lake less than one-quarter full—or three-quarters empty—for most of its life. As an important source of water for multiple cities, its existence is crucial, but with evaporative rates averaging 6 feet per year[3] and chronic problems with silting-in, its future as a water supply looks bleak.

Waving goodbye to Destiny and her family, I turn away from the lake and walk up a small rise toward an unmowed area of thick grasses and scattered small mesquites. In the distance, brush thickets undulate, distorted by shimmering heat waves. I crest the hill. A bractless blazingstar stands tall and spindly, its waxy, delicate white blossoms closed against the day's heat. Two feet taller than the short grass, it looks out of place; its narrow leaves with ruffled edges look like the jaws of tiny creatures. I turn around; a Western diamondback rattlesnake has crawled onto the road in front of me. Kinked into tight, sinuous curves, she flattens her body to bring her belly closer into contact with the hot surface. She doesn't rattle or even flick her tongue when I step closer, but instead exhales and nestles into the warm sand. But when I move too close, she flicks her tongue rapidly, then slowly eases off the road to disappear into the tall grass.

I walk down the road and then step into the shin-deep grass to walk toward a cluster of mesquite. Knowing there is a rattlesnake nearby, I feel like I've sprouted whiskers, sensitive antennae quivering along my spine and from my knees, elbows, and hands. The crunch of dry grass under my feet, the scratching of stems against my jeans, the rushing sounds of birds, wind, and insects are deafening. I smell the dry soil, the concrete-after-a-rain smell of the lake, and hold the metallic taste of nervous fear in the back of my throat. Disintegrating toilet tissue flowers festoon the mesquites—it seems I've found the Ladies' Room.

I take a step, and there is a feathered brown explosion under my foot. I hear a horrible high-pitched squealing sound as I levitate. I land and freeze, running a quick checklist: No pain in any extremities. No buzz of a rattlesnake. No blood. I look around for the source of the terrible noise. The realization that I was the one who emitted the girly scream creeps over me, and I impulsively duck down to hide in the grass. I surreptitiously check to see if anyone is on the way to rescue me, but the fishermen are too far away to have heard me. I gently part the grasses by my feet. Nestled deep into the stems, four brown speckled eggs cluster in the warm shadows of a domed meadowlark nest. The meadowlark hops nervously from foot to foot in the nearby mesquite.

Sitting in the rough grass with the meadowlark nest before me and a healthy rattlesnake somewhere off to my left, I'm confounded by the juxtaposition of emotions and facts. The quiet joy and simple satisfaction in finding a bird's nest is offset by a marrow-deep sadness tinged with the red bloom of anger and a single-digit number.

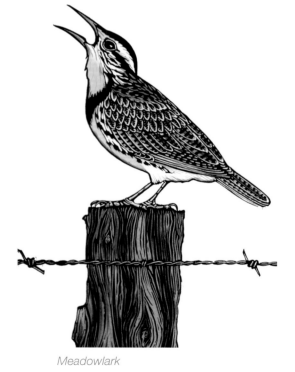

Meadowlark

One percent. All that remains of Texas' original grasslands and prairies is one percent. Texas was once a state rich in abundant grasslands—from the Western Plains to the Gulf Prairies and Marshes. The plains and prairies supported more than grass; the diversity of plants found in a native prairie surpasses imagination. Moreover, linked to the plant diversity is an intricate and expanding web of interdependent insects, arachnids, birds, reptiles, amphibians, and mammals. About 40 percent of all our bird species live in grasslands, and they are the first to suffer from habitat loss. A few opportunistic species like killdeer and red-winged blackbirds seem to have adapted, but most hang grimly onto the edge of survival. Occasionally a bird attains state or federal threatened (or endangered) status, or a popular game bird like bobwhite goes into decline, and money is poured into panicked studies so scientists can try to figure out what essential ingredients are necessary for its survival. Habitat preservation is nearly always the answer, but with so little pristine or even restored grasslands left, even the best-designed plans are close to impossible to implement. When we lose our prairies, we will lose an enormous number of plants, birds, reptiles, insects, and mammals that live nowhere else. How, I wonder, can I feel so keenly the loss of something I have never known?

The expanses of the Rolling Plains were open grasslands and prairies filled with scattered woods and gallery forests arching over streams and rivers. In the 1870s, there was a huge influx of domestic cattle into West and Central Texas. Several years of above-average rainfall in the early 1880s resulted in a lush, luxuriant growth, probably the source of the oft-told story of settlers finding miles of stirrup-high grasses. Believing the grasses would always be abundant, ranchers badly overestimated the available forage and underestimated the possibilities of drought and harsh winters. The results, while not intentional, were devastating. It took less than twenty-five years to wipe out huge expanses of the rich and productive shortgrass, midgrass, and tallgrass prairies. In addition to overgrazing, conversion to cropland, invasive plants, brush, and urbanization have gobbled up the grasslands.

I carefully pick my way back to the road. The rough land may not be an honest-to-goodness prairie, but it provides refuge for meadowlarks. And rattlesnakes.

As I pull out of the park, the rust-red glow of sunlight on the wings of a tarantula hawk wasp catches my eye. She flies alongside the truck as I drive, her black body shining blue. Millipedes are everywhere—tiptoeing across the

Lubber Grasshopper

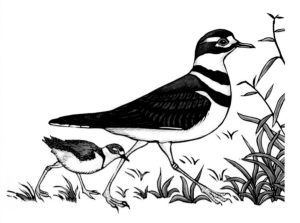

roads—enough of them to guarantee a solid case of heebie-jeebies to some-one with an aversion to invertebrates. Grasshoppers cluster on the asphalt, both flightless lubbers and outrageously patterned painted grasshoppers. Their crushed bodies are delicacies for the mockingbirds and loggerhead shrikes poised on the power lines. In my rearview mirror, I can see the birds swooping down to glean the treats left by the truck tires. Flashing gold and black, a golden-fronted woodpecker and a Bullock's oriole spiral up the trunk of an old mesquite.

A pair of killdeers runs beside a tire-track puddle of rainwater at the edge of the road. A brown and white fluff ball teeters out of the grass on chopstick legs and hustles, squealing, after its parents. It looks like a child's drawing: a fluffy circle for body, another smaller fluffy circle for head, big round black eyes, and ridiculously long legs. I stop and stealthily exit the truck with camera, but I'm immediately distracted by a handsome checkered garter snake floating in the shallow water of the ephemeral pool. With three steps, I alarm the snake and terrify the killdeer, so the parents fly off shrieking, and the chick melts back into the roadside shadows. The garter snake takes off into the tall grasses, and there is a rocketing explosion of frogs.

I've managed to evacuate the area of all visible wildlife in less than 30 seconds. Chagrinned, I scour the area and find a lone plains leopard frog in the puddle and a small dirt-colored Blanchard's cricket frog who are kind enough to pose for photographs.

I hear the explosive bleat of a leopard frog in distress. Following the un-mistakable cry, I spot the bright white of the frog's face, open mouth, and forelegs beside a clump of grass. The frog gives a jerky movement, and then I make out the head of a checkered garter snake swallowing the back half of the frog. In the time it takes me to point the camera and snap the shutter three times, the frog has been engulfed by the snake. I look for fear or emotion in the frog's eyes, but its features are regular and bland even as the snake's mouth closes around it. The frog does not struggle against the snake, yet, eerily, I can hear the frog's distress call continue as it slides down the snake's throat into the gullet. I follow the snake through the grass for 10 feet, listening to the frog call from the snake's belly, it's like macabre squeaky-toy.

Outside of the park, I pass poorly maintained pump jacks spewing black oil that coats the ground and coagulates into evil-smelling pools. Glossy black moats surround rusty tanks striped with leaking oil. I turn off onto a side

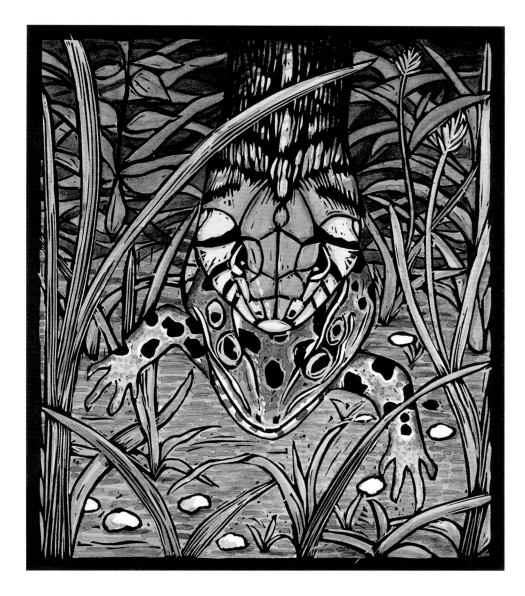

Big Gulp

road that, according to the map, dead ends at the lake shore. Off to my right I see what looks like a water intake station. It extends off a bluff, a glass cube supported by tall concrete pillars that plunge into a wooly sea of grasses and brush. To my left, a groaning pump jack is perched on a pimple of land, grinding away and emitting sulfur fumes. A dressing of black oil oozes along one side. Fifty years ago, the pump jack would have been surrounded by water; now it is surrounded by a rank thicket of saltcedar, seep willow, grasses, cockleburs, and other brush. A ribbon of tall, bright willows parts to reveal

the river: orange, opaque, and lazy. A concrete apron slick with moss and algae forms a low-water crossing. Tangles of fishing line and bright red and white plastic bobbers swing from the branches. In the deep, quiet shadows, it is cool and green. According to the map, I am currently underneath 20 feet of water in the center of the lake. I need a new map.

My truck surfaces from the green shadows of the willows into the scalding sun, and I head back up onto the bluff. Vacation cottages and mobile homes, circa 1960, line the edges. A few maintained homes and occasionally a newer house pepper the rusting and decaying rim of buildings. Concrete boat ramps end in tangles of cockleburs, willows, and more feathery saltcedar. In the distance, I see the turbid orange-brown of the lake.

Colorado City

A thin dribble of water flows from the dam into the riverbed below Lake J. B. Thomas. By the time the river reaches Colorado City, it has gained enough water to have a modest presence. Yet the river seems to be entirely ignored by the town: there are no parks along the river and no public access; without the bridge signs on the highways, I'd never have known the river was there at all.

Tired and sunburned, I check into a motel on Interstate 20. The lot is full of trucks and trailers loaded with big yellow steamrollers and other heavy construction machinery. From the office, I see a group of guys standing outside the open doors of their rooms, leaning against trucks and enjoying a loud camaraderie with lots of manly shoulder punches. When I park in front of my room and kill the engine, there is a sudden silence. Not wanting to encourage attention but being curious, I sneak a look. Like a group of prairie dogs on alert, the guys are stock still, peering over the hoods of trucks and around cars to check out the latest arrival. I pick up my suitcase and feel multiple pairs of eyes. Instead of feeling threatened, I'm seized by a temptation to drop my bags and run at them, yelling and arms waving, just to see if they'll bark in alarm and dive into their rooms like prairie dogs. I resist the temptation and, giggling at the image, collapse onto the bed in the artificial motel twilight.

I'm up and packed before the sun rises. In the cool of the morning, I explore Colorado City. Dusty yards with scattered children's toys and gently degraded houses lend an air of benign neglect. Cresting a low hill, I look down

into the river bottomland where floodlights blast the early morning away. The shining razor wire and chain link fences of a prison are a stark contrast to the town.

Behind Main Street, and over the railroad tracks, I find a street running along the backside of the downtown near the river. A couple of houses look barely inhabited; the rest are falling down. Through broken windows and missing doors, I see layers of wallpaper peeling off the board walls. Asphalt shingles, asbestos tiles, and wood siding slough off the outside of the dry, disintegrating buildings. Empty cotton trailers with ragged bits of fluff clinging to the wire sit in overgrown yards. I pull onto a track crushed into tall weeds and park next to an empty metal warehouse.

A field of head-high weeds surrounds the buildings. I push my way through towering giant ragweed and Johnson grass. The saw-leafed daisies are not blooming yet, but the sharp-edged leaves clasping the tall stalks are identification enough. Sleepy daisies huddle with petals tightly closed against the morning air. They will unfurl their yellow flowers in the bright sun, and then close again at dusk.

Old sofas, cushions, and disintegrating recliners slump in the weeds; rubble heaps of bricks and construction debris litter the field, and rusting appliances peak out from behind the screen of vegetation. I slink through, stepping from trash mound to tin pile. Small game trails have formed low paths through the grass and weeds, so I crouch to scramble under tangled branches, hoping I won't come face to face with a rattlesnake. I can hear the frantic scrabbling of fleeing creatures as I step on abandoned sheet metal. While the air of neglect gives the place a melancholy aspect, I know that my husband would be thrilled with such a rich hunting ground. As an avid herpetologist, nothing makes him happier than an abandoned house with piles of roofing tin and siding he can flip to look for snakes, lizards, frogs, and toads. The detritus of civilization is a different sort of wildness.

To reach the river, I slip through a barbed-wire fence and into a thicket of dead willows. Saltcedar crowds the sandy banks of the river. The water is surprisingly clear. Small fish dart in the pools. There is a strong sulfur smell, similar to the hydrogen sulfide gas released by oil pump jacks.

The west side of the river has reddish-brown sandstone humps eroded into graceful and wild shapes. Overhangs and crevices carved by wind and water flow into smooth curves and glides. Morning light hits the tips of the rocks

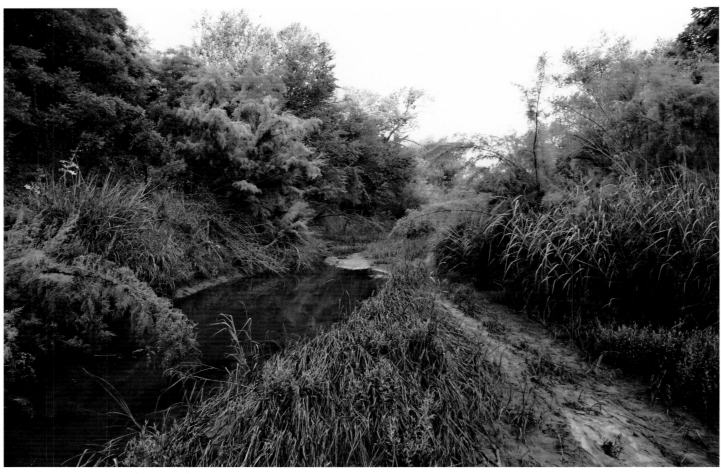
River and saltcedar near Colorado City

with a burst of red and gold. It ricochets off the rocks and down into the river bottom where it is caught in droplets of dew. Blooming saltcedar—feathery fronds swaying low under the weight of dew—sparkles like a net of jewels in the morning light. It is breathtakingly lovely, with pale lavender flowers clustered at the tips of pale frosted green. I take a photo of a dew-drenched branch of the non-native plant.

Just across the river, I see dump trucks busily driving up and down the bluff. I cannot see any names or logos on the trucks. I creep upstream and look out onto a stripped landscape. Bulldozed raw soil scrapes the river's edge. The stench of sulfur suddenly makes everything seem poisoned and polluted. I've seen no snakes, frogs, or lizards; and then I'm stumbling, rushing to get out of there, spooked by the trucks, the smell, and the desolation.

From the I-20 business bridge I look down over the bulldozed area. Stretching downstream are shallow pits, viscous-looking green ponds, and a raw dirt basin with white plastic pipes protruding from the soil. Busy dump trucks rumble around the site. I do not know it, but I am looking at a Superfund site, a hazardous waste site nasty enough to garner the attention of both the state and the Environmental Protection Agency (EPA).

One of five Superfund sites in the Colorado River Basin[4] (but the only one on the river), the Col-Tex Petroleum Refinery, built in 1924, operated for forty-five years and was mostly dismantled in the 1970s. But the owners continued to use a few above-ground storage tanks. Three of those tanks squatted next to the river and leaked oil and toxins into the river, soil, and groundwater. Adding insult to injury, on the other side of the highway (but still next to the river) they used a dammed and diverted gravel creekbed as an open pit for separating petroleum mixed with brine. A polluted seep from the old refinery contaminated the groundwater that still flows into the river.

Back at home, my husband slips quietly out of the room when he sees the Texas Commission on Environmental Quality (TCEQ) Superfund Web site on my computer screen. He's listened to my astounded enumeration of the facts and, while sharing my anger, leaves me to wrestle with the implications. The language used in the settlement makes my stomach clench and shoulder muscles constrict into knots. Since 1990, the oil companies or, "Potentially Responsible Parties," have been "remediating" the area. Seven thousand tons of petroleum-soaked dirt were recycled into asphalt road base and "donated" to the county for resurfacing roads. Mediation for cleaning up contaminated groundwater is under way, and a restoration plan for the site is in motion. "Yeah right," I mutter. "Restoration probably means a field of Bermuda grass and a herd of cattle."

I click on the link to the restoration plan. I scroll down. I stop sneering. Rolling down my computer screen are the carefully thought out and exquisitely detailed steps needed to restore the river corridor back to a healthy riparian ecosystem. I page down and find everything from diagrams noting planting densities for different zones (color coded on an aerial photograph) to tables of appropriate trees, shrubs, and vines. Four thousand feet of river corridor will have the saltcedar and Johnson grass removed. Cottonwoods, black willows,

and other native trees will be planted, and the slopes along the river will be seeded with native grasses and planted with native shrubs, vines, and trees.

Instead of ignoring the damaged land—or scraping it bare—our state, in the form of TCEQ, the Texas Parks and Wildlife Department, and the General Land Office, has arranged for the PRP (potentially responsible parties) to clean up their mess and leave the place nicer than they found it. Truthfully, the work may never happen, or it may be completed and then never maintained. But for today, there is a small fissure of optimism in my protective shell of cynicism. Three-quarters of a mile of river cleaned and restored, with erosion control, overhanging trees for cool shadows, wildlife-friendly plants, and clean water. Out of the total length of the river, it is a tiny fraction, and the effort may be akin to bailing out a sinking ship with a teaspoon. But since the river builds drop by drop, maybe, just maybe, we can save it piece by piece.

Maddin Prairie Preserve

On a cold March day, I returned to Colorado City to visit Maddin Prairie Preserve, an 1,100-acre mixed-grass prairie a couple miles south of town. Arriving at sunup, I bundle into coat, gloves, hat, and scarf. New binoculars, camera, water bottle, and a couple of granola bars in my pockets finish off my bulky ensemble. Walking down from the old home site, I pass numerous unoccupied badger burrows while a female harrier hawk silently circles low over the prairie. In the early morning stillness, I trudge up the small hill to the prairie dog introduction site.

Maddin Prairie Preserve was donated to the Native Prairies Association of Texas (NPAT) by Alfred Maddin in 1995 with the proviso that they restore the deeply eroded cropland back to native prairie. Earlier, Mr. Maddin had the vision to contract with the United States Department of Agriculture's Conservation Reserve Program (CRP) to seed fifty acres with erosion-taming native grasses. Now there are thick stands of sideoats grama, little bluestem, blue grama, and sand dropseed sloping down to Champion Creek, a tributary of the Colorado. The creek curves through the property, lined by old willows, pecans, walnuts, hackberries, and thick clumps of switchgrass. Freshwater mussels live in the gravel beds. Owls and woodpeckers roost in the big trees. The banks of the creek record the numerous mammals that visit: deer, feral hogs,

Cottontops

raccoons, badgers, armadillos, skunks, and rodents. One side of the creek has water-eroded and sculpted rock alleys and channels between hillsides sheathed with slabs of rock and crushed stone. Dense clusters of cactus ring the small hills. Every prickly pear is a wood rat fortress clotted with dung, sticks, and mesquite thorns. Raceways patted smooth by tiny, naked paws link the social beasts. The area looks ideal for prairie rattlesnakes, although it is unlikely they've survived the intensive farming in the area; but I'm sure that western diamondbacks live in the rocky piles. Texas horned lizards, colonies of the dark red harvester ant, scaled quail, and northern bobwhite live in the open grasslands of the preserve.

The sun crests the earth and breaks with streaming gold light over the prairie. On cue, a black-tailed prairie dog pokes its head out of a burrow. One after another, the dogs move slowly, even lazily, out of the shelter of the burrow to bask in the sun. Some sit upright with paws folded on bellies and doze in the sun like fat little Buddhas. Some are spread-eagle in the dirt, with butts angled toward the sun. One burrow squeezes out seven dogs, and they drape over each other like teenagers loitering on a park bench. Chevrons of trumpeting sandhill cranes fly over, migrating north and filling the morning with the most optimistic and joyful of all sounds. A burrowing owl joins the prairie dogs basking in the sun and blinks slowly at me.

Maddin Prairie, with its patchwork of native grasses, prairie restoration, and re-introduced prairie dog colony, is a vivid illustration of the link between grasslands and healthy waterways. When NPAT acquired the property, rain and runoff had gouged steep ravines from the plowed fields down to Champion Creek. With every downpour, soil washed down from the field, muddying and smothering the stream with silt. The ravines baked in the sun, and few, if any, plants could take root in the hard bare dirt. With each season, the raw cuts between the field and stream grew deeper.

Imagine, if you will, a fat raindrop plummeting out of the sky toward the naked earth of the eroding ravine. It hits the dirt with a stunning impact and rebounds, shattered into droplets mixed with particles of soil. The droplets begin to flow downhill, gathering speed on the steep inclines. The rain runs off so rapidly, very little soaks into the ground. The water flows along the surface, carrying soil and debris into rills and channels. The runoff transports its burden into the creek, sweeping branches, trash, and any other goodies on the ground, clogging the streambed.

Prairie Dog

But, imagine a sister raindrop that falls onto a prairie. The drop hits a blade of grass or a leaf and shatters into multiple droplets that hit other blades of grass or plants. Some will drip off of leaves or run down stems to the ground. Much of the water will stay on the leaves, blades, and stems of the plants; soon, it will return to the atmosphere through evaporation, increasing humidity, and thereby reducing the overall evaporative rate. Capillary action pulls water from the surface so that it follows the channels created by the roots of grasses deep into the ground. The fresh and dried stems, blades, and leaves of the grasses and herbs slow down the water left on the surface, catching debris, holding the soil in place as the water makes its way down the watershed. The water that infiltrates the soil nourishes the plants but is also on its way to becoming groundwater that could feed streams and rivers.

NPAT and a flock of dedicated volunteers restored the banks of the creek so it slopes gently with a thick mantle of native grasses that absorb, slow down, and capture the precious rainwater. By attempting to reinvigorate the prairie and its resident creatures, NPAT and other volunteer groups are hoping to recreate a historical biological richness; this may be impossible, but in the process they are learning why and how the prairies and their residents function. The hope is that by learning about the native prairies, saving the scattered remnants and attempting to recreate the extraordinary historical diversity of plants and animals we, the people of Texas, will not only preserve our history and heritage, but may also discover solutions to some of the current problems plaguing our ranchers and farmers. Maddin Prairie is a thousand acres of history looking to the future.

E. V. Spence Reservoir

Just above the E. V. Spence Reservoir, I stop at a small bridge. From the road I can see where the river runs into the ragged edge of the Edwards Plateau and, although deflected to the east, it has bisected a large arm, so the distinctive limestone-capped and cedar-clad slopes are to both the northeast and southwest. I slip over the rails down to the water. A narrow stream, it glows an unreal, brilliant orange from the clays it picked up on its journey through Triassic redbeds and badlands. Dark green cedars, bright green saltcedar, and a vibrant blue sky intensify the color. I crouch under the concrete bridge and

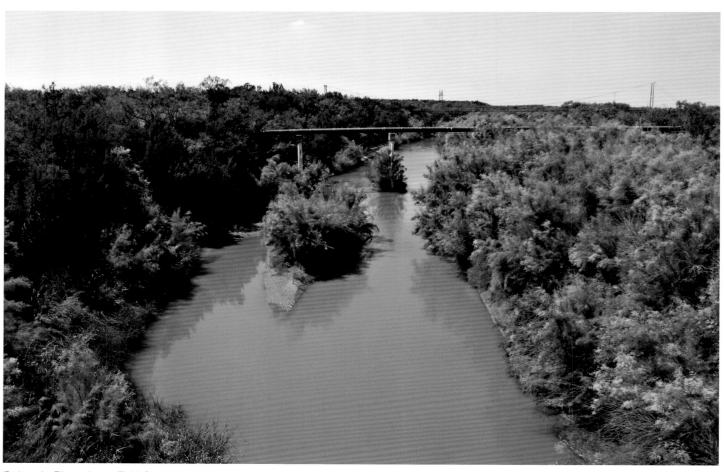

Colorado River above E. V. Spence Reservoir

watch wasps scrape up balls of orange mud and fly away. A fence stretched across the river discourages any ideas I have about paddling here. Cliff swallows wheel around me, shrill with displeasure at my presence so close to their mud nests plastered to the underside of the bridge.

The lake shimmers tantalizingly in the distance as I drive toward it. Small home developments planned as lakeside communities rim dry canyons. Boat ramps disappear into dense thickets of saltcedar.

I pull into the CRMWD's Paint Creek Marina. As I unload my kayak, a couple drives up for an afternoon swim. They'd seen me driving around and are unabashedly curious. We stand next to the boat ramp, and the woman points up at the top of a bluff. "When the lake had water, that's where we'd pull the boat up to get bait or drinks or gas from the store." Thirty feet up, in a tangle of trees and vines, I see a rusting metal ladder.

"The water is awful here," she confides, wading into the lake. "Full of salt."

"And the golden algae killed all the fish," her husband adds, almost comically mournful.

I look around. The cove is gorgeous. Layers of red and orange Whitehorse sandstone that capped the canyons around the river stack up on both sides. Flame-like dark green cedars lick up the sides and crown the ridges. Vivid green saltcedar pries roots into any available pocket in the rocks and crowds the soft soil of the banks. Red-winged blackbirds screech and warble from the cattails that line sections of shore. Clear water gently laps at my feet. It is, frankly, beautiful—and I say so. The wife, bobbing in the water laughs and nods. Her husband sits on the dock kicking his feet in the water. As I paddle down the cove, she calls out to me, "The best part is that with those CRMWD crooks doing their best to ruin it, we've got the lake all to ourselves!"

It is a peculiarly Texas trait, to rush to enumerate the faults and list all the deficiencies of something beloved and get them all out in the open. It feels like a test; if I tell you the worst faults and failings, can you see and appreciate the best aspects?

E. V. Spence was dedicated in 1969 and in all these years has never filled. Like Lake J. B. Thomas upstream, it consistently runs less than 15 percent full.[5]

Swallows skim the water around the kayak. I quietly paddle around Paint Creek and out into the lake a short ways. The water reflects the deep blue sky, and a breeze riffles the surface. Even though it is a beautiful day, there are no anglers out on the lake or around the boat ramp.

Typically the public's perception of water quality and the health of a lake are judged by the quality of the fishing and the appearance of the water and the surrounding area. If judged on purely visual terms, E. V. Spence Reservoir is magnificent. If judged by the quality of its fishing, the lake is in trouble. In terms of water quality—that is another story entirely—one that is closely linked to the devastated fishery. The water in Spence, like the rest of the upper basin, has high levels of chlorides and alkaline minerals. In addition to natural sources, there are hundreds of uncapped or improperly sealed oil wells in the watersheds and in the lakebed. Whenever the lake levels drop low enough, the Railroad Commission hustles to cap exposed oil wells. Additionally, in 1986, Natural Dam Lake west of Big Spring, one of the saltiest lakes in the world, experienced a near failure of its dam after torrential rains. Releasing a glut of

intensely salty water downstream prevented catastrophic failure of the dam, but it corrupted Spence's water quality for over a decade. Now the District pumps the lake's water, no longer considered impaired, to Big Spring, San Angelo, Midland-Odessa, and pretty much all over the CRMWD area.

The reservoir (and now the entire CRMWD region) is home to golden alga, *Prymnesium parvum,* a usually benign single-celled primitive plant. Too small to be seen without an electron scanning microscope, no one knows if it was introduced or if it is native; but it wasn't identified until 1985. Most of the time, golden alga lives in a comfortable mix with blue-green algae and is virtually unnoticeable. However, in water heavily laden with salt and minerals, when water temperatures are low and blue-green algae is dormant, golden alga sometimes bloom. A golden alga bloom, or population explosion, doesn't always result in a fish kill. But, if nutrients (specifically, nitrogen) are low in the water, golden alga can produce at least two chemical compounds that combine with magnesium and calcium in the water to make toxins. The poisons cause exposed cells on the gills of fish and other aquatic creatures to burst. Eventually, multiple levels of cells fail, and the fish start to hemorrhage or bleed from the gills and skin. Here's the creepy part: because blood is a great source of nitrogen, the primitive plants engulf the blood and tissue cells from the dying fish like microscopic Draculas and feed on the nutrients from the cells. The idea of alga feeding on blood twists my traditional "big fish eat little fish" idea of the food chain into a disturbing loop.

Most of the fish kills in E. V. Spence involve gizzard shad and other small fish, but these are the prey of bigger game fish. Without the shad and minnows, the bass do not survive. The good news (yes, there is some good news) is that golden alga does not seem to bother anything else. Birds can gorge on the dying fish with no apparent side effects. Cattle and wildlife can drink the alga-filled water with no problem. Because the alga thrives in alkaline, brackish waters, the problems seem confined to Spence and the salty waters upstream.

In addition to golden alga blooms, unplugged oil wells, chloride contamination from natural sources, and extended drought, the CRMWD and landowners all along the river are contending with saltcedar, an invasive plant that is taking over the banks of rivers, streams, ponds, and lakes and crowding out native plants. Any discussion of saltcedar with biologists or landowners tends to invoke a long list of scurrilous descriptions, more than a few curse words, a

general expression of panic, and, ultimately, a look of total despair. Descriptions lapse into phrases better suited to describing horror movies or terrorist scenarios than a growing plant: it is an exotic invader intent on conquering all of the freshwater streams and lakes in Texas; it sucks up obscene quantities of water and then spitefully poisons the soil and remaining water; it is impossible to destroy—you can't burn it out, dig it out, flood it out, or dry it out.

Well, the truth is only slightly less lurid. Sadly, the widespread invasion of this interloper is due mostly to our very own U.S. Department of Agriculture (USDA) who, in the flush of problem-solving, created another, larger problem. By the 1920s, overstocking and overgrazing by livestock had destroyed stream banks throughout the United States. The USDA's solution to the ero-

sion problem was to distribute the Mediterranean plant, *Tamarix,* or saltcedar, to farmers and ranchers to plant along streams, creeks, and rivers.

In a twisted way, saltcedar's tenacity and indestructibility is almost admirable. It cheerfully tolerates extended droughts thanks to exceptionally deep roots that tap right into streamside aquifers. Those same roots soak up tremendous amounts of water, much of which the plant releases to the atmosphere through transpiration. You can cut it or chop it down, you can even burn it, and saltcedar will gleefully shoot out sprouts quicker than you can say "uncle." It pushes out all other riparian plants and instigates a member's only club that devastates local habitats. Saltcedar shoves its way to the head of the line and crowds stream banks, choking and clogging gravel beds and sandbars. The streambeds narrow and deepen, and the normal amounts of silt carried by the river hurry downstream instead of settling out and building new banks and sandbars. The truly insidious aspect of this herbaceous interloper is that saltcedar not only tolerates brackish water that other riparian plants disdain, but it also absorbs the salts and minerals from the soil and water, concentrates them in a mineral crust on the needles, then drops the needles in a thick cushion around the roots—effectively poisoning the soil and water. Granted, it is handy for stabilizing soils in the desolate moonscapes created around pump jacks and old brine pits, but saltcedar just doesn't stay put; it manages, with a continuous cycle of blooming and seed production, to release over half a million seeds per plant per year. Although some birds and animals will use it for shelter, especially if there is no alternative, the foliage and flowers of saltcedar provide little food for native wildlife species.

CRMWD biologist Okla Thornton told me, "Years ago I used the word *eradicate.* Now I know we will never eradicate saltcedar and can only hope to control it . . . somewhat." He went on to tell me about research on biocontrols for saltcedar. The most promising is a beetle that feeds on saltcedar leaves. The beetles don't kill the plants outright, but they can demoralize it to the point that it gives up for a while, which might allow native plants to get re-established. While tests indicate that the beetles will only eat the saltcedar, I cannot help but wonder if in a few years we will spend research dollars trying to find a solution to a problem created by the solution created by another solution. Only time will tell if there is any way to curtail saltcedar—or if changes will allow other plants to compete with the bully.

As I return to the boat ramp, a minivan pulls up, and a small dog and

three little girls in bright swimsuits spill out. Their mother watches from the dock as the girls splash, swim, and giggle. Cujo, a petite black and tan canine combining a dachshund's wiener body and dwarf legs with the pop-eyes and apple head of a Chihuahua, ignores the girls' entreaties to play so that he can protect the family from all threats, real and imagined. He barks ferociously with astonishing volume. He latches onto my sandal strap with sharp little teeth. Growling furiously around a mouthful of nylon, he stiffens his legs, and yanks back on the strap. I'd like to pick him up and heave him into the lake, but I'm too tired to draw the ire of small children. I load the kayak dragging Cujo who relentlessly tugs, heaves, and twists on the strap like a hooked bass on a fishing line. I finally detach him without either of us drawing blood. The girls smile and wave as I drive off while Cujo stands guard, as regal as a Doberman Pinscher.

Rancho Escondido

Bob and Janie Houck's Rancho Escondido straddles the boundaries of two ecoregions; it combines the soils and vegetation typical of both the Rolling Plains and the Edwards Plateau. The terrain is characteristic of the steep watersheds rimming E. V. Spence. Wildcat Creek, dry for much of the year, drains across their land, leaving etched trails in the slopes and deep deposits of alluvial sand and gravel.

Bob is tall, sports a ponytail, wears overalls, and has a ready laugh. He sprinkles his conversation with phrases like "What a hoot" and "It really puckered me." He readily admits that restoring their property to a semblance of its historical identity is a quixotic venture. "Really a tilting-at-windmills kinda thing," Bob calls it. He and his wife are both quietly determined to leave the property in a better state than it was in when they bought it.

As a new landowner, Bob set out to learn what he could about taking care of his property. He contacted the local Natural Resources Conservation Service (NRCS) for help. Bob tells me, "I had a guy come out from the local NRCS office. He was getting ready to retire, so he actually took the time to make a site visit. There I am going on and on with my questions about planting native grasses, how many cows we could put out here, using fire to manage brush, and so on and so forth. I told him that we didn't want to do anything

that would hurt the land." Bob mimicking the agent, scratches his chin, leans close, and drawls, "Why Bob, there is nothing you can do to hurt this place ANYMORE. It's ALL been done."

"What a hoot," Bob says softly as we look out across the ranch toward E.V. Spence Reservoir in the distance.

A line of broken ridges curves across the back edge of the property—the hard, tattered fringes of the highly dissected edge of the Edwards Plateau. Bob drives me up the steep flank of one of the limestone-capped ridges. From this vantage point, I can see the broad valley the Colorado River has created, slicing steep-sided mesas away from the plateau's harder limestones and cutting deep into the layers of softer Permian sandstones under the Rolling Plains. Before a combination of drought and the presence of too many cattle and sheep irreversibly altered it, there were grasslands, running creeks and, likely, forests along the creeks. Probably not year-round running water (annual rainfall is only 20 inches here), but it is possible there were springs seeping from the base of the plateau too. I can trace Wildcat Creek's arroyos and gullies etched into the steep slopes. The twisting line of the seasonal creek cuts across the valley until it ends as one of the narrow canyons along the reservoir's jagged sides.

As we bounce along a rocky track, I watch the soil changes reflected in the plants. From the thin, rocky limestone soil sprout plateau live oak, red bud, Spanish dagger, red berry cedars, bear grass, resurrection fern, small cactus, little bluestem, and tough wiry grasses I can't name. We drop down into deep deposits of sand and gravel along the streambed. Wild pear, seep willow, and hackberries line the dry waterway. The rest of the ranch is composed of assorted Permian sandstones and crowded with mesquite, red berry cedars, and tough grasses. Laura Hansen, a botanist and friend of the Houcks who has been collecting plant specimens at the ranch for several years, explained to me that changes in geology equal changes in soils equal changes in vegetation. She said, "In a place like Rancho Escondido, the variety of soil types in the transition from the Edwards Plateau ecoregion to the Rolling Plains ecoregion combined with all the alluvial deposits from Wildcat Creek means that there is still an extraordinary diversity of plants to be found."

We drive to an area that Bob and Janie have cleared of cedar. Without the dense evergreen cover, grasses and wildflowers are already growing thick on the shattered limestone soil. When I compliment the work he's done, Bob pulls his pony tail and says, "Well it's not rocket science."

Most mornings, Bob gets up and goes out with the Bobcat and tree-shears. Every cut cedar stump needs painting with a potent herbicide to keep it from resprouting. There are few programs or assistance in this county to help with the cost of the work, so Bob and Janie do it all on their own (with occasional help from family and friends).

At a crossing of Wildcat Creek, Bob points out the remains of last year's bridge. "If nothing else, getting some good grass established would slow down the runoff a little and save me a bundle in bridge and road building and re-building."

He grins and flips his pony tail, "And because it's the right thing to do."

During the time I spend with Bob and Janie, I learn, among other things, that wild hogs have a weakness for strawberry- and grape-flavored Jell-O, so it makes great bait for hog traps. Even scattered on the ground in a trap, the smell wallops me back to hot, sticky summer days of childhood; suddenly, I'd cheerfully trade all my worldly possessions for a Pixie Stix.

Bob demonstrates his patience and curiosity over and over by standing on the brakes every time I yell "Stop!" so I can tumble out of the truck after flowers, birds, flaked chert, plants, and lizards. I discover that a round-tailed horned lizard can perform a passable impression of a rock even when perched in the sweaty palm of an artist.

The most important thing I learn is that the best way to approach a habitat restoration project is to: a) fall in love with your land, b) maintain your sense of humor, and c) share both items a and b with as many friends and strangers as possible.

Below E. V. Spence Reservoir

I have a dream—a nightmare actually—that I'm caught hopping a gate, tres-passing to get to the river. A furious rancher waving a double-barreled shotgun comes charging over the hill with a herd of eye-rolling, head-tossing black heifers. Halfway over the metal gate, I freeze with my leg up in the air like a dog peeing on a stump.

I wake with a pounding heart and lingering sensations of guilt and fear. In my waking life, I have done my best to be scrupulously honest and never trespass, but there *was* a locked gate a few weeks before that was too much

for my resolve. It was in Runnels County. On that day, I'd pointed the truck in the general direction of the river and drove along small dirt roads near the town of Ballinger in hopes of finding public access to the river. All morning I had been able to see the river corridor looping across big pastures, with a rocky bluff holding the watercourse in place. At the end of a promising road were two gates. Both locked. I could smell the river. It was only a few hundred yards away, and I just had to see it. Grabbing my camera, I clambered over the gate and furtively dashed through shoulder-high ragweed, sunflowers, and Johnson grass. Thoughts of a gang of chiggers happily taking up residence in my underwear did cross my mind, but I had a goal and would not be deterred. A herd of black heifers stared at me from the lee side of a small cabin. Scanning the faces of the cattle as they watched me, the squish of the cow pie in the lugs of my hiking boot registered just as I felt my foot slip out from under me. I fell heavily on my butt in the moist green dung with a loud "Oof!" The cattle, appalled by my behavior, started running toward me instead of away. "Trespasser Trampled! Cattle Guard the Range!" is what the headlines would read when they found me. I stood up and waved my arms. The cows stopped, confused. Twisting around to look at my green slimy backside, I cursed. The cattle, being extremely sensitive, wheeled and ran, bawling and yelling. Dogs all over the county were howling, and the sound of a truck door slamming and engine turning over ricocheted over the pasture. With only a brief glance at the river (the banks were too steep for me to get down to the water) I ran for the truck. I'm over the gate and in the truck by the time the rancher pulls alongside. I wave cheerfully. He gives me what I call the Texas nod (with an expressionless face, he juts out his chin and tips his head up and down about one-half of an inch) and drives away. The thirty minutes of scraping cow poop off myself and out of the truck upholstery is enough to convince me I have no aptitude for criminal endeavors.

The day after the nightmare, and a month after my attempt at being a scofflaw, I'm driving with a growing sense of dread while I follow a couple of CRMWD aquatic biologists down the same road. It would be too much of a coincidence if I'd gotten an invitation to visit the same ranch. We turn into another gate, but we are less than a quarter of a river mile from the site of my manure-embellished trespass.

The ranch we are visiting is reputed to be *the* spot to see the controversial Concho water snake. The snake itself isn't much to consider—small, brown,

drab, with a few spots, but nothing special. However it nearly stopped the building of the Stacy Dam and O. H. Ivie Reservoir. Back in 1985, when the CRMWD finally received a permit to build a third impoundment on the Colorado River, the government had just instituted a new permitting process (404 permit) that required attention be paid to pesky details like preservation of historical and cultural sites, cataloging and moving cemeteries, and assessing impact on wildlife. This is where our friend the Concho water snake comes into the story.

Most of the people I've spoken with (besides biologists) view the Concho water snake vs. the Stacy Dam battle as either hard evidence of a vast conspiracy by liberal-environmentalist-federal employee/slackers to seize private land and waste taxpayers' money, or an embarrassing mistake that exposed the abysmal stupidity and ignorance of our state and federal employees and their total inability to complete the simplest task without bungling it up and requiring a bootful of cash to clean up the mess. But all agree that taxpayers' money was wasted (even though CRMWD paid for all of the research, and they are supported by water sales).

The truth seems to wallow in a small mud pit of inaccurate research, a lack of basic information about the creature's natural history, and a knee-jerk negative response by all parties involved. Well, except for the snake, not having knees and all.

According to CRMWD biologist Okla Thornton and other knowledgeable herpetologists, listing the Concho water snake as an endangered species on either the state or federal level was a mistake in the first place. The Concho water snake, a Texas endemic, lives nowhere else and has one of the smallest ranges of any snake in the United States. The snake's historic range likely included all of the Concho River's length and extended up and down the Colorado River, from where E. V. Spence Reservoir now sits down as far as Lake Buchanan. Dams and lakes along both the rivers flooded miles of river habitat, submerging the rocky shorelines and riffles of the river, and greatly reduced the snake's range. The concern was that the construction of Stacy Dam and reservoir would have two major impacts on the snakes: additional loss of habitat and, after completion of the dam, reduced river flows that would alter the shape and nature of the river downstream as well as its biological diversity.

All parties agree that the original population study was faulty. A group of college students set out to survey the population of Concho water snakes,

catalog the sites, and generally accumulate as much information as possible. To the student's surprise (and a slew of academicians), they discovered that the seasons do not abide by a university's academic calendar and, as it turns out, neither do water snakes. By the time the students could get out in the field for research, summer temperatures had hit and, unbeknownst to the valiant young researchers, the snakes were lying low. The students spent days walking the rivers looking for the snakes with little or no luck. They reported their meager finds and panic ensued. Later, Okla Thornton, armed with two crews who could work twenty-four hours a day, seven days a week if needed, went out and discovered dense populations of healthy Concho water snakes throughout the current range, including along the shores of the reservoirs. The snakes have a limited window of activity in the spring and fall when air and water temperatures are agreeable. Outside of that time, the snakes are next to impossible to find. However, the issue had garnered national attention, and years of public bickering and ill feeling became synonymous with the small brown snake. If you really want to raise a local rancher's ire, ask about the Concho water snake "condominiums," the expensive artificial riffles built in the Colorado between E. V. Spence and O. H. Ivie (Stacy) reservoirs. Then step back while the invectives fly.

After multiple hearings, statements, and negotiations, the U.S. Fish and Wildlife Service determined that the dam would not cause irreversible damage to the remaining populations of the water snakes. The Lower Colorado River Authority (LCRA) settled its suit against the CRMWD (more about that lawsuit later), and the permit was granted to build a dam and flood the confluence of the Colorado and the Concho Rivers. As part of the agreements, the CRMWD agreed to release water from both E. V. Spence and the new reservoir in perpetuity to ensure a little water in the river and habitat for the snake. Although the debacle is a sore point for many, cost an enormous sum of money, and enraged people, the result is that Concho water snakes (currently listed as threatened, down from endangered) thrive along the lakes and, when available, water flows in the river.[6]

On this day, I don't have any luck finding Concho water snakes—or snakes of any kind. As I poke around the tall grasses overhanging the rocky ledges at the river, I relentlessly quiz the CRMWD aquatic biologists while they collect water quality data for the Clean Rivers Program, record stream flow, measure water and air temperatures, and collect water for additional tests. How high have you seen the water? How often does the river go dry here? When do you

see Concho water snakes? What kind of freshwater mussels live here? Do you like your job? Is the water clean here? They answer the questions with good humor, explain the tests and equipment, and actually accomplish quite a bit of work in spite of my pestering.

I leave the guys to finish their testing in relative quiet and walk down the river. Flat slabs of rough brown limestone and sandstone layer the riverbed. A slow current pushes over a few water-smoothed pebbles and burbles around the sharp-edged chunks. The water is brown, warm, shallow, and lightly clouded with silt. The exposed shelves of a rock ledge break the river with a dark shadow. Only a small section has water trickling over, but it will make a 6-foot waterfall when rains fill the river. Limestone and sandstones in the river's track have split and slid down the banks, exposing silicified fossils: humped shells radiating spines and curling ram's horns lie slick and silky in the rough matrix. Flipping rocks in the riverbed disturbs mayfly and caddis fly larvae that scurry off the edge of the dripping stones. Dragonfly naiads prowl the shallows in search of tadpoles and minnows. Whirligig beetles spin in circles on the dimpled surface of the water. A dragonfly at the end of its metamorphosis is pulling out of its nymph husk, its body creased with crumpled, soft wings. In sync with my heartbeat, the dragonfly pumps fluids into its wings and body. In the warmth of the sun, the yellow-tinged wings will unfurl, flatten, and turn glassy. In the space of a few hours, the body will plump and harden into a green and gold enameled shell, and the transformation from a gill-breathing, squat, dingy brown aquatic predator to a glistening aerial hunter will be complete.

Clusters of lavender damselflies are mating and laying eggs in the river. They hold onto trailing grasses and dip their tails into the water, hundreds of delicate purple lines swaying in the dark shadows. I hear my name being called and run back to meet the guys at the truck. Ribbing me, they say they thought they'd have to leave me behind, locked in the ranch. I seem to have trouble staying on the right side of gates in Runnels County.

A few miles downstream, I throw the kayak into the water at the 12-mile Bridge, the head of O. H. Ivie Reservoir. I easily paddle upstream for the first half a mile in deep, slow water. Then the current picks up over shallow gravel riffles. I paddle furiously, laughing as the current sweeps me downstream again. I give up and walk upstream with the kayak tethered to my waist and bumping along behind. I trip and fall down repeatedly, get soaked, watch

dragonflies and damselflies from water level and generally have a good time getting muddy and up close with the river. The ride back is a thrill because the current shoots me downstream in a tenth of the time it took me to paddle and walk upstream.

While I'm loading the kayak, a dusty red pickup with several guys crammed into the cab drives over the bridge. Their faces are shadowed beneath gimme caps pulled low, and their eyes are hidden by dark glasses. The truck crawls past a second time with three expressionless faces turned toward my truck and me. I hear them turning around at the other end of the bridge, radio blaring. I suddenly feel vulnerable. I'm 30 miles from the closest town. I have no cell phone signal, and no one has a clue where I am. I jump in the truck and take off with straps flying, and gear bouncing around in the bed of the truck. The red truck roars up behind me and relentlessly tailgates me for a few heart-pounding miles. They suddenly lose interest, turning off onto another road, and I drive the isolated roads too fast, rushing to a paved highway and the road home.

O. H. Ivie Reservoir

It is 7:30 A.M. and my husband Bill and I are out in our jon boat just above the historic confluence of the Colorado and Concho Rivers. Below us, former pecan orchards and fertile bottomlands hide in the depths of O. H. Ivie, the third CRMWD reservoir impounded in the Rolling Plains. The color is already starting to leach from the matte blue dome of sky as the sun barrels overhead. Bill is busy dangling a succession of increasingly garish rubber worms in the water in an attempt to seduce a large bass onto the line. Repeatedly, something big grabs the worm, mouths it, and spits it out without taking the hook. Bill pulls out an incredibly smelly pink and black worm filled with glitter. He threads it onto the hook explaining that it is "The Worm of Choice" for certain bass lakes. The smell is awful in the hot sun, but Bill is certain that the Tequila Sunrise Special will work its charms on the big bass lurking in the underwater brush. I'm watching a beaver swim back and forth across the cove. Its den is under a stack of piled brush. When the boat drifts over, I see fresh willow saplings cut and stacked, and I hear a loud, vigorous gnawing that makes me laugh aloud. Bill tells me I'll scare the fish, yet the beaver chews away, ignoring us.

A few months earlier, I'd stood on a bridge 50 miles east of San Angelo and traced the ghost of the Concho River threading through shallows crowded with silvery, dead trees. Around the snags, acres of pale yellow-green saltcedar swayed under a dank gray sky. Large, expensive houses built to perch at the water's edge were hundreds of feet away from the shoreline. I drove home and told Bill about the loss of the bottomlands, the woods swallowed by the reservoir, the ugly battles over water rights, and endangered water snakes. Though he listened sympathetically, his first comment was, "All those dead trees could make for great bass fishing. Fish like lots of cover."

Fishing is something I hadn't considered. When Ivie was impounded, there was limited clearing of trees and brush from the basin, so there are thousands of acres of flooded pecans, mesquites, oaks, and junipers creating marvelous habitat for fish. Near state-record-sized largemouth bass, bluegill, catfish, and crappie breed in the waters of the lake. Fishermen come from all over to troll crankbaits for white bass, flip jigs and rubber worms around standing timber for largemouth bass, or drop baited lines for big catfish.

The Tequila Sunrise Special has not worked its magic. Bill reluctantly reels in the lure and points the boat upriver. He opens up the engine, and we skim over the calm surface. I lean into the breeze. We are in a 14-foot aluminum flat-bottomed boat with a 15-horse outboard motor—small for a lake this size—yet I am thrilled with the speed and the fine spray splashing off the hull. A pair of conjoined dragonflies darts up to the boat, then crosses our bow and zips ahead. My GPS unit says we are running over 20 miles per hour, but the dragonflies have left us far behind.

We motor to a sharp bend in the river with a shallow cove extending away from the river. Dead trees stand in the shallow water with their arms filled with the messy nests herons and egrets build. The chaotic piles of deadwood look like they could collapse at any minute to rain long-legged chicks and snapped twigs into the water below. Bill cuts the motor, and we drift under a tree holding at least five residences. Three smaller nests bulge with the gangling limbs and necks of great egrets. The adults stand graceful and elegant, with snowy plumes trailing in the wind. The chicks have startling apple-green skin on the head and neck that is strangely appealing, even with scruffy white down and dashes of pinfeathers. The larger nests are so jumbled that I can't tell if there are two or three. Many pairs of yellow eyes watch us from behind the screens of twigs. The soft blue-gray and black of the juvenile great blue herons match

the nest material so well that, until the chicks move, they are virtually invisible. One decides to switch nests, and I hold my breath as it wobbles on long legs, hopping carelessly up to a higher platform. Its nest mates take advantage of the new space, and three heads periscope up in unison. Our tree is silent, but dozens of others in the cove are full of croaking and squawking birds that sound like giant frogs.

In March of 1990, the dam for O. H. Ivie was completed, and the lake rapidly filled over the next two years. With a surface area of over 19,000 acres and the ability to hold over 108 billion gallons of water, it is a substantial lake. While the conflict over the Concho water snake made headlines and inflamed tempers across the state, the legal struggle between the LCRA and the CRMWD was equally dramatic. In 1977, when the CRMWD applied for a permit for a third impoundment on the river, the LCRA was concerned that the planned reservoir would cut off water from the Highland Lakes downstream and make it impossible for the LCRA to meet downstream water needs in the future. The CRMWD countered that unused water was being wasted into the Gulf of Mexico and an essential water supply was being lost for West Texas cities such as Odessa, Midland, Big Spring, Snyder, San Angelo, and Abilene. The fight for the permit volleyed between the Texas Water Commission, the 53rd District Court, the Texas Supreme Court, and back to the Texas Water Commission before the LCRA and the CRMWD finally negotiated a settlement.

In order to understand the conflict, you need to know a few basics about water in Texas: Surface water (rivers, creeks, reservoirs, estuaries, and bays) is owned by the state and held in trust for the people of Texas. The water is parceled out through permits granting water rights for specified quantities of water (usually measured in acre-feet[7]). Water rights each have an assigned priority date that establishes the owner's "place in line" for water. Senior rights, with earlier assigned dates, have priority over junior rights. Everyone gets in line, obeys the rules the legislature has set up about exempt uses (domestic and livestock) and intended uses, and regardless of how dry it is or how badly you might want that water, it flows downstream to the person who holds the oldest permit.

What concerned the LCRA about the Stacy Dam project (as well as the E. V. Spence project years earlier) was the part of the water law regarding impounded water. Vastly simplified, it says that water, once impounded in a

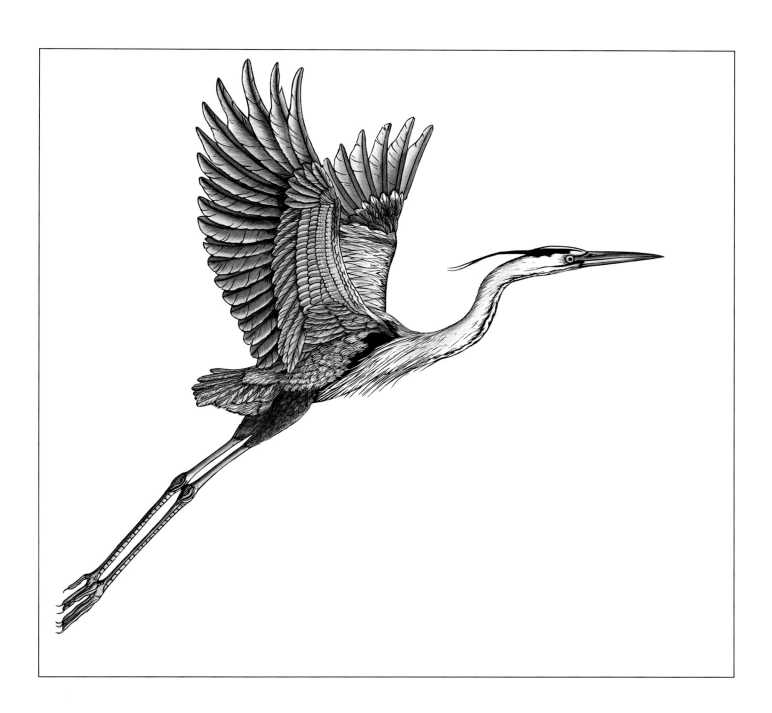

reservoir, belongs to the reservoir owners. The water is theirs and theirs alone, no matter how much they've got or who holds senior water rights downstream. The reservoir owner is required to release as much water out of the dam as is flowing into the reservoir to meet the rights of permit holders downstream, but in times of drought, that can be scant consolation. With two other dams and the majority of the upstream water rights, the CRMWD could critically alter the flow of water into the Highland Lakes. It was also the LCRA's position that with evaporative rates averaging about 6 feet a year, the new reservoir would lose more water through evaporation than it would gain in storage.

Finally, the CRMWD and the LCRA came to an agreement that included a comprehensive water release plan to protect lakes downstream. When the dam was completed, the reservoir was named for General Manager O. H. Ivie, not after the town of Stacy as planned. The CRMWD successfully pumps water from the lake through massive pipelines 48 miles to San Angelo and an additional 109 miles to Midland-Odessa.

In the last two decades, the water level in Ivie has dropped.[8] It hasn't been full since 1997. The average inflow is calculated at 126,503 acre-feet per year, but the actual figure swings annually from a high of 457,817 to a low of 16,716. The water pumped out of Ivie for use by the customer cities is around 40,000 to 50,000 acre-feet. But more water is lost by evapotranspiration than is sent to customers. A calculated 70,000 acre-feet a year is lost through evaporation and plant transpiration, especially from the hundreds of acres of dense saltcedar ringing the lake. LCRA's original argument that the lake would lose more water to evaporation than it would gain in storage seems prescient now.

Bill pulls the boat up to the shore, and I step out onto a dry, rocky ledge. I've traveled from water to a desert-like environment in two steps. Similar to the other impounds upstream, there is little or no riparian edge to the lake. Since this lake is so new, it is especially obvious that the water filled arid canyons. The transition between the water and land is abrupt without the usual diversity of plants and animals living in the intermediate zone. A buttonbush covered with white pompons is perched next to the water, and it has hundreds of satellite carpenter bees, bumble bees, honey bees, and wasps swirling around the sweet flowers. A few feet away, spiky purple thistles dig their roots into parched soil. Brittle grasses and dusty plants crumble underfoot. Cedars, mesquites, prickly pears, and yucca crown the tops of the former bluffs just yards from the water. Intensely blue damselflies land on the layered rock shelves of the shore, close enough for me to see the delicate bands of color. While I'm staring at a damselfly, my attention is drawn to a spiral in the rock. The gray limestone is full of fossils. Brachiopods look like double-humped clamshells with radiating spines. Spirals of what could be a coiled nautiloid or a snail bump against the surface of the rock. Bill is sitting in the boat under a lone mesquite casting a rubber worm into the shallows and looking for turtles. We call out our discoveries to each other. "I swear that was a *Graptemys!*" Bill calls. "Map turtles here? Oh cool, you should see this fossil," I reply. Bill sees red-eared sliders, river cooters, and map turtles. I find shards of gypsum that break in my hands, brachiopods, bright red bits of quartz-like rocks, hard vermilion seeds, blooming thistles, black phoebes, canyon wrens, and cardinals. I unload my collection of rocks and seeds from my pockets (pocketfuls of stones seem foolish in a small boat). Sprawling in the bottom, I look up into the branches of the mesquite, watch the patterns of sun and shadow cast by its branches

tossing in the breeze, and doze to the sound of Bill casting the line, alternately cursing and entreating the fish.

We spend the next hours exploring the Colorado River arm of the lake. The farther we go up the arm, the more interesting it becomes. As the lake restricts itself to the original clay riverbanks, the trees and plants along the banks diversify. Small stream-cuts in the banks look like good fishing holes, but we are running out of time and daylight. Large spotted gar roll and flash in the sun. Smaller longnosed gar float just below the surface of the water, waiting to nab small fish with sudden sideways slashing of their heads. Bass hit the surface of the water, feeding on insects and small fish as the evening approaches. In the shallows, big carp nuzzle the muddy bottom. Bill makes plans for our next fishing trip.

The wind has picked up; hard choppy waves make for a rough trip across the open body of the lake. We have stayed out too late, so Bill pushes the boat, slamming us against the waves in a race to reach the marina before dark. By the time we reach the boat ramp, our eyes are streaming tears from the wind and from scanning the rough water for snags and branches in the glare of the setting sun.

The Colorado River Municipal Water District's job of supplying water to customers in a near-desert region looks like a nearly impossible job. Constant demand, limited supply, extended droughts and a serious overestimation of runoff amounts have kept all three of the CRMWD impoundments on the Colorado River consistently low. As important sources of water for multiple cities, their existence is crucial, but, with high evaporative rates, chronic problems with chloride contamination, saltcedar, silting-in, increasing populations, and heavier demand for the limited resource, the future of the river and its reservoirs looks bleak.

The CRMWD manages the river and reservoirs as a water supply first and as an ecosystem second. Water supply management can result in healthy river and lake habitats, improved water quality, and aquatic communities. But if water supply is treated as the primary purpose of a river basin, the river is treated like a pipeline and the lakes as holding tanks—not as complex, delicately balanced natural systems. The CRMWD can only charge the costs of

Renegade

collecting and distributing the water to their customers, so they have limited money for education, conservation, or habitat restoration programs. When water levels become critically low, CRMWD can restrict industrial use, but it does not have the ability to impose conservation measures on its municipal customers and must rely on the cities to promote conservation. Midland, one of CRMWD's customers, is one of the top ten highest per capita users of water in the state, while San Angelo, interestingly, has one of the lowest rates. With the Colorado River and the reservoirs so far away from the cities it supplies, it is—not surprisingly—difficult to impress a distant public with the unpleasant reality of shrinking reservoirs and drying streambeds.[9]

The question is, when there is no water flowing in the riverbed, will it still be the Colorado River? Or will it be a dry valley with powdery memories of water, fish, snakes, and birds?

River Revealed

3: River Revealed

CROSS TIMBERS AND INTO THE LLANO UPLIFT

Below the dam at O. H. Ivie, the Colorado River cuts across layers of time, digging into the exposed shelves of millions of years. Alluvial deposits along the bed and banks of the river are recent, but the river has relentlessly carved away at the cover of Cretaceous rocks exposing the tilted stacks of old sedimentary rocks in the broad basin. On a geological map, multiple parallel bands of color stripe north to south. The river slices across in a twisting gold line of alluvial soils, descending from young to old, across pale bands of Permian limestone and shale, pink blobs and squiggles of sediment eroded from the Cretaceous and Permian rocks upriver, and into the dark blue patterns of older, exposed Pennsylvanian sandstones. Curving in a tight arc, the river bounces between the old sandstones and tongues of limestone and shale before snaking down the deep canyons of ancient Ordovician limestones into the heart of the Llano Uplift.

In this length of river, seven or eight counties, depending on how you count them, crowd up to the river, nudge each other's shoulders, and wiggle their toes in the stream. It is a land of big ranches, white-tailed deer and turkey hunting, a few row crops, and pecan orchards. The river regains its strength, pulls water from creeks and springs, and works its way back into a free-flowing stream for a few miles before running into the dams of the Highland Lakes downstream.

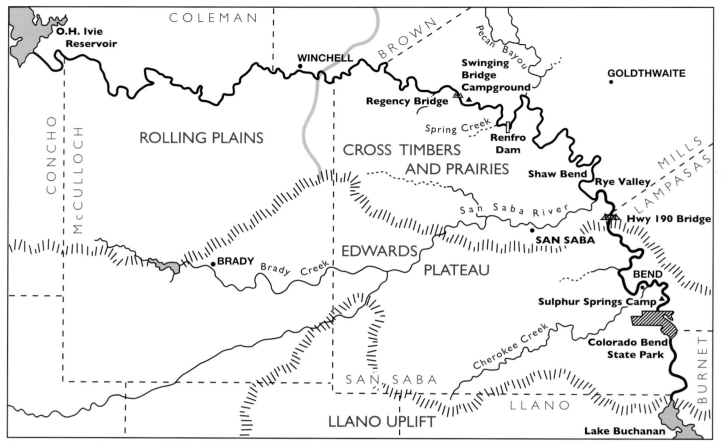

COLEMAN

O.H. Ivie
Reservoir

WINCHELL

BROWN

Pecan Bayou

GOLDTHWAITE

Swinging
Bridge
Campground

Regency Bridge

Spring Creek

Renfro
Dam

ROLLING PLAINS

CROSS TIMBERS
AND PRAIRIES

Shaw Bend

Rye Valley

MILLS

LAMPASAS

CONCHO

McCULLOCH

San Saba River

Hwy 190 Bridge

SAN SABA

BRADY

Brady Creek

EDWARDS

PLATEAU

BEND

Sulphur Springs Camp

Colorado Bend
State Park

BURNET

Cherokee Creek

SAN SABA

LLANO

LLANO UPLIFT

Lake Buchanan

Below O. H. Ivie Reservoir to Colorado Bend State Park

I'm standing on the concrete bridge downstream of the O. H. Ivie dam. Vertigo makes me go queasy, and my vision darkens around the edges as I look over the concrete guardrail. Cliff swallows are spinning around me, feeding in the April evening. Every photo I take reveals black smudges of small, feathered bodies and blurred streaks of beating wings. I am able, if I hold on tightly to the concrete rail, to look directly into the river below. A female spotted gar swims in the shallow water with a dozen smaller males clustered to her flanks, waiting for her to expel eggs into the stream. The eggs are poisonous, and although they will be scattered over the gravel and left to hatch, they will be undisturbed. Big carp root in the soft bottom; backs and fins glisten bronze and gold out of the water as they stir up clouds of silt and thrash through the shallows. A raccoon steps gingerly off the bank into the river. It walks on tiptoe, its head and tail held high up out of the water looking like a woman trying to keep her skirts dry. Feeling with its paws, it rummages through the

mud for morsels. A trio of deer steps out of the brush bordering the wetlands at the base of the dam. I nearly faint; it is so bucolic and pastoral. Glints of water shine off the dam. There is a shallow trickle down the riverbed.

Swinging Bridge to Renfro Dam

Two months later and four counties downstream, Bill and I pull up to the office of the Swinging Bridge Campground under the shadow of the Regency Suspension Bridge in Mills County. A sign on the door reads:

TODAY'S SPECIAL
Hot Dry Air
Burnt Grass
Green Water

We walk down to the river as night falls. The still water is green but clear. We've dropped a vehicle off downstream and, after planning how we will get the kayaks and gear to the river, we cautiously pick our way back to our cabin. Engaged in the domestic routines that fill the hours wherever we might be, our

evening passes quickly, and we fall asleep to the rumbling of an AC window unit.

At 5 A.M. we struggle out of bed and drink strong coffee. The cabin has dark brown shag carpet circa 1970 and an ultra-modern kitchen unit from the 1950s that is so stylized the refrigerator/freezer has fins and giant triangular buttons for latches. Still-gleaming chrome highlights the two electric burners and small enamel sink. It looks like the rear end of a car stranded in a sea of wood paneling and harvest gold linoleum. It is simple and clean and suits our needs.

We dump the kayaks into the river. The 1939 Regency Suspension Bridge hangs high overhead, spanning the river canyon. When a truck rumbles over the bridge, we watch the boards hop and rattle under the tires. A 65-foot deluge in the flood of 1936 washed the first bridge away. I have no standard for imagining so much water. I look up at the bridge in the morning light and try to imagine a wall of floodwater rising up from the riverbed, washing over the wood and steel cables of a bridge 50 feet above me.

The first run of river is shallow, but we glide along in the cool morning mist, lulled into a state of complacency. A bronze-colored carp stirs up a billowing cloud of silt; a nutria swims across the river and disappears in a hollow behind a willow stump on the bank. Painted buntings, yellow-billed cuckoos, and wrens are starting to sing, and the sun burns through the mist.

After paddling almost two-thirds of a mile, the river ends. Gone. No more water. An expanse of rocks and gravel fills the river bed. We unload cameras, binoculars, our cooler, paddles, and water bottles and carry them to the other side of the rocky span. Then we each grab a handle and carry one kayak and then the other, staggering across a hundred yards of ankle-wrenching boulders, grass, mussel shells, gravel, and sand. We repack the kayaks. Slip into the water.

One hundred yards later, we repeat the portage exercise over another long section. My serenity has been shattered, and I worry about straining my back. I indulge in a few moments of drama; one of us, immobilized by back spasms, stranded on the river. Could a helicopter get in here to rescue me? I check my cell phone for a signal. There is nothing—not even a whisper of a connection. My electronic lifeline is plastic junk here. I suck in my stomach, swear I'm going to do sit-ups everyday for the rest of my life, and grab a handle to haul the boats over the next pile of rocks.

By the end of two miles, the sun is up, the heat is pressing down on us, and we've had two very long portages and two short ones. I'm cutting glances at Bill, trying to assess his mood. I finally ask, "Okay?" "Okay," he replies. "Still having fun?" I persist. "I'm glad to be here," he says, successfully silencing my worry. We've given up on carrying the kayaks across the gravel bars and now drag them behind us on lengths of rope like large, ill-mannered mutts.

With the three big CRMWD dams upstream and dozens of side channel reservoirs that sop up the streams feeding into the main river channel, increased use of water for irrigation, plus decreased runoff from improvements in rangeland management and agricultural practices, it is a wonder that there is any water in the river at all.

The same elements that prevent water from reaching the river channel in dry periods are beneficial when they contain storm runoff or slow down floods. Dams that curtail floods do prevent loss of property, but the damage inflicted on the river by the construction of main channel reservoirs is of a pervasive and lasting nature. A dam puts a full stop on the river's dynamic cycle of destruction and creation, its continual tearing down and rebuilding of stream banks, gravel bars, and riparian zones. Without periodic floods to scour streambeds clear of debris (brush, trees, silt, and rubble), the very course of a river is changed. The debris slows the current, which changes the way silt and gravel deposits move and shift. In summer, oxygen levels fall in slow warm water, stressing or killing aquatic life. Algal blooms flourish in the same water, causing more death. Gravel-bottomed riffles silt up, and the available habitats for myriad creatures adapted to specific niches collapse. Native freshwater mussels choke on the silt, but invasive Asian clams proliferate. Without floods, vegetation creeps in and narrows the streambed, changing the flow patterns and altering the riparian area (the transition zone between land and water). Saltcedar and other invasive plants flourish in such situations; native plants prefer the cyclical nature of natural stream flow.

But what will happen to the river? Is it still a river with little or no flowing water? The public has been blandly assured multiple times by straight-faced officials that a dam will have no negative impact on the river downstream. "We're only going to impound the excess flows," they say, "just collect the floodwater that would run downstream and be wasted in the Gulf of Mexico."

Yet, here I am, yanking a kayak over gravel in a dry river bed. Whatever the causes—dams, drying aquifers, droughts, or reduced runoff—the quantity of

water flowing down the river in this section has drastically diminished in the last seventy-five years.

A section of riverbed curves into a broad shelf of dry sandstone. We clamber up a ledge and look down into a clear pool. A school of tiny channel catfish with deeply forked tails whirls in a crevice. Male green sunfish hover over gravel nests, fanning eggs with their fins to oxygenate the area. The fish have turquoise, orange, and green iridescence that glows in the sunlight-filled water. Red shiners skim just below the surface, and stonerollers drift along the bottom. We see baby bass, tiny gar, schools of mosquito fish, and balls of just-hatched fry that swarm in tight clusters. The sandstone is a warm brown with iron-rich deposits trailing orange stains down the ledges. Summer tanagers flash vermilion in the trees, calling, "Look at me, look at me!" from leafy perches.

We bounce the kayaks over the rocks to the pool, admire the little bluff from water level, and continue paddling. Steep clay banks and heavily wooded hills with sandstone scarps and ledges line the river. Scissor-tailed flycatchers squabble in the tops of mesquite trees near the shore. I watch a blotched water snake dive to the bottom of the river. A green sunfish darts from its gravel nest and hits the reptile broadside, deflecting the snake away.

Carp measuring a couple feet in length root through the shallows; to entertain myself, I invent a game I call Carp Rodeo. The rules are simple. First, look for the dorsal fin and the big-scaled back of one of the fish intent on feeding but blinded by the cloud of silt it is stirring up as it sucks up muck and blows out inedible bits. Second, paddle very slowly and stealthily up behind it. This is much harder than you'd think; carp are surprisingly sensitive to their surroundings. Third, when within reach, touch it with the paddle or, better yet, make a grab for the tail. A startled carp makes an impressive amount of noise and fury. I inevitably earn a face-full of tail-flicked water, but it never fails to make me laugh.

Thanks to our own government, carp are in just about every U.S. waterway. In 1877, the administration of President Ulysses S. Grant decided that the Asian fish would be the very thing to feed the rapidly booming population of the country. By 1881, a zealous young Texas Fish Commission had introduced carp to the state. Excited officials built Texas' first freshwater hatchery, just for carp, at Barton Springs in Austin. Within a few years, carp were swimming in just about every Texas river system. Unfortunately, the difficult-to-

catch fish never succeeded as a sport fish, and the oily, bony flesh, though popular in Asia and Germany, never caught on in local culinary circles. The hatchery closed, and the Fish Commission dissolved. The carp, on the other hand, proliferated. But over the years their reputation sank to the level of river bottom mud. Adding to carp's ignoble status is their ability to survive in less-than-pristine water. I'm not the only person who has been convinced that carp are not only too bony to eat, but also that their flesh is toxic because they live in polluted water. Here, I am somewhat mistaken. Although it is true that carp are more tolerant of compromised water quality than other fish, their presence does not necessarily indicate polluted water.

As the morning wears on, we drag the kayaks from pool to remnant pool. I cheerfully slog through warm, stagnant water. Every time I step into a hot, murky pool clotted with turd-like balls of algae, a part of my brain (decked out in a white lab coat with pocket protectors) recoils in horror. "Oh-my-goodness-get-out-of-that-water-you-never-know-what-kind-of-bacteria-is-proliferating!" my inner microbiologist shrieks. "Whatever floats the boat," I tell myself tersely and step from a gravel bar into a pit of stinking, black anaerobic mud while the kayak lags behind.

Bill and I drag the boats up Spring Creek's dry bed. Above the steeply sloping banks are thick native grasses, mesquites, and tall cottonwoods. A big shelf of rock has collapsed into the creek bed, and the jumble of rock blocks our path. Last year I'd looked down on this same pile of rock with land owner Joe Freeman. He took me on a tour to see the wild pecans along Spring Creek, the rich alluvial soil in the river bottom dense with grasses, and the remnant bottomland forest of hackberry, Texas persimmon, elm, pear, and post oaks. He pointed out some rock ledges with hollowed out metates for grinding grain and mesquite beans. He also showed me the archeological sites with shell, bone, charcoal, and other small bits of debris left behind by different Indian tribes. As we walk, he tells me stories. It is not a friendly land, he says. The early settlers were durable people who lived amid both the rich bounty and the harsh realities of the land. They often faced difficult choices, sometimes with brutal consequences.

The region was the last stronghold of the Lipan Apaches and the Comanches in Central Texas. Pressures on the remaining Indians increased as more settlers moved in and hunters slaughtered the bison herds for sport and profit. Attacks on settlers by Comanches, who were attempting to defend their tra-

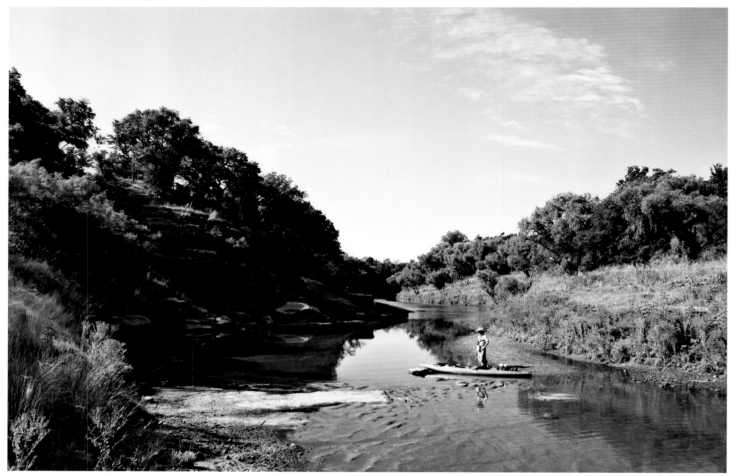

River above Renfro Dam

ditional range, continued until well into the 1860s. But it was the influx of Anglo-American settlers after the Civil War that set off a remarkable period of lawlessness. The war had left Texas relatively unscathed, and settlers from war-ravaged southern states flooded in and over the frontier. The deep canyons and cuts of the Colorado and San Saba Rivers provided home sites for honest settlers, but also refuge for cattle rustlers, horse thieves, army deserters, carpet-baggers, land sharks, and other rogues. Vigilante committees were formed in local counties to deal with the criminals but, in most cases, the groups degenerated into warring factions that conducted what amounted to open warfare. Lynchings, assassinations, and men abandoning home and family in the middle of the night were commonplace during the period of "mob-rule" between

1880 and the late 1890s. Eventually, the Texas Rangers arrived and restored order.

Back on the river, we are nearing the old Renfro Dam and the short sections of water begin to lengthen. A pool of green, still water collects behind the low sandstone dam, even in the depths of summer. After hours of dragging and hauling the kayaks over arid riverbed, it looks like an oasis. But impoundment pools can pose significant problems for fish and other aquatic creatures. Unlike rivers where the current is constantly mixing the water, equalizing temperatures, and distributing dissolved oxygen evenly, in lakes or ponds the water quickly stratifies into distinct thermal layers. Dark, cold layers at the bottom of a deep lake (like Lake Travis downstream) hold little oxygen and are inhospitable for fish. Surface layers in small ponds, like this one behind the Renfro Dam, can become so warm that algae blooms occur, resulting in low dissolved oxygen levels and fish kills. Native fish accustomed to riverine conditions may not survive in the altered habitat.

We lazily move downstream, enjoying the ease of the kayaks gliding in the torpid water. Softshell turtles paddle up to the surface, snorkel air, and then plunge into the depths. Red-eared sliders and river cooters sun on the piles of driftwood snagged along the banks, waiting until the last moment to belly flop out of danger's way. Clouds of damselflies cluster on driftwood, mating and laying eggs. Bluebell gentians and sunflowers bloom along the banks. A wood duck hen herds her chicks to safety below an undercut bank as we paddle past. An immature yellow-crowned night heron regards us grumpily through big gold eyes from a roost in a shattered water oak. In the shadow of an overhanging willow, I see a 3-foot spotted gar just below the surface of the water. She cruises downstream, and I match her speed until we run in parallel tracks. Gradually I slip over until she is calmly swimming next to my kayak. I dip my hand in the water and run it down the length of the gold body. Her thick

Spotted Gar

rhomboid scales are hard and slimy under my palm. She is undisturbed by my touch until she rises to the surface to gulp air and the shadow of the boat falls across her eyes. With a sudden flick of her tail, she is only a leopard-spotted memory in the opaque, alga-infused green water.

At the dam, Bill and I unload the kayaks then carry/drag the boats up a steep trail. We've been in the sun for over eight hours and made it down nine hard river miles; we are dehydrated, yet sated with a sense of accomplishment.

Shaws Bend & Rye Valley Ranch

I have only met a few people who are so passionate about the river and identify with it in such a way as to transcend standard notions of ownership or possession. One of these people is Stanley Burnham, an athletic octogenarian whose identity is so firmly intertwined with the river that he has never lost his child-like encompassing view of the river: a complete world wholly his own.

The Burnham family's association with the river goes back to Stephen F. Austin's colony near the Gulf Coast. Stan's great-grandfather, Theodore C. Burnham, followed the river north from the colony, settling for a while in Burnet County before moving up to the San Saba area. T. C., as he was known, purchased land in Rye Valley at the confluence of the San Saba and Colorado Rivers, later expanding his holdings on both sides of the Colorado. He settled his family in Shaws Bend, a distinctive north-south bend in the river on the San Saba side.

I'm standing with Stan and his nephew, Reagan Burnham, on the old home site in Shaws Bend. The present owner has planted a thick mat of Bermuda grass that obscures all traces of the house, barn, outbuildings, and foundations. We look out over plowed fields to the line of trees defining the river.

Shading his eyes with one hand, Stan pulls me over then stretches out his arm to point below us. "See that little line of red dirt with a couple mesquites? That is where the slough was. It was raccoon heaven and water moccasin hell! It emptied into a deep pond; right in front of us, that is where the long pond was. That pond was 6 foot deep and always had water. It was covered with cottonwoods, willows, hackberries, elms—all the river trees. Every year when the river would rise, it would back up the slough into the ponds. When the river

would start emptying, it would leave the wetlands filled with fish and all kinds of aquatic things."

He tells me, "I learned a lot in those wetlands. I learned there really is a God. I learned life and death 'cause I'd see it happen right before my eyes. I think living on those wetlands was one of the great blessings of my youth." Reagan nods in agreement as Stan continues, "The wetlands and the river were a focal point of my life, and I'd try every day, rain or shine, work or play, school or not, to be in and around that river. And pretty soon, there developed a kinship between me and the river. I began to think 'that river is mine.' I resented the people who lived across the river when I would see them down there fishing or something. I truly indeed felt: THAT. IS. MY. RIVER.

"Years later, in my Navy days, people would talk about rivers around the world, and I would think about my river. I'd wish I could see my river. That's hard to explain, a river being so important and so much a part of me. I really get a little angry when I see people mistreat the river. Throwing junk in it or abusing it. It is kind of a sacred place to me. The wetlands definitely were.

"The river flooded every year, and I mean every year, but when we had the big floods, the water lapped at the porch of the house." This means that the entire bend would have been under water. Stan laughs, "We had a 200-acre farm, and all but about 10 acres was under many, many feet of water."

"Jump ahead 50 years—a bunch of my faculty friends at the University of Texas at Austin wanted to come to San Saba to see my river. They said, 'He has his own river!' They'd tell that all over the campus. Not only will he take you fishing, but he has his own river. And I still take delight with being identified with my own river."

Now the wetlands, ponds, and slough are gone. No one really knows when they finally dried up, but Reagan and Stan say the entire area is much drier than it used to be. The spring at the base of the sand hill has gone dry; the creeks in Shaws Bend only run when it rains. I think of the quote that Stan had pointed out in Norman Maclean's classic, *A River Runs through It:* "Even the anatomy of the river was laid bare . . . so I could enliven the stony remains with the waters of memory."

We cross the river at the old Double Ford. The truck surges through the water, scaring up a great blue heron fishing at the rock ledges above the crossing. "Now we're in Mills County on Burnham property," Stan announces proudly. "I'm so glad Reagan has it all now [the land] because he's going to

take care of it and the heritage continues." Reagan smiles at his uncle's remark, then his features shift into a somber expression. "It is the right thing to do," he tells me. "Taking care of land, being a good land steward, isn't a choice, it is a moral obligation."

Recently, the ranch gained admission into the Family Land Heritage Program, an organization that recognizes ranches and farms that have been in continuous agricultural operation by the same family for one hundred years or more.

We drive through a thicket of blooming bee brush. The tiny white flowers fill the cab with a dense perfume. The three of us take deep breathes in unison, gorging on the fragrance. Thick cedar brakes are interspersed with grass and woody brush. When I ask Reagan if he's ever had part of the ranch cleared of cedar or brush or if he has any plans to clear out cedar, he tells me that the cost is prohibitive. He'd be happy to clear out the cedar to make room for more grass, but he just can't justify the expense based on agricultural production. Stan points out a section of land cleared in the 1950s. Two large bulldozers with a length of heavy chain stretched between them crossed the hillside, stripping the brush and trees away. Now the area is a dense cedar brake with no grass. Reagan tells me, "You can't make enough money to justify the expense of removing brush, because once you clear an area you have to keep at it. Otherwise the brush'll just take over again."

"And be worse," Stan adds.

Reagan drives us down the steep hills, past sandstone ledges, and through native bottomland pastures shaded with stately pecan trees and oaks. A broad grassy terrace sweeps down to the river. Stan and I walk down to the gravel bar and stare across the Colorado to the San Saba River. The San Saba meets the Colorado River at an improbable right angle on the apex of a sharp bend of the larger river. It looks like a recipe for colliding currents to devour the riverbanks, but somehow the forces cancel each other out. Though some of the sandbars shift, the Burnham riverbanks are solid and steady with thick grass. Years ago, a huge reservoir was proposed for this area with the dam site placed at Fox Crossing Bend just up river from where we stand. As big as Lake Buchanan or O. H. Ivie, it would inundate land for miles up the Colorado River and Pecan Bayou. With steep banks and sparse populations, the canyons of the Colorado are desirable for an additional impoundment to control floodwaters in the lakes and river downstream. For now, the proposals are mostly forgotten

by the public, but with continuing demand for water, the engineering studies and the plans sit on the shelves of the LCRA, CRMWD, and the Texas Water Development Board, waiting.

Reagan and Stan are laughing about Stan's grandsons smuggling pint jars of muddy Colorado River water and sacks of river rocks on planes to take back to their mom in Arizona. Stan tells us about feeling homesick while he was in the Navy and how his mother, Myrtle, sent a package of dry cow patties so he could remember how home smelled. They both tell me about Myrtle, who created a home for multiple generations on the banks of the Colorado, dragged children—and cows—out of river mud, spent days fishing and hunting with kids and grandkids, and left a collection of hundreds of heart-shaped rocks filling her house.

Listening, I feel as fleeting and insubstantial as a wisp of smoke. I do not belong to any place with the certainty and conviction that this entire family does—their lives are centered on the river: from Stan's childhood, to his daughter's memories, to boxes of river bank dirt transported to other states so babies could be born on Texas soil, to Reagan's quiet passion. I belong to no place. A yearning as rough as burlap drops over me, and I struggle, fighting a sense of loss that has no roots.

Stan takes me to visit Marilynn and Lamar Johanson at the neighboring Rye Valley Ranch. Like Stan's family, Marilynn's maternal ancestors followed the river from Austin's colony, through Bastrop and up to San Saba and Mills Counties. We sit at their kitchen table, and memories of grandparents, mothers, floods, pets, and the river slip from them as easily as leaves in the current. I snatch at bits; scribble what I can.

Listening to Stan, Marilynn, and Lamar trade memories, I realize that people who grow up on rivers do not understand how different they are—at least not until they are grown and their lives have moved them away. The certainty of a river's presence—its moods, changeability, dangers, and pleasures—are taken for granted. Every spot along these wide bends has a memory. The Double Ford at Shaws Bend that Marilynn and Lamar use regularly to cross into San Saba County harbors the ghost of her grandfather, "Ole man Timberlake," rowing across in a boat on Sundays to meet his son for groceries, supplies, and a week's worth of newspapers. The acres of bottomland rye grass prairie shaded by hackberries, elms, pecans, and oaks on the bench of deep soil along the river evoke floods that spread the river across pastures and woods for

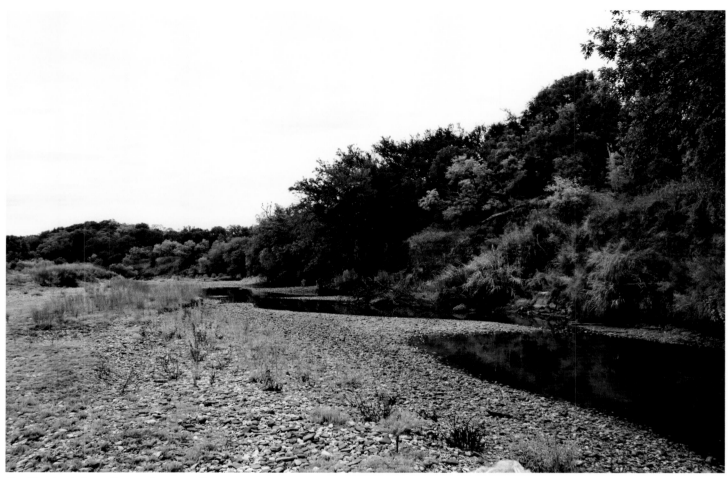

Dry Riverbed above the confluence with the San Saba River

miles. In the riverbed, green pools and rocky banks summon up flowing water and bathing parties (no one called it swimming back then, Marilynn confides) with family and friends. Marilynn, Lamar, and Stan all agree that prior to the building of the dam at O. H. Ivie, the only time they'd seen the river dry above the San Saba inflow was during the record drought of the 1950s. "Oh, some years it would get low, but not like this." Marilynn points at a stagnant pool. "It's not only the CRMWD," Stan tells me. "There are a couple of people that abuse their water rights. This one guy has the rights from Pecan Bayou downriver, and he just sucks the river dry."

Later I ask Stan why he, his family, and his neighbors are so passionate and protective of the river. So many others seem to regard the river only as a commodity: water for sale or consumption. Stan replied, "The river was a real source

of life for the community. It was valuable property because you depended on that river for water for your family and animals, and you depended on that river because it was a built-in irrigation system. It was all one thing—it was the economy. The whole economy was built around the river. Those of us who were fortunate enough to have good farmland along the floodplain always had 6 inches of new soil every year. And man, could you produce some crop. And furthermore, the other major money crop grew right on the banks of the river— pecans. All of the Colorado River from Brownwood to Bend is pecan country. I mean solid pecans. Those pecans were worth as much then as they are now. People really didn't discover pecans until about 10–12 years ago. PEE-cans or pah-CAHNS," he says thoughtfully, then grins and tells me a story about asking for pecan pie in New York City's Grand Central Station. "That waitress didn't have any idea what a pecan was, much less pecan pie!"

Elsie Millican is the granddaughter of the pecan pioneer, Edmund E. Riesen, the man who devoted his life to creating the foundation of the local pecan industry. She is elegantly dressed, with skillfully applied makeup, white hair coiffed in a sophisticated chignon, and impeccably lacquered nails. Her energy and candor immediately squash any notions of frailty even though she is ninety-six years old.

"Now this book you're writing," she says as we sit on a sofa in her parlor, "I want you to tell people to leave the river alone." I don't think I'm qualified, but I promise to do my best. "I've lived along the river my whole life, and I've seen all the comings and goings, the plans, and the changes. Don't those leaches know that it isn't a river without any water?" She looks at me, her love of the river and a bright anger shining in her eyes.

In 1960, Elsie and her husband Winston started Sulphur Springs Camp in the deep river canyon below Bend. A simple fish camp at first, they built cabins, swimming pools, and campsites along the river but continued to graze cattle on the uplands.

The question of whether or not the O. H. Ivie Reservoir has changed the river comes up. Elsie is quick and emphatic in her judgment. Just one year after they finished the dam, she tells me, she walked up the dry riverbed from Sulphur Springs all the way to Barefoot Camp. In fifty-plus years of owning

Sulphur Springs Camp, she'd never seen the river dry up. In her mind, there is no doubt it was caused by the new dam upstream. "They never intended to leave any water in the river," she said. "Once a dam is up, it is just too bad for the other people. The only reason they [the CRMWD] let water out at all is because they have to honor water rights downstream."

Highway 190 to Sulphur Springs Camp

Elsie's son-in-law Dean stands watching us, trying his best to hide a smile as Bill and I unload kayaks and gear. Our truck disgorges a heap of dry bags stuffed with clothes, sleeping bags, sleeping pads, tent, cameras, binoculars, fishing gear, and food. Dean will drive the vehicle back to Sulphur Springs so it will be waiting for us when we arrive in a couple of days. Late the night before, a thunderstorm moved through Sulphur Springs. Cracks of thunder shook the canyons, and it sounded like the downpour was going to wash us away. This morning though, the river is calm. Although the trees and grass glisten with heavy dew, the only real sign of the rain is the slick clay we skid back and forth on.

To get the kayaks into the water, we have to tip them over the edge of a 10-foot bank, then, using rope, leverage the other end around so the boat pivots on its prow in the mud. Bill stands below and I dangle gear over the edge. The dry bags slip snug into the hatches. Last to be loaded are the small cooler with a few precious icy drinks and ice cubes and Bill's casting rod and fly rod. We are hoping to feed ourselves.

Big pecan orchards line the banks. The smell of wood smoke drifts over the river. The burn ban lifted with last night's rain, and the deadfall and trimmings from the pecans are burning. The banks of the river are steep, red clay—typical of what I have seen from the Regency Bridge on downstream: big willows, cottonwoods, elms, and oaks along the banks interspersed with switchgrass and Johnson grass. White-eyed vireos, cardinals, titmice, chickadees, and woodpeckers are animated by the rain; they sing, call, and flit along and over the river. I look up from my binoculars to realize Bill has disappeared downstream while I'm gawking at birds. This pattern will repeat itself many times over the next few days.

I paddle through a mating frenzy of mayflies drifting like cottonwood fluff over a gravel bar. Their wings pat my face and their tails tickle my nose.

On a gravel bar covered with rounded pebbles, multi-colored chert, big mussel shells, and sand, we stop for a snack. A spotted sandpiper runs up and down the shore bobbing in frantic activity and a killdeer keens from the opposite bank. We are poking around the ephemeral pools left by the rain when we spot a hognose snake. It spies us and freezes. We rush over; the pugnacious creature flattens and flares out its neck and weaves back and forth like a cobra. I flop down on my belly with the camera while the snake expands and contracts its entire body, exhaling with a loud hiss. He lifts the front of his body up above the grasses, waves his head, showing us the fearsome size and colors of his flattened neck and head. He then lunges at me repeatedly and with great fury—but with his mouth closed. If I didn't know he was harmless, I would be convinced by his display that, indeed, he is a deadly asp or viper. He stops. We wait. The hognose suddenly twists and turns convulsively, thrashing from side to side and throwing his body in unlikely loops. Then, he is still. Belly up, mouth open with tongue dangling from the side. I am taken in, as I am every time I witness this performance. I swear he looks at me to see if I am convinced. Bill gently rights the snake. Indignant at the theatrical intervention, the snake flips onto its back again, tongue still lolling out of the mouth, now with a tiny drop of blood for extra authenticity. We place the thespian back on his belly. I almost believe I see his eyes widen in frustration, "What does a snake have to do to be taken seriously around here?" The snake flops over again. The script is in their genetic code: in order to be perceived as dead, it is essential that one be upside down, on one's back with tongue protruding. Bill and I settle in and watch the snake stoically maintain its lifeless demeanor, but the seemingly sightless eyes are watching our every move. We imitate inanimate objects. After five minutes, the snake slowly rights itself. The tongue flicks, and with head raised high, the hognose tastes the air once, twice, and then is gone; a liquid motion slipping through the grass.

Back on the river, I listen to a wild turkey and her chicks purling and clucking as they stroll along the bank. We see each other at the same time; they disappear behind a screen of blooming water hemlock, while I bob in my bright boat midstream. Their voices cackle in dismay at my intrusion.

I hear the liquid notes of a canyon wren, out of place in the clay bluffs and deep soils of the river. I turn the bend, and a tall wedge of limestone juts into the river before me. The canyon wren sings again from the rocky cleft. A lone mountain laurel clings to the rock. A cedar crowns the bluff. It is a slice

of Hill Country: a slim tongue of Marble Falls Formation limestone, with accompanying plants and animals.

Then it is gone and I am back in the sandstones, the deep red dirt, pecan groves, tall cottonwoods, and intense green brush. Wildflowers cling to the banks, and I hear bees when I drift near the clusters of blooming flowers. Bill yelps with joy when a fish is hooked. I paddle up in time to see him pull in a dinner-for-two-sized gaspergou. The freshwater drum grunts as Bill threads a stringer though the gills so it can swim behind us until dinnertime.

When German geologist Ferdinand Roemer planned to visit the San Saba Valley in 1847 to inspect the property owned by German immigrants via the Fisher-Miller land grant, he described it as "the unknown, almost mythical wonderland with which every Texas settler associated with ideas of unsurpassed fertility and loveliness." In January 1847, he joined an expedition to inspect the grant. He describes one camp as "a beautiful prairie in which tender grass and mesquite trees grew" (Roemer, *Roemer's Texas*).

The river slips in and out of character. One minute it is slow, deep, and embraced by sloping red banks thick with grasses and overhanging willows. Then the river compresses, glides over jumbled cobbles and limestone beds. It sparkles, splashes, and slips into my ideal of a river. I admit to a terrible prejudice. Though I grew up next to the great beast of the Mississippi and have spent weeks paddling the slow waters of the Colorado in Bastrop County, mountain streams cascading down steep slopes, clean and wild, form my ideal. Now, here is my river transformed into a Hill Country stream with cold springs feeding the rushing, clear water.

The river threads through deep canyons with limestone bluffs looming over us. We stop to eat lunch on house-sized boulders at the base of a cliff where an enormous house overlooks the river. Dozens of vultures sun on the porch rails, roofline, deck furniture, and staircases. It was certainly considerate of the landowners to build such a fine roost for the buzzards. I scarf down my peanut butter and bagel. Bill has a tuna kit complete with four crackers, tiny packets of mayonnaise and pickle relish, a teeny plastic paddle, and a foil packet of tuna. Having finished my food and lulled by sun and breeze, I subside into a trance, abstractly focused on Bill orchestrating his lunch. First, he uses the little plastic paddle to mix the tiny packets of condiments into the tuna using the handy plastic package as bowl. The plastic paddle transfers a heaping quarter teaspoon of tuna salad to the first cracker. Bill eats the

Cliff Swallows

cracker. He assesses the quantity of remaining tuna and the number of remaining crackers. A new cracker is perched on kneecap ready to receive a scoop of salad. The gob of salad slides off the little plastic paddle onto Bill's shirt as the cracker blows away. Bill flicks the tuna salad off his shirt. Taking matters firmly in hand, Bill leverages tuna onto the next cracker just as it crumbles into tiny shards leaving him with a fistful of damp tuna. The last cracker rolls down the rock into the river. Mayonnaise-lubricated tuna slides down his leg. I watch tiny fish nibble at the edges of the cracker, pushing it along the shore. By now there is a low grumble emanating from Bill. I hand him a box of crackers. He lines up the tuna, tiny spatula, and crackers. More tuna greasily slips onto his shirt. He curses, then looks over and notices my distracted, slightly unfocused gaze. "You're not going to write about this, are you?" he asks. "Of course not," I lie and lean back to watch the vultures.

The river throws itself into a tight backloop that reminds me of this morning's hognose snake. It twists through tall limestone cliffs before exhaling back onto the Rolling Plains as a series of slow bends through open, gently sloping topography.

In the now deep, unhurried river, our prime activities, along with bird-watching and fishing, become turtle tallying and water snake patrol. The snakes lounge in the hot sun on driftwood. By paddling very quietly, it is possible to get within a foot or two of the sun-drugged and fat-bodied creatures. We see blotched water snakes and a diamond-backed water snake, but not a single cottonmouth or other venomous snake. Turtles are extremely wary, and the binoculars are invaluable when counting the river cooters, spiny softshells, and red-eared sliders. A pair of ducks, blue-winged teal, stays just ahead of us, flying around each bend only to be startled back into flight when we reappear.

The corridor condenses into a narrow channel with a section of steep, unbroken cliffs that reach from below the waterline to the tops of the plateau. The rocks, smoothed and shaped by water and wind, are monolithic blocks of limestone. Balanced rocks, eroded spires, and weirdly-shaped hoodoos line the river. Overhanging slopes have clusters of swallow nests glued to their undersides. Patches of plants grow from crevasses where thin soil has collected. Tenacious Virginia creeper and wild grape cling to the cliffs; phlox blooms in sweet profusion behind tall water hemlock. As we let the boats drift, the buzzing of hundreds or thousands of bees surrounds us. It makes Bill nervous, and

he paddles away, but I sit in the kayak surrounded with the scent of blooming flowers, the sound of the bees, and a lingering, possibly imagined scent of honey.

The last stretch of river we paddle seems to have almost no current—what whitewater paddlers refer to as "dead" water. A stiff breeze is blowing upstream that makes paddling more work and less play. Beyond the steep red banks lining the river lie open pastures and pecan orchards. There are no islands or gravel bars where we can legally get out to stand and stretch, much less to spend the night. In the late afternoon, we finally reach a sizeable gravel bar where Rough Creek joins the river. Across the river, the owner of a pecan orchard patrols his property and stops and watches us unpack our gear. We set camp close to the rushing channel of the stream to block out the sounds of vehicles on a nearby road, lawnmowers, people yelling, and the orchard owner driving back and forth along the river. We have spent the day paddling, indulging in the illusion that we were moving away from civilization and into wildness. The distance we traveled on the river did not take us deep into a wilderness, as I'd imagined. Although we saw no one and little evidence of the people that live along the river during our trip, at our campsite we are closer to noisy people, roads, and cars than we are at home on our small acreage in Bastrop County.

We haul a bucket of water to filter, set up the tent on a patch of pea-sized gravel that is fairly level, and fill our glasses with hoarded ice and generous splashes of bourbon. Bill fries up the gaspergou in olive oil with garlic. We eat the fish with our fingers as dusk falls. A few desultory cricket frogs chirp, and a barred owl calls a few times before flying downstream. As the sun sets, a heavy dew falls, and everything is drenched. We crawl into our little tent and hurtle into the satisfied sleep of the physically exhausted.

We wake to morning mist and every surface saturated with dew. We drink coffee and wait for the sun to come up to dry the gear so we can stuff it into waterproof bags to keep it from getting wet. Somehow, this seems logical at the time. We drink more coffee, take photos of morning mist, and admire the sweep of the current past the gravel bar.

We spend the morning fighting a headwind. The river loops, languid and weighty, through more of the red Pennsylvanian sandstones and clays. It looks like superb ranch land or cropland. Heavy soil banks, cut and eroded by cattle paths down to the water, stand slick and bare. A cow skeleton—a jumble of

white bones picked clean by scavengers—is mired in the clay at the river's edge. Tall trees line the riverbanks. The wind tosses the limbs around and mutes the calls of birds. When I try to look through my binoculars, the wind grabs my kayak and sends it spinning back upstream. I decide that I am not a true nature lover; I do not like nature when it is 30 mile per hour gusts of south-southeast headwind.

We stop at a gravel bar just above the town of Bend. I point out the layers of Smithwick Shale, the black rock rumored to be full of trilobites. I find no fossils, though we note the trip's first map turtle and enjoy our break. In the shallow water, the black stones are lustrous and mysterious. As they dry, they shatter into regular-sized bits in tidy piles. At the bend of the river is a long, flat shelf of dark gray slate. The owners have been prying it up and loading it into trucks. I see crumbled black deposits on hillsides above the solid rock.

Around the bend, we have to choose a direction. To the right, the river runs shallow and sparkling over shale and limestone bedrock. To our left, the river slows and deepens in the shade of large trees. Not wanting to risk a portage with loaded kayaks, we veer to the left. A pecan orchard on the top of a high dirt bank is losing the battle with the river. Whole trees lie at the bottom of the eroding slope. The property owner has tried to slow the process by piling additional brush at the bluffs edge, but other than pecan trees, there is only short grass to hold the soil in place. The brush, debris, and soil heaped at the base will wash downstream in the next big rain.

We cross under the bridge at Bend and with the swallows flying overhead comes sunlight; the river is swift and rippling over a rocky bed. The current carries us faster than the wind can blow us backward.

We stop at a big gravel bar at the confluence of Cherokee Creek. We are ambivalent about the site at first. There is no island and we worry about trespassing. A lone large willow tree sits at the verge of the pasture. We walk across the hot gravel to the willow. The air is cool in its shade, and a pair of scissor-tailed flycatchers scolds us from the top branches. Fine gravel lies beneath the tree; although scattered with a few dry sheep pellets, it is free of large rocks or fresh cow pies. It is idyllic. The headwind that plagued us all day is unrecognizable, transformed into a flirty, friendly breeze.

With most of our gear unloaded into the shade of the tree, Bill relaxes in a chair; I sprawl on a sleeping pad with a dry bag for a pillow. We try to read, but the breeze through the leaves of the willow is tantalizing, swallows are skim-

ming the river, and a killdeer is dashing around the gravel bar, shrilly keening. Bill points out that the killdeer periodically stops to sit in the rocks. We quietly walk over. Nearly invisible in the confusion of gravel, is a spotted egg. We jam a dry branch in the ground a few feet away from the scrape (the killdeer's version of a nest) so we do not accidentally crush the egg. The killdeer skitters near the egg then retreats. A sprint toward the egg abruptly ends, and the bird calls anxiously. We worry that the branch has the bird spooked, and the egg will get too hot in the bright sun. Another killdeer lands, they both dash about—shrill and frantic. They converge at the egg, bow to each other, and quickly copulate. While Bill wonders aloud about the rapidity of bird sex, we notice the new bird sitting on the egg. (Later that evening, we discover two eggs in the scrape).

I'm propped up, pretending to read, when I'm slammed on the side of my head by a small, buzzing, rock-hard object. I react appropriately: shriek, bat at my hair, flail around, and kick sand over all the gear. Meanwhile, the perpetrator is lying with its legs folded into grooves on the underside of its abdomen and thorax, looking like a narrow white-speckled black rock with two white-ringed, eye-like spots. I pick it up to show Bill and with a loud "click" it flips itself out of my grasp and back onto the ground. "It's an eyed elater!" Bill exclaims. "I haven't seen one of these in years." "A what?" I make him spell the name. "E-1-a-t-e-r," he says. I am convinced he is making up names at this point. With Bill's East Texas accent, it sounds like, "Ahye-yee-ed ee-lay-tor." We entertain ourselves by placing the motionless beetle on its back and waiting until it "clicks" and propels itself into the air. Every click and flip of the beetle strikes us as funny and we giggle, and then laugh until doubled over and holding our sides. Exhausted, wonder and pleasure mingle while willow catkins tangle in our hair; we watch the killdeer parade, the elater flip flop at our feet, and the swallows' aerial feasting and drinking. A harsh raptor's cry yanks our attention to the west and the creek. A dark bird is harassing a larger bird in a dead tree. We grab binoculars and watch a zone-tailed hawk dive-bomb an adult bald eagle. Hunched in a fork of the tree, the eagle screams at the hawk, sounding peevish and irritated. The hawk circles and launches, feet first, at the eagle. Both birds take off upstream. In the relative quiet that follows, we can hear the raucous cries of a golden-fronted woodpecker, indigo buntings, mockingbirds, sparrows, and a wren fussing in the thickets across the river. Above us, the scissor-tailed flycatchers squeak, conversing about the

encroaching evening. The swallows that have been feeding along the river before us begin to disappear. A few bank swallows retreat into nests in the dirt bank opposite our gravel bar, while the cliff swallows fly downstream.

I wake up at 2 A.M. to the bright light of a full moon burning through the nylon of the tent and the persistent song of a territorial mockingbird. Bill is flat on his back sawing wood with vigorous, deep, athletic inhalations. I stumble out of the tent, trip, and sprawl in the gravel. I look up into the eerie horizontal pupils and slightly alarmed face of a ewe. "Bahhh," the sheep explains, in a grass-scented gust. A ring of twenty white sheep surrounds the tent. They appear indigo, black, and turquoise in the moonlight. Every one of them is intently staring at the rumbling tent. I elbow my way through. The sheep are so enthralled with the sound of Bill's snoring that I have to shove a couple of

sheep butts to the side in order to get through. When I creep back inside, Bill wakes for a moment, and hearing the mockingbird, he mistakes the moonlight for morning. He announces that he slept all night then plunges recklessly back into a sound sleep. Wide awake, I resist the temptation to punch him, and I doze in the moonlight listening to the mockingbird's lullaby and the soft snuffling of the sheep until I drift to sleep.

Dawn brings clear skies and more wind. We load our gear, tuck our heads down, and put our backs into paddling.

We coast past the clucking of a flock of wild turkeys hidden behind a thicket of white-flowered water hemlock spangled with the big pink blooms of evening primrose. I cut beneath a low hanging elm and disturb a family of sleeping raccoons. They hump their way down the trunk on stiff legs, glaring down at me. One young coon reaches the ground and sinks onto his bottom, rubs his eyes with black paws, scratches his gray tummy, and yawns at me. An adult returns, chirrups, and nudges the sleepy youngster into reluctant retreat up the limestone steps of the canyon wall.

The river has carved a channel through massive layers of limestone. The canyon walls soar overhead and the river runs over cobbles, boulders, and solid slabs. We coast down riffles, blast through chutes, paddle through small rapids, and around dozens of fishermen. Without an audience, I am assured, confident, and work my way through the rocks without mishap. But put a couple of anglers in the holes below a small rapid, and I guarantee a hidden rock will snag my kayak and cause panicked paddling, cursing, and a rush of adrenaline as I fight to keep from getting dumped into the river.

We curve around Barefoot Camp, a private campground. Grassy slopes pocked with campsites face steep limestone cliffs. Dozens of trucks parked on the water's edge sit with doors open like elytra, the hard protective covers on beetle's wings. Competing stereos blast music, voices, and advertisements. In amazement, I watch a family load gear into a truck: cooler, chairs, fishing rods, and tackle boxes. The parents and two teenagers pile into the vehicle, drive about 50 feet, park on the gravel bar, and unload their gear at the river's edge.

Sheet metal shelters and aluminum picnic tables furnish Barefoot's campground. As attractive as they are now, I wonder if they will survive the next flood or if they will end up as twisted trash caught in piles of drift along the banks. Even with O. H. Ivie upstream, the river can rapidly transform into a wild creature that plunges and twists, battering the corridor and canyons,

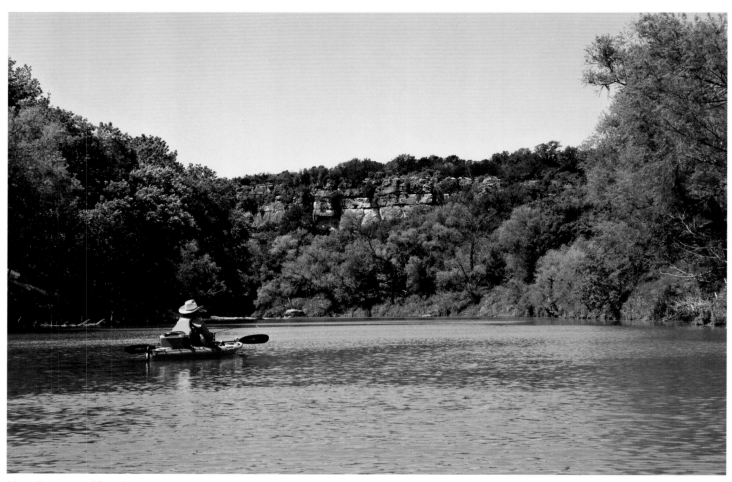

Near the town of Bend

sweeping away houses, shelters, and boats. In 2004, a series of thunderstorms dumped a stunning amount of water into the river basin in a few short hours. Water rushed into creeks and down to the rivers. On June 9, 2004 at 7 A.M., the river at Winchell, downstream of the O. H. Ivie dam, was running a placid 9 feet, with a cubic-foot-per-second flow of about 1,250. In less than three hours, the river rose to 33 feet, and the water barreled down the river with over ten times the volume. The San Saba River rose 22 feet and crested at over 26 feet. Downstream, the Colorado River at the town of Bend crested above 27 feet. Cherokee Creek transformed from a mild-mannered stream into a torrent, pouring into the Colorado at a rate that would fill thirteen Olympic-sized swimming pools every minute. It pushed the river level up to an estimated 35 feet. No one knows how high the river crested below Cherokee Creek and

above Lake Buchanan because there are no river gauges in that section. In fact, it hardly counts as a flood—except in the memories of local residents. Kay, Elsie Millican's daughter, told me she had called the LCRA and politely inquired after the river levels on the morning of June 10, 2004. The helpful operator told her that the river levels were all normal. Kay makes a face likes she's just had a swallow of cold, bitter coffee, "I told them they needed to get out of the office and actually look at the river 'cause we had about 40 foot of water running through the canyon!"

A gust of wind hits us in the face, and we smell Sulphur Springs before seeing the clear waters pouring into the river. At the base of a limestone bluff, the spring gushes hundreds of gallons per minute of 68°F clear water heavily tainted with sulfur. As early as 1850, people traveled through rough Comanche country to drink and bathe in the curative waters. Jacob de Cordova, a land promoter, wrote about the springs in 1858, endorsing the mineral-laden waters as healthful and beneficial and the scenery as magnificent. Bathhouses, a commissary, and a dance platform catered to the tourists until the late 1880s when the mineral springs in Lampasas stole the trade. The public forgot the springs until Elsie and Winston Millican opened the area to the public as a fish camp in 1960. They installed a swimming pool below the springs and built cabins on the second bank of the river. Taken with the beauty of the river, Elsie says that people always ask why they didn't build the cabins on the first bank. She is proud that the cabins her husband built have never flooded in over fifty years. Her daughter Kay and son-in-law Dean now run both the camp and the ranch. The acres of land above the river canyon feed cattle and deer but, unlike much of the land in the area, which is solid cedar, their ranch has oaks and tall grasses. When I ask Dean about the cedar, he scoffs and tells me that land does not take care of itself and what I see is the result of hard work and planning.

We drag our kayaks onto a gravel bar and from there pull them up to our waiting truck. After we lash the boats down, we stow the gear and drive down the canyon to select a campsite.

Our campsite, one of the few available, is between an astonishingly primitive outhouse, the Lampasas Boy Scout troops campsite, and the road that leads down the narrow canyon. It overlooks the river with stunning views of cliffs, hunting osprey, and belted kingfishers.

We pull out chairs and tables to stake out our territory. I'm feeling so possessive of my space, I'm ready to go pee on a bush. Cricket frogs are starting

to chorus in the late afternoon. Mexican buckeyes, mountain laurels, hackberries, cedar, Mexican persimmons, elms, and pecans crowd the base of the cliff behind us. Lizards and small birds forage in the dry grass and last season's leaves. The crackle and rustling at the base of the weathered gray rocks magnifies the creatures' sizes. An ambitious armadillo sounds as big as a rhino from a few feet away. A red truck drives past, billowing dust, exhaust, and thumping music. A kettle of Swainson's hawks pours over the edge of the canyon. They circle and swirl around in a tight mass as though vigorously stirred in a pot. The evening light gilds their wings and bellies. A green truck crosses in front of us and blocks the view of the river. The osprey continues to patrol the river, and a kingfisher rattles the canyon with its bold call. The red truck rumbles past, going back down the canyon. A white truck bounces along the dirt track and pulls up within a few feet of us to let the red truck pass.

A pair of blue-gray gnatcatchers is giving alarm calls behind me. I finally get up and see, just 10 feet from where I had been sitting, a slit-eyed, lichen-gray screech owl hunkered down on a slender limb. The tiny rambunctious gnatcatchers yell in his face; he ignores them. When I walk up, the gnatcatchers huff and preen a couple times then flit away. The owl continues to watch me through half-opened eyes, his head swiveling around to follow me; the movement is so subtle that it seems a trick of light.

The green truck retreats back down the canyon. Another red truck, or possibly the same one, booms past us. Bill and I sit in shock, dazed by the vehicles driving past. With the road pinned between the river and the canyon walls, all the campsites are within a few yards of the road. We never figure out why the same trucks, billowing dust, exhaust, and grating music, drive back and forth,

over and over again (though the state of the outhouse could be an indicator). In the morning, we will paddle 8 river miles down to Colorado Bend State Park. At midnight, a barred owl competes with the ghost stories from the Boy Scout troop, the persistent rumble of trucks, and the distant murmur of the river.

Sulphur Springs Camp to Colorado Bend State Park

We launch the boats in early morning quiet. The Boy Scouts are all asleep. White-eyed vireos call back and forth across the river. Canyon wrens drench us in liquid cascades of song. Spotted sandpipers bob along the shore, squeal plaintively, and fly downstream whenever we draw too close. The riverbed is rocky, and there is enough water and current to form small rapids. Within the first five minutes of being on the river, I get distracted from maneuvering through boulders by an eastern phoebe dancing over the water, snagging insects. The current pins the kayak sideways on a rock, and I'm almost dumped out of the boat.

The anglers are soon out in force. Every rapid has an angler or two working the pools below. We glide past dozens of people fishing in the river and from the banks. For most, a Texas nod is enough. Some, we are compelled to ask one of the infinite variations of the fisherman's greeting, "Catching anything?" A few ask us if anyone upstream is having any luck. This time of year, most are trying for the last of the white bass run.

The Colorado River above Lake Buchanan has one of the strongest white bass runs in Central Texas. As early as February, schools of males migrate upstream to locate running water with a gravel or rock substrate for spawning. April and May—when the redbuds are blooming—are good months for fishing; spawning is over and hungry fish are migrating downstream to the reservoirs. Some fishermen swear by flies, others insist that small jigs are the only lure to use. As far as I can tell, when the fish are schooling and hungry, they will bite just about anything.

The canyons are flat-out gorgeous. Sulphur Springs and a hundred other springs seep through the karst limestone to flow pure and clear into the river. The swift current spills over rocks, riffles, and small rapids. The river's voice is ringing through the canyon: laughing, sparkling, vivacious, and compelling.

Bill and I arrive at Gorman Falls just before noon. We tie the kayaks to a rock and scramble up the steep, bare dirt riverbank to the falls. Hot, sweaty people stand behind the fence and the "Do not enter" signs. They stare at the cool, dripping water of the 75-foot falls with unabashed lust and a solemn reverence. We take photos and admire the moss and fern-covered cliff glistening with spring water that flows over stone, plants, and travertine deposits down to the river. A breeze swifts across the face of the waterfall and a cool mist wafts over the crowd. The people around me groan and are visibly weak-kneed. Hikers ask over and over, in whispers, if we rented our kayaks or know where to rent canoes.

According to Elsie Millican and her daughter Kay, the falls are a poor imitation of their former splendor before Texas Parks and Wildlife (TPWD) took over the private property and renamed it Colorado Bend State Park. Elsie and Kay both described the water as pouring over the cliff and the house above the falls as a wonderland of roses and elephant ears. On an earlier trip, I'd walked the trail, through the park down to the falls and the old home site. TPWD uses the former Gorman home as a conference center, and the rose bushes are gone. The next-to-impossible-to-eradicate invasive elephant ears still crowd the stream edges and the lip of the falls. Gorman Springs sends water flowing through woods to the old house where it pools in lily ponds and then drifts through a boggy area to the cliff edge. I walked out into the grassy area where the stream breaks into dozens of small, shallow channels. A twisted metal rail guards the edge, and a faded sign warns of the drop-off. The grassy edge visually breaks against the cliff on the opposite side of the river. If I hadn't walked to the base of the falls earlier, I'd never have known about the grotto below, with its trance-inducing rhythm of spring water tumbling over lush cushions of emerald mosses, ferns, and bright wildflowers and the rounded humps of travertine building up at the foot. When TPWD acquired the property, water cascaded over bare rock because visitors climbing over the cliffs had stripped away all the vegetation from the rock face. It gave the impression that more water poured over the edge. Now, as much water, if not more, flows over the cliff, but over and through thick mats of ferns, moss, and vines that are striking and dramatic in their own quiet, vibrant way.

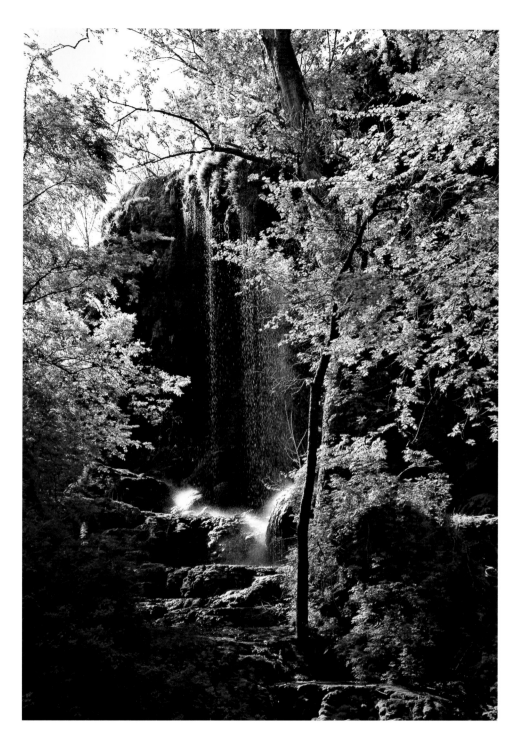

The dry canyons surrounding the falls are still covered with the cedars, red oaks, mountain laurels, and yucca that historically blanketed the slopes. The uplands, however, would have been a grassland of native grasses (little bluestem, Indiangrass, tall dropseed, and sideoats grama) dotted with small groves, or motts, of plateau live oak. Without an understanding of how fragile the Hill Country was (gained through hindsight for the most part), early settlers allowed excessive grazing by livestock, harvested the trees, and suppressed the fires that would have burned the brush out of the grasslands. The trail I take down to the falls crosses a jumble of weathered gray limestone caught in a stop-action image of a slow cascade of stone down the canyon. There is little soil on the rocky slope. Once overgrazed, without the thick grasses and their extensive root systems to lessen physical impact and aid in absorption, the water cascaded down the steep slopes, carrying away the already thin topsoil during the area's seasonal torrential downpours. The rains rushed off without having a chance to soak into the soil and down through the fissures and cracks of the porous limestone to feed the springs. With the topsoil virtually gone, cedars were just about the only plant that would thrive. The property owners chose to let the place grow up into thick, almost continuous, cedar brakes. An industry developed, and "cedar choppers" harvested the posts for building and fences for use all over Texas.

While it is currently popular to cast Ashe juniper (commonly called cedar) in the role of water-hogging villain, absolute judgments of any sort are worthless in the natural world. A cedar is neither good nor bad—it is a tree. While an overgrown cedar thicket is a symptom of a larger imbalance in the ecosystem, the trees do produce berries for wildlife, and a number of birds—including the endangered golden-cheeked warbler—use the bark as nesting material. In a long-term restoration effort by TPWD, sections of the 5,328-acre park, including the Gorman Creek drainage, are slowly being cleared of most of the brush and cedar, reseeded with native grasses, and periodically burned to maintain the grasslands. The overall goal, according to a TPWD employee, is to restore as much of the native grasslands and oak mottes—and the accompanying unique plants, invertebrates, birds, mammals, reptiles, and amphibians—as possible and protect them for future generations. As I walked up the road from the old homesite Gorman back to my truck, a singing persimmon tree caught my attention. I watched and waited while the bush continued to trill. A small bird with red eyes, a bold white eye ring, black cap, and

greenish back bounced into the open, sang for me, and then disappeared into the dark shadow of brush. It was a black-capped vireo, a federally listed endangered species, making himself at home in the recently cleared and burned slopes above Gorman Falls. The scarlet flame of a summer tanager lit up the sky. I "phished" at a cluster of trees, and a fluffed-up, indignant blue-gray gnatcatcher scolded me vigorously as I hiked back through the park.

From the falls, Bill and I skid down the steep bank back to the kayaks. In the river are huge chunks of limestone karst, once part of Gorman Falls. I look into the rotten heart of the stone, into the fissures connected by fragile-looking, slender ribs of stone and tenuous bridges. It reminds me of images of the interior of bones. Because rainfall is normally slightly acidic, it naturally dissolves the limestone as it seeps through fractures and clefts in the rock. The steady drip of water through the limestones and dolomites of Colorado Bend State Park have created an extraordinary variety of karst features including sinkholes, caves, underground streams, and fractures.

The last mile or two of river slows with still water backing up from Lake Buchanan. The rapids, riffles, and boulders are submerged.

We end our paddle at a TPWD boat ramp. Behind a rim of thick grass lining the shores, the broad sweep of campground is jammed with people, brightly colored tents, kayaks, canoes, and picnic tables covered with food, stoves, and lanterns. Kids are running around, and anglers of all ages troll the banks. The murmur of many voices and the smell of grilling meat fill the air. While I prefer to be a little more secluded, the sight of so many families enjoying the river is a profound pleasure.

I watch the kids running and playing games while others attend to the serious business of fishing. I think of Stan Burnham and his river; Elsie and her anger at the river's treatment; the many people I have met who live along the river. An ancient Chinese proverb speaks of a silken red thread of destiny, which connects one person to another. The magical thread may tangle or stretch but never break. For me, the Colorado River is a magical green thread that winds its way through the heart of Texas, binding the lives of people together.

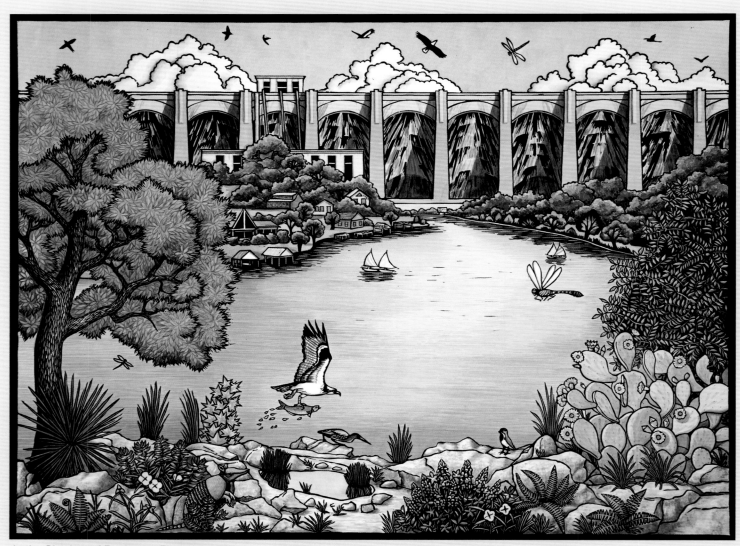

In the Shadow of Buchanan Dam

4: Another Colorado

THE HIGHLAND LAKES AND LADY BIRD LAKE

"Who knew," the ruddy-faced man seated in front of me whispered to his wife, "that bald eagles are really bald? That one doesn't have a single feather on its ugly red head." His wife lowered her binoculars and said doubtfully, "That's a bald eagle?" Meanwhile, the enthusiastic birdwatcher had pushed her way out of the cabin and onto the foredeck of the *Eagle II* to misidentify more birds. I scanned the sky, "Oh look!" I called and pointed. A dozen sets of binoculars snapped to the section of sky above the limestone canyon. "Oh heck, it's just another turkey vulture." I announce. The couple murmurs to each other. "Bald eagles aren't bald," she says with satisfaction. "But turkey vultures are," he replies.

I'm on the Vanishing Texas River Cruise[1] with a group of birdwatchers and tourists; we are cruising up the limestone canyons at the head of Lake Buchanan, the first of the Lower Colorado River Authority's (LCRA) Highland Lakes. Our boat, the *Eagle II,* is a big, broad vessel with a shallow draft and a glass-enclosed cabin protecting us from the raw January day. A few hardy souls stand outside in the drizzle and wind scanning the skies for bald eagles, osprey, and other winter residents of the canyons. Ferns embellish the cliffs near the waterfalls. Slender trees and shrubs, cactus, yucca, clumps of wiry grasses, and other determined survivors knot their roots into crevices and narrow pockets of soil along the rock face.

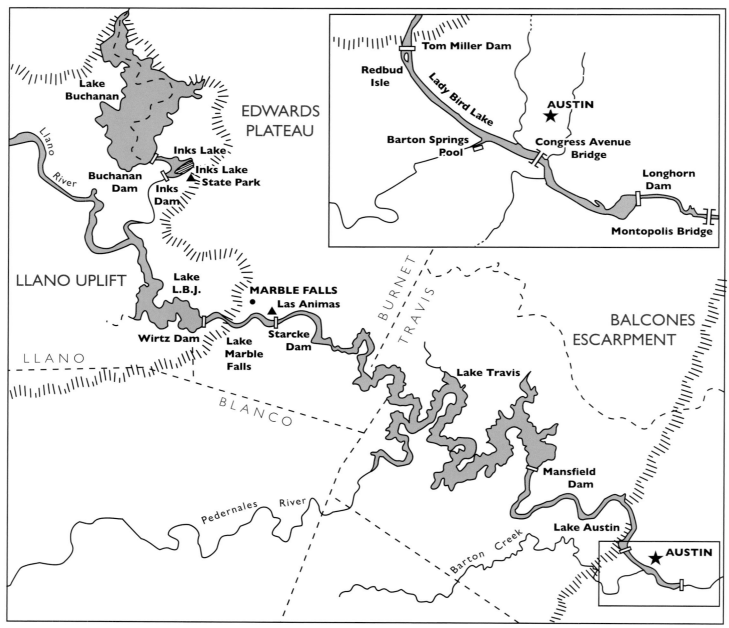

Highland Lakes and Lady Bird Lake to Longhorn Dam

We retrace our way downstream through the limestone canyons until the river merges into the giant reservoir like a neck sloping into shoulders, collarbones, and breast. Somewhere in the depths, the river channel snakes through a granite bed, the spine of the Lake Buchanan beast that spreads its broad sternum up to the pale wintry sun. The reservoir spreads its waters over red and pink granites. Some of the oldest rocks in the country, they are the result of a collision between ancient continents nearly a billion years ago. The impact pushed up mountain ranges, crushing and heating volcanic and sedimentary rocks to create metamorphic gneiss, and schist. Molten rock bulged up through the cooling layers to form giant, dome-shaped, pink granite batholiths. For nearly 200 million years the rolling humps and mounds of granite, gneiss, and schist eroded into layers of sediments. Then shallow seas deposited thick layers of limy creatures to create the ubiquitous Cretaceous limestone of Central Texas. About 10 million years ago, the earth shuddered and heaved the entire Edwards Plateau up nearly 2,000 feet above sea level (the Balcones Escarpment is the edge of the plateau). Since then, the rivers and streams have cut and scoured away the layers of softer limestone to reveal the harder Precambrian granites and igneous rocks beneath. The Llano Uplift is this roughly circular bowl of exposed granites ringed with gneiss and schist, and surrounded by higher and younger limestone. The Colorado River continues to erode and sculpt the river corridor even as dams fill the canyons with water and slow the currents.

Out of the protective canyon, the wind pushes the waves into a heavy chop. A ribbon of silvery driftwood—whole trees stripped of leaves and bark by previous floods—lines the shores at the high water mark. Even the hardiest of the birdwatchers has retreated into the close, warm air of the cabin. We look down and across the lake: 30 miles long, 5 miles wide, and 22,335 acres of surface. The lake holds 285 billion gallons of what looks like plain old H_2O—rainwater, creek water, river water, spring water—but it is actually *power:* hydroelectric, political, nuclear, steam-generated, coal-fired, and economic power. The kind of power you plug an appliance into and the kind that forms and directs local—and sometimes national—government. In Texas, whoever controls the water holds the influence to direct the lives of just about everyone and everything downstream: ranchers, farmers, businesses, cities, towns, industries, and power plants.

The behemoth that juggles all of this—not always successfully and not

always equitably—is the Lower Colorado River Authority. Although the Colorado River figures prominently in the name and in the public's perception of the quasi-state agency, the LCRA's billion-plus dollars a year annual revenues center on the sale of electricity generated from coal, natural gas, wind, and hydroelectricity. Of the eleven billion kilowatt-hours of annual LCRA-generated electricity, the string of six dams impounding the Highland Lakes produces less than 2 percent. Once the major source of LCRA's electrical generation, indeed the raison d'être for the creation of the agency, hydroelectric generation is now primarily a by-product of other river activities controlled by the LCRA.

But wait, I hear the sonorous Texas drawl of an LCRA voice-over: queue up the dramatic music (close-up of muddy floodwaters crashing through floodgates on one of the dams, then cut to a black and white photo of a houseboat caught in a flood on the brink of the Austin Dam in 1900). "This river of contrasts with devastating floods and choking droughts has ruled the lives of all who call it home. It is like a wild animal. The Colorado is a placid stream that turns, without warning, into a deadly, raging torrent mightier than the Mississippi. A river that can and will ravage a broad swath of land from the headwaters all the way to the Gulf of Mexico, causing millions of dollars worth of damage, destroying the homes, farms, cities, and countless lives in its path."[2]

Cultural anthropologist Jane A. Morris, PhD, in her analysis of the LCRA, describes two origin myths for the quasi-state agency. In the popular version of the agency's beginnings, which she calls, "Taming Nature for the Good of Mankind," the LCRA transformed the barren and desolate Hill Country into the productive Highland Lakes. The LCRA saved countless lives, protected property, and opened up the river valley for settlement by damming the river and imposing benevolent human will over the unreliable forces of Nature. Another version, what Dr. Morris refers to as, "Harmony with Nature for the Long-Term Public Good," sees the creation of the LCRA as the honest hand of the long arm of Roosevelt's New Deal policies restraining private greed for the triumph of the public good. In this version, the river, while still an uncontrolled and vaguely malevolent force, is secondary to the efforts of federal and state government who wrested control of the water supply and hydroelectric generation out of the hands of greedy privateers (Morris, *Board and Staff*).

Bits and pieces of the truth are scattered throughout both versions, though each omits essential elements. The history of the agency is complex; further manipulations over the decades by the LCRA's public relations department (now hailed as Corporate Communications) have resulted in a muddle of facts and fictions.

First off, let us consider the Colorado River's propensity for flooding. Does it flood more than most rivers? When compared to rivers in the rest of the continental United States, the answer is unequivocally YES. Compared to other rivers in Texas? Not at all. The Colorado, along with the Brazos, Guadalupe, San Antonio, Frio, Nueces, and the other rivers that pour through the steep uplands and narrow canyons of the Balcones Escarpment are all located in "Flash Flood Alley," a swath of land that wraps around the edge of the escarpment from Dallas to west of San Antonio. In fact, the National Weather Service has identified Central Texas as the most flash-flood-prone area in the United States. The combination of weather patterns (warm, moist air from the Gulf of Mexico and the Eastern Pacific Ocean plus cold air masses billowing down from the Great Plains) mixed with the abrupt drop off at the edge of the Edwards Plateau at the Balcones Escarpment results in the formation of large thunderstorms that tend to stall and drop prodigious quantities of rain in short periods of time. These "rain bombs" are nothing new. Spanish explorers and the early settlers remarked on the area's rivers ability to dramatically rise and fall in stunningly short times.

Has the Colorado always flooded with such swift and sudden violence? It is hard to know, because no one collected records of rainfall or floods systematically until after settlers had moved into the area—and significantly altered the landscape. Early descriptions of the Hill Country, including the Llano Uplift, do not portray the desolate, hard land with thin, rocky soils at the heart of the LCRA's standard description. In 1847, German geologist Ferdinand Roemer marveled at the immense grasslands dotted with groves of oaks and the steep slopes of the canyons and hills held in place by tough cedars (Roemer, *Roemer's Texas*). A few years later, Frederick Law Olmsted (journalist and landscape architect) noted in *A Journey through Texas* that "following the Llano and San Saba, downwards, the land becomes richer and better wooded, and the region of the Upper Colorado was described to us as being one of the finest parts of the state."

The eventual destruction of the grasslands through overgrazing, suppression of wildfires, agriculture, and the cutting of the timber tore rents in the

hydrological fabric of the Hill Country. The grasses, essential for absorbing rainfall and slowing the water's rapid progress downhill, were diminished or gone. The topsoil washed away. (It is true that the limestone and granite uplands have never been rich in topsoil, but the loss of the grasses and plants allowed the precious resource to wash away.) With downpours hitting bare soil and rock, the water rushed in torrents off hillsides and through the narrow canyons. It made an arid, naturally drought- and flood-prone area just that much worse. Moreover, because the fertile land needed for agriculture was in the river valleys, creek bottoms, and the broad prairies below the Edwards Plateau, settlers built their homes, then towns and cities, in the floodplains. Not surprisingly, as more people settled onto the fertile floodplains along the river, the Colorado's historic flood patterns had more impact and caused considerable damage to those imprudent enough to build in the river's path. We still don't have this figured out: almost every year, Texas leads the nation in flood-related damages and flood-related deaths.

Numerous schemes and attempts to dam the Colorado River by private ventures were mounted and failed before the LCRA came along to finish what others started. In the early twentieth century, before the development of the oil and gas industry, the companies that controlled hydroelectric generation were major political forces in Texas and the rest of the United States. In addition to generating huge revenues, they were the state's largest employers. The dams were installed to produce hydroelectric power; as a secondary benefit, they also partially controlled seasonal floods, which, in turn encouraged growth along the reservoirs and river corridors. However, there is a functional conflict between dams built for hydroelectric generation and dams built for flood control: an empty reservoir cannot run generators, and a full reservoir cannot capture floodwaters.

If we are going to point fingers at the original instigators, we need look no farther than Adam Rankin Johnson and Charles H. Alexander. In 1854, while surveying school lands for the State of Texas, Johnson spied what he considered the perfect spot for a dam at a place named Shirley Shoals in the granite canyons. He incised an "X" on a pink boulder then marched off and bought 10-acre lots on either side of the river (Buchanan Dam splits those lots almost exactly in two). Although Johnson lost his sight in the Civil War, he went on to found the city of Marble Falls, or "Blind Man's Town," remarkably laying out the streets and planning the city entirely from memory.

Charles H. Alexander, a wealthy businessman, was also taken with the idea of damming the Colorado. He amassed water right permits and property up and down the river. In 1909, he started a multi-million dollar dam just downstream from the present town of Marble Falls. The dam project failed, and Alexander was nearly ruined.

In 1893, the city of Austin completed a dam built out of big blocks of pink granite at the current site of the Tom Miller Dam. For a while, the impounded river provided electricity and recreation on Lake McDonald, but droughts and the rapid silting-in of the reservoir curtailed the production of electricity. The lights went out in Austin. In 1900, a flood destroyed the dam (more about this later). The city rebuilt, and a flood promptly destroyed the new dam. Years of finger pointing and court cases resulted.

By 1926, Charles Alexander had regrouped. With his sons, he organized the Syndicate Power Company. Alexander, along with powerful water rights holders from downstream, interested Samuel Insull, a former protégé of Thomas Edison, in a project to build hydroelectric generation dams along the Colorado.[3] By this point, the Syndicate Power Company not only owned Johnson's Shirley Shoals site but also held permits for a total of six dams—four in Burnet County and two in Travis County.

Samuel Insull and his brother Martin started plans to build five or even six dams across the Colorado for hydroelectric generation; their enterprise drew both enthusiastic interest and outright conflict from the public. A squabble ensued with the West Texas Chamber of Commerce and a group of ranchers worried that they were having their water stolen. They did have a basis to their fears; at that time, permits were issued for the amount of water a reservoir could hold, so the river could be impounded until the reservoir was full (modern permits allow for a specific amount of water from normal river flows so, theoretically, the river continues to flow).

The politicians wrangled and compromised. A deal awarded the West Texas ranchers a permit to create the Brownwood Dam on Pecan Bayou. The Central Texas Hydroelectric Company, owned by the Insulls through a pyramid of syndicates, was allowed to begin the massive project of building the Hamilton Dam (renamed Buchanan) on the very site chosen by Adam Rankin Johnson more than fifty years prior.

Samuel and Martin Insull are by turns vilified as unscrupulous corporate

thieves—the Enron executives of their time—or praised as visionaries destroyed by the economic slapdown of the Great Depression. While raising a few eyebrows, their innovative financing techniques (what we would refer to as pyramid schemes) did not cause alarm because the Insulls controlled the largest utility company in the United States. The thought of them failing did not occur to anyone—they were just too big and well known.

Work on the dam halted abruptly a year later on April 20, 1932, when the Insulls' pyramiding schemes and financial empire fatally collapsed. The brothers fled the country, but both would return to face trials for fraud, embezzlement, and violation of federal bankruptcy laws. Hamilton Dam stood less than half completed; more than two years would pass before construction began again.

The country struggled through the double whammy of the Great Depression and drought. A judge appointed Alvin Wirtz, the former state senator and brilliant lobbyist, as receiver for the bankrupt Insull company. Ralph W. Morrison, a San Antonio financier who had made a fortune in the utility business, wrangled a deal with some of the Insull utility companies. In exchange for the Central Texas Hydroelectric Company bonds (considered worthless at the time), the utilities would get 49 percent ownership of a new business, the Colorado River Company. Morrison was eyeing federal dollars, and, after forming the new company, immediately applied to the Reconstruction Finance Corporation for a $4.5 million federal loan to finish the dam. The loan was turned down in the fall of 1932.

Then, in 1933, Franklin D. Roosevelt created the Public Works Administration (PWA). The program had a budget of $3.3 billion along with a mandate to make grants and loans for projects to stimulate construction and put people back to work. It seemed like a match made in heaven: an unfinished dam and government money just waiting to be spent. But the PWA wouldn't fund projects by private corporations like the Colorado River Company. So Alvin Wirtz enlisted the help of congressmen James P. "Buck" Buchanan and Joseph J. Mansfield, U.S. senators Tom Connally and Morris Sheppard, and a young man by the name of Lyndon B. Johnson.

They gained the support of rice producers and other farmers downstream with the promise that the waters stored behind the proposed dams would be available for irrigation when the river ran low. Wirtz used his influence to ex-

ecute a little redistricting magic in the Texas Legislature to cement Buchanan's support. Burnet County and the Hamilton Dam site moved into Buchanan's Tenth District.

The team worked to convince President Roosevelt that damming the Colorado River was an endeavor worthy of federal dollars. It wasn't a hard sell; throughout FDR's career, water development and the large-scale development of cheap, public hydropower had been priorities. On June 28, 1934, Buchanan received a telegram that announced that President Roosevelt had conditionally approved a $4.5 million PWA loan to complete the Hamilton Dam project—with one condition: it had to be a public project instead of a private venture. The president's telegram read, "It would be worth $4,500,000 to stop those floods and conserve the water if no other use were made of the dam." Buchanan's fans clamored to change the name of the dam to Buchanan Dam; that it was against federal law to name a dam after a living person didn't faze them a bit.

With the announcement that federal dollars were available to complete the dam, Wirtz promptly terminated his receivership of the Insulls' Central Texas Hydroelectric Company by selling the assets and canceling the power-purchase contracts with the Insull subsidiaries. Morrison's Colorado River Company emerged with ownership of the Hamilton Dam property, six valuable water permits, twenty-eight parcels of land, and the "worthless bonds" from the Central Texas Hydroelectric Company; he then announced his willingness to sell it all to a new state agency.

Wirtz composed a bill using Article 16, Section 59 of the Texas Constitution as the provision to create a "Colorado River Authority" as a Reclamation and Conservation District. Public opposition, fueled by the idea of the Colorado River Company making money off the deal and resistance to Roosevelt's New Deal programs, was ultimately tempered by a brilliant campaign by Wirtz, Buchanan, and others, including the Austin Chamber of Commerce and the Colorado River Improvement Association, a coalition of farmers and citizens from the Rice Belt. The politicians downplayed the potential revenues from power generation and emphasized the role of the new river Authority and the Hamilton Dam in preventing flood damage. They guaranteed water to downstream farms, and promised jobs for at least 1,500 out-of-work Texans. The bill stalled three times before finally passing with the support of Governor "Ma" Ferguson. The Lower Colorado River Authority was official. The Colorado River Company sold their holdings to the new agency for a final sale price of $2,639,000.[4]

But wait, the LCRA as a Conservation and Reclamation District? Granted, the meanings of the words "conservation" and "reclamation" have evolved since the 1930s, but the Texas Legislature gave the LCRA the unique ability to generate and sell electricity in order to support its mission (and pay back the PWA construction loans). LBJ wrote from Congress in 1947: "The Legislature intended that the ten counties in the Colorado River valley should come together into a district for the preservation of the natural resources of that district. The Authority, in lieu of taxes, was to become self-supporting through the sale of hydroelectric power, created incidental to its other broad purposes" (Johnson, *A Program for All*).

Has the LCRA been successful in fulfilling its obligations? The rest of the story lies downstream.

Inks Lake and Lake LBJ

Bill and I are sitting below the big dam in our 14-foot jon boat, looking up at the ramparts of algae-streaked barrel arches holding back the waters of Lake Buchanan. The dam is an architectural rarity. Canted at about a 30-degree angle, the long row of arches is oddly compelling. Dark stains from water and algae create a herringbone pattern on the stacked semi-circles of concrete that comprise each arch. Buchanan Dam is the longest multiple-arch dam in the nation. It relies not on brute strength, like a gravity dam, but on the delicate balance of opposing forces between the steel-stabilized concrete and the weight of billions of tons of water.

Several houses are under construction or just finished in the shadow of the big dam. The homeowners, lured by the impression of permanence, have built houses beneath a wall of water. I don't have that kind of trust. In contests between nature and concrete, nature, especially water, comes up with unimaginably destructive tricks.

The LCRA does closely monitor their dams and, if any organization has the money and talent to maintain their dams, the LCRA does. Nevertheless, concrete deteriorates and erodes; America's dams (along with other infrastructure) are in trouble as they age. More and more of our country's dams rate as High Hazard structures. This is not just because they are showing signs of wear and tear from the stress of holding back the weight of billions of gallons

of water, it is also because so many homes and businesses are constructed in the floodplains below dams: any failure would result in significant loss of lives and property damage.

Inks Lake, the smallest in the chain of the Highland Lakes, is called a "pass-through" lake by the LCRA and a "constant level" lake by just about everyone else, including lakeside property owners. Unlike massive Buchanan or Travis Lakes, the Inks, LBJ, Marble Falls, Austin, and Lady Bird Lakes don't store water; they just funnel it downstream and generate a little hydroelectric energy in the process. In defiance of nature, the pass-through lakes retain the illusion of abundant water even in the severest drought. That doesn't mean the lake levels don't go up and down. If Buchanan Dam has to open any or all of the thirty-seven floodgates that sit like three toothy gaps in its two-mile length, water will surge through three rocky channels into this placid pool and overwhelm the banks.

In the early morning cool, it is serene under the dam. Deep gold light suffuses the trees and brush in the undeveloped area to my right and below the floodgates. The LCRA recently acquired 330 acres of land just below the floodgates to limit further development in the floodplain and restrict possible terrorists access to the structure. Bill and I pass a clump of young sycamore trees, maybe 15 feet tall at the most; there are big rickety nests of sticks jammed into the crowns of the slender trees. Gilded by the morning light, adult great blue herons stand, stretch, flap their wings, and greet the day. From the blazing leaves of the sycamores, pin-feathered chicks peer out, indescribably absurd with tufts of white fluff clinging to lumpy skulls and scrawny, undersized necks.

Bill has two spinning rods, one with a lurid purple rubber worm that glistens and sparkles in the morning light. On the other, he has affixed a crankbait, a small fish-shaped lure with life-like silvery glittering sides, yellow belly, red gill slit, and sharp treble hooks dangling off each end. We see a school of small fish leaping from the surface, and Bill sets off in pursuit of the predator. The worm does not get much reaction, but when Bill starts trolling with the crankbait, he gets an immediate response. Something big grabs the lure and runs with it. My husband's face shines with the ageless thrill of the dance, the give and take until the tired fish finally surrenders to the inevitability of line and reel. The 2-pound small mouth bass is unhooked, admired, photographed, and released. Bill tosses out the lure to troll

behind us as we slowly motor along. Within moments, he gets another hit, and the line strips off the reel as the fish heads to deep water. This fish fights hard, and Bill works the line, trying to tire the fish as it yo-yos between the depths and the surface. It hits next to the boat and flips on its side before it heads to the bottom. I can see it's glistening scales, flared fins, and flashes of gaudy blue, gold, green, and red. Bill reels the fish in. It is a huge grand-daddy bluegill with a knobby forehead that looks deformed but Bill says it is normal for older fish. He is trying to clip the barbs off the treble hooks that hold the bluegill in the mouth and gills when the fish thrashes around, and one of the hooks snags Bill on the index finger. The fish is flopping around, Bill is cursing, and blood is flying. I watch, unable to help either husband or fish. The final barb of the bottom treble hook is snipped. Bill places the fish in the lake with a hand cupped under its belly until it is oriented; with a muscular flip of its tail, it is gone. While Bill is dripping blood and I'm finding a clean towel, he remarks that many fishermen no longer use treble hooks if they are planning to catch and release. The hooks cause too much damage. Bill and I look away from his bleeding finger. You didn't want to eat that bluegill, did you? he asks. Naw, I say. We have lots of food, and an old fish like that deserves to keep going.

A big bass splashes under the Highway 29 Bridge. We motor over and anchor in the shade. Bill starts tossing rubber worms and Blakemore Road-runners into the water. He gets a couple nibbles, but no bites. The traffic over-head is noisy and pigeons coo loudly on the concrete pillars. I try to convince Bill that he needs to use a brighter rubber worm; that in the shade the fish cannot see the purple. I offer to select the perfect lure—I'm bored, and picking through his tackle box sounds entertaining. Bill nixes the idea, and keeps his stash of rubber worms and lures safely out of my reach.

By 10:30 A.M., the big powerboats are out dragging water skiers around the lake, Jetskis zip around with the aesthetic appeal of giant hornets, sprin-kler systems are going full blast, and the kids at Camp Longhorn are swim-ming, sailing, and screaming. Vibrant emerald lawns run down to the water, and pumplines run up to the sprinklers. Other than the LCRA land by the spillways and Inks Lake State Park, all the land surrounding the lake is private homes or golf course.

We wallow through the wakes of the boats and Jetskis and pull off into a cove near the Roy Inks Dam. We tie up to a boulder and hop out to explore. The

rocky hillsides of pink Valley Spring gneiss have weathered to blackened humps. Lichens paint the rocks with bright orange splashes, cool green rings, and scattered vivid yellow-green smudges. Belying the verdant lawns across the lake, the brittle leaves and stalks of flowers gone to seed crumble under our feet, and we scatter the seeds into the wind. Resurrection ferns curl in tight brown fists in the shelter of the jumbled rocks. Dry mosses wait for rain as they hide in crevices and shadows. The boulders have "exfoliated" off the gneiss domes. Over time, water seeps into the stone, and sheets of rock slip off like the layers of an onion. Wind and water erode the slipping layers into slabs, boulders, and whimsical shapes. From the corner of my eye, I glimpse fanciful stone creatures, waiting for my absence to resume their slow movements.

I remember a visit years ago when rain slicked the rocks and turned the world into a vibrant strip of pink rocks, orange and green lichens, and springy green mosses—all sandwiched between a gray sky and a dull leaden lake. Today the dark blue of the lake mirrors the intense blue of the sky, and the sun's heat reflects off the rocks and collects in areas usually shaded—the backs of my knees and chin, for example. We slide down the rock incline into the water cooled by storage in the depths of Lake Buchanan. Female painted buntings bounce between the Mexican persimmons, huisache, cedar elms, and sycamores that have pried their roots into fissures near the water. A male bunting lurks and nervously trills from deep in a thicket of brush and prickly pear. While we imitate a pair of hats bobbing on the surface of the lake, birds descend to our rock shore to drink and splash less than two yards away: a trio of painted buntings, mourning doves, white-winged doves, mockingbirds, bickering scissor-tailed flycatchers, and the surprise of a black-throated sparrow. Cold and hungry, we reluctantly scatter the birds and scramble back into the boat to return to our cabin.

After lunch, we walk through the Inks Lake State Park campground on our way to the Devil's Waterhole. Many of the campsites have electricity, and the revelation of electric appliances in tents amazes me. We pass nylon tents inflated into neon marshmallows by whirring fans. A microwave perches on the end of a table clad in a red-checked tablecloth next to heaped bags of food. The playgrounds are full of excited children swirling around slides, swings, and jungle gyms. Whole families bob in the lake just feet from their grassy campsites.

Along the wooded edge of the Devil's Waterhole, parents with toddlers,

babies, or children too young to clamber up the rocks crowd to watch dare-devils plunge 25 feet off a pink rock ledge into the pool below. Tones of hot vinyl, dirty diapers, and a full trash can underpin the tropical fruit smell of sunscreen. Florescent vinyl air mattresses, beach balls, and inner tubes float in the clear green water. There is a lot of squealing, yelling, and yelping by the kids and teenagers, all overlaid with the less-than-calm voices of parents cautioning and trying to reason with excited offspring.

Kayaks and canoes have paddled up from the lake to watch the kids—and a few adults—leap off the rock. A small redheaded boy and his blond older brother come to the head of the line. The older boy runs and jumps, yelling instructions for his younger brother the entire time. The redheaded boy

Devil's Waterhole at Inks Lake State Park

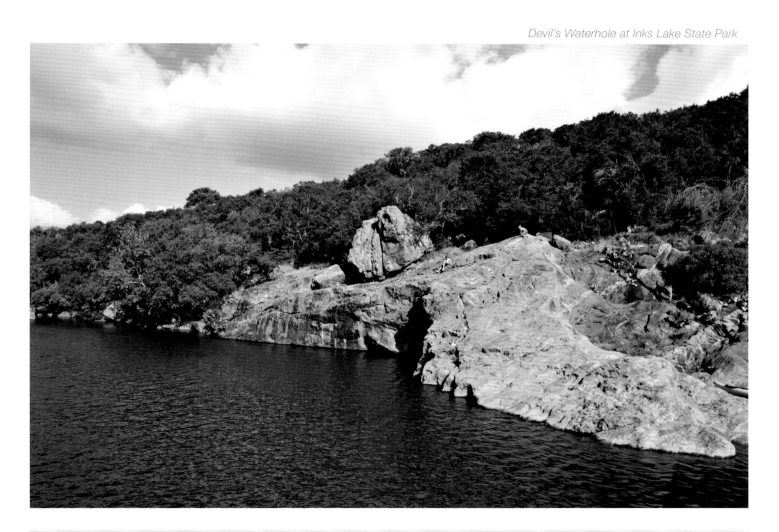

scoots on his butt to the brink and freezes. I know how he feels. His brother yells encouragements, which quickly turn to taunts, while the line of erstwhile jumpers drip and shift behind the redheaded boy. He shakes his head in a final declaration and moves off to the side, bottom, feet, and hands in contact with the rock at all times and sits with his head buried in his arms. The congested line uncoils like a spring and kids pop off the edge, arms, and legs pinwheeling as they hit the water with yells and whoops.

Below Inks Dam, from the banks of the U.S. Fish and Wildlife Ink's Dam Fish Hatchery, the head of Lake LBJ is riverine, with water coursing along a rocky bed. But the boat docks clustering along the edge contradict the impression. The LCRA recently stabilized and reinforced the concrete gravity dam above me to withstand an extreme flood.

Lake Granite Shoals and Granite Shoals Dam were the original names for Lake LBJ and the Alvin Wirtz Dam. Named after the distinctive granite rocks and gravel bars in the river below the confluence with the Llano River, construction on the dam began in 1949 in tandem with the Max Starcke Dam and Lake Marble Falls downstream; it was completed in 1951. In 1952, the LCRA renamed the dam for Alvin Wirtz. In 1965, the LCRA changed the lake's name to honor Lyndon Baines Johnson, the 36th president of the United States and an area resident. The main purpose of the lake is hydroelectric power, but it now provides cooling water for the LCRA's gas-fired Thomas C. Ferguson Power Plant on Horseshoe Bay.

Lake LBJ, with the spring-fed Llano River flowing in from the west, illustrates the Sisyphean task of attempting to manage the river by containing it behind mounds of concrete, steel, and earth. Every few years the weather and river conspire to remind lake dwellers that there are not one, but two rivers—and a number of large creeks—merging to form Lake LBJ. The Llano, one of Texas' only free-running rivers, generates more flash floods than any other tributary of the Colorado, and it has the fastest discharge rate of any river in Texas. When floodwaters rush down the Llano, they slam into the Colorado at a right angle that creates a bottleneck and makes a tough situation worse. Because LBJ is a pass-through lake and has no room to store floodwaters, the roiling water has

to exit through the dam's floodgates. If water flows into the lake faster than the dam can release it, the situation can quickly turn dangerous.

In 1998, a storm dumped extraordinary amounts of rain—even for Flash Flood Alley—over the neighboring Guadalupe River Basin. People watched in amazement while Canyon Lake filled, then overflowed Canyon Dam. The floodgates were incapable of handling the quantities of water flowing into the reservoir. Emergency personnel frantically alerted residents downstream to evacuate their houses along the river. The Guadalupe River erased hundreds of homes and businesses in the floodplain below the dam and caused millions of dollars in damages. The LCRA, realizing what a narrow escape it had been, wiped their collective brow, and issued a sigh of relief. Then they set their experts to figure out what would have happened if the storm had moved just a few miles north—to the Llano River Basin. It would have been disastrous, even if not as extreme as the floods of the 1930s. Floodwaters would have surged down the Llano River, uprooting trees, and boulders. The water would have smashed into Lake LBJ, pushing up over 841 feet above mean sea level, to overflow Wirtz Dam by more than 3 feet.[5]

Hundreds of homes would be inundated. Boats and docks would be crushed and add to the mass of debris carried by the flood. Roads, bridges, septic systems, sewer lines, and water lines would be underwater. Such a flood would disastrously interrupt—if not destroy—the lives of thousands of people. Floodwater would fill Lake Marble Falls until Starcke Dam overtopped. Lake Travis would come within a few feet of overflowing Mansfield Dam, even with all the floodgates open. Lake Austin would overflow Tom Miller Dam, and floodwaters would cut the city in half. No one doubts that the dam structures would hold, but the LCRA would not be able to release water fast enough from the floodgates on the Highland Lake dams to prevent widespread flooding and catastrophic damage.

So why do we build homes and put our lives and our precious possessions in areas where it is not a matter of *if* it will flood, but *when?* According to archeologists, the river valleys of the Colorado River have always been desirable places to live. Since Clovis times (13,500 years ago, or about 11,500 B.C.) the natural concentration of resources drew people: permanent springs; spring-fed rivers and streams with an abundance of fish, turtles, and other aquatic animals; fertile river terraces with overhangs in the high bluffs for shelter; forested valleys with concentrations of desirable plants and animals; and high-

quality flint (chert) for tool-making. The natural resources that drew prehistoric people to the area also drew early Hispanic and Anglo settlers. But early settlers had enough respect for the river's seasonal floods to build homes set back from the river's edge and out of the floodplains. Since the construction of the Highland Lakes, our response as a society has not been to build our homes and businesses on safe ground away from the floodplains, but to attempt to control the rivers and streams. We throw up dams, channels, and diversions and reinforce riverbanks with rocks, steel, and concrete.

Marble Falls to Lake Travis

Just above the town of Marble Falls, the recently reinforced Alvin Wirtz Dam squats on solid pink Town Mountain granite, the same granite quarried and used to build the state capitol building in Austin. Below the concrete wall, the river slips from the unyielding Precambrian granites to cut into layers of limestone and sandstones deposited under shallow seas over 200 million years ago. I look at a photo taken of the river overlooking the town of Marble Falls long before the dams were built. In the grainy black and white panorama, a natural lake pools behind the first set of falls. The river thinly glitters on the broad stair-step shelves of limestone so hard and dense that early travelers mistook it for marble. From the town, the river drops over 20 feet through a series of three falls.

How many people consider what was here before the Highland Lakes covered the river channel with a bland, smooth blanket of water? If they are like me, they believed the portrayal of the Hill Country as a harsh and infertile land. But what of the miles of limestone canyons bordered by cypress, cottonwoods, and pecans that the Spanish explorers described and about which early settlers gloated? "I have found a land of flitter trees and honey," Hugh Clark wrote to his family in Tennessee in the early 1870s. "Come to Texas" (Thompson, *The Valley*). What of the beauty of those river corridors with the fluid notes of a canyon wren cascading down limestone bluffs to a cool, clean river that tumbles over natural falls?

There are sections where one can catch a glimpse of what the Colorado River was before the waters closed over the canyons. Spots where, when the lake levels are low, you remember she is still a river beneath her impoundment

attire. The Canyon of the Colorado is one of those rare places. Below Marble Falls, a canyon (reputed to be older than the Grand Canyon) formed when the river cut through massive blocks of limestone. It was here, in 1909, at the second set of Marble Falls, that Charles Alexander started the dam that would nearly bankrupt him. The concrete remnants of the dam lie deep in Lake Marble Falls. From a vantage point on a limestone shelf above Starcke Dam, you can look upstream onto the placid surface of Lake Marble Falls pinned behind the dam's stolid and blocky structure. Though it isn't visible under the waters of the lake, the canyon runs one and a quarter miles, cutting through layers of extremely hard limestone that ring the granites of the Llano Uplift.

Downstream, below Starcke Dam, the canyon is spectacular, with a wild and unexpected beauty. The multiple thin, braided channels of river glisten in the shadow of the sheer limestone walls as they move around boulders and geologic debris from eons of river sculpting and erosion. The 300-foot cliffs are draped with hardy plants that set seed in narrow crevices and survive: cactus, prickly pear, mountain laurel, wildflowers, and grasses. High on the canyon walls, dusty sticks and twigs are jammed into cracks and fissures—not-so-subtle reminders of the physics of fast-moving water trapped in a confined space. Walter Richter, a local resident, recounts what he saw in the canyon during the flood of 1935:

> I just happened to be down on the river on our ranch when the flood-waters started bursting through the high-walled canyon and immediately to the west. The waves were huge, and within minutes they covered the field/pasture which normally is some 20 feet above the water level.
>
> I ran home, telephoned my classmate/neighbor Arthur Schroeter, and urged him to come over quickly so we could climb up the bluff west of us and watch the phenomenon. He did, and we did. Our vantage point put us immediately above the raging waters and permitted us to observe how, as it escaped the canyon, it spread widely bank to bank, covering roughly a half-mile of what was normally pasture.
>
> Particularly spectacular was witnessing what the floodwaters did to about thirty huge pecan trees which lined the normal riverbank eastward. From our great vantage point, we saw the powerful, ever-rising force of water as it escaped the canyon and smashed into the trees. Each of them would shudder and tremble and then, one by one, they were uprooted,

and we watched them go tumbling downriver. Only a few were spared, they being to the right of the bluff, just beyond the main thrust of the flood (Thompson, *The Valley*).

Those pecan trees still stand sentry around Bluebonnet Hole below the mouth of the canyon. The land is open—gently rolling. The placid surface of the deep basin gives no hint of the depths or of the currents swirling around boulders and debris far below. Before the river cut the canyon, a waterfall poured off the edge of the massive block of limestone, cutting the 125-foot-deep teacup-shaped hole at its foot. The river stretches downstream in thin braided channels of water shining blue and green over gold sands and tawny gravel bars. Officially, it is the head of Lake Travis but with the current low lake levels, it is a river.

Lynda and Harris Kaffie were looking for a small piece of land when they found Las Animas Ranch. It was thick with brush. Malnourished white-tailed deer crowded the thickets, and feral hogs ran unchecked and destructively rooted up the land. Trash was piled by the river where debris had flushed over Starcke Dam and heaped next to Bluebonnet Hole. Four-wheel drive vehicles had gouged deep tire ruts in the riverbanks and gravel bars.

The Kaffies have encouraged the native grasses and plants to grow in a thick strip along the river. In cooperation with the federal Natural Resources Conservation Service (NRCS) and the LCRA's Creekside Conservation Program (CCP), they have cleared 100 acres of bottomland terrace, leaving a few mesquites and other trees for wildlife. They believe that there is a viable seed bank in the alluvial soil, and, with a little encouragement, a native prairie will redevelop. Thick stands of wild rye beneath the pecan trees bear witness to their faith in the land.

The programs have also helped the Kaffies thin and clear cedar from the rocky uplands. Native grasses have vigorously rebounded and are busily rebuilding the soil on the rock slopes. Harris Kaffie pauses when I ask if he is going to run cattle on the ranch. "This land," he says, "is susceptible to overgrazing. While there are many good Hill Country ranches that run cattle and keep the range healthy, it is easy to stress the land. A drought, a few too many cattle—it just doesn't take much to devastate the land, and it doesn't recover quickly." That being said, he isn't averse to using cattle as a management tool to maintain the open areas, but he'd prefer to use fire to recreate the historical

balance between grasslands, brush, and timber. From the crest of the ridge overlooking the river, he points out the thickets of brush and cedar on the steep hillsides preserved for wildlife.

The CCP is the 1990s version of the LCRA's first soil conservation program. Few people realize that the Texas Legislature established the LCRA under Article 16, Section 59 of the Texas Constitution as a Reclamation and Conservation District with the purpose of conserving and developing natural resources. Some would argue that the use of Article 16 of the Texas Constitution was only for the sake of expediency and that the authors of the enabling legislation were using what tools were available to create an electric utility company. Lyndon B. Johnson did not think so. A letter he wrote to

Head of Lake Travis

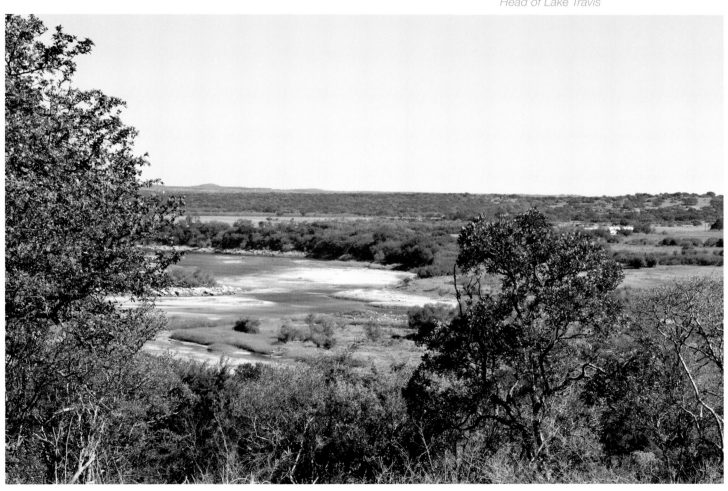

the LCRA's board of directors around 1947 says: "Other reclamation districts were given power to tax—the LCRA was denied that power. It [the LCRA] was given one source of income; the sale of hydroelectric power, not at a profit, but at rates which would enable the Authority to 'fulfill its obligations': Flood control, forestation and the prevention of soil erosion."

LBJ envisioned the LCRA as a major force in reclamation and conservation. In the letter, he succinctly pronounces, "Soil conservation in the Hill Country involves the problem of ridding the hills of cedar and replacing it with cover grass." He laments that, "year after year, the soil has washed into the streams and settled into the riverbed." In 1948, after the public prompting from LBJ, the LCRA adopted a soil conservation program called the Farm and Ranch Improvement Program. For years the LCRA had example farms throughout the river basin (often supplied with free electricity) demonstrating the new farming and soil conservation methods encouraged by the U.S. Government Soil Erosion Service (now the NRCS). In addition to controlling water where it falls on the land, the other goals as described by then General Manager Max Starcke were, "to develop proper utilization of this water for the production of vegetation, to prevent erosion of the soil and to trap and store the balance of the water which runs off the land so that it might be utilized for the domestic, agricultural and industrial needs of the people of the area." LBJ emphasized that erosion has a double economic loss for the LCRA. First, he says, the loss of the valuable topsoil; second, every acre-foot of silt destroys an acre-foot of water storage in the lakes paid for by public dollars.

The CCP's work surprises folks that only identify the LCRA with dams, lakes, and power lines. Although it is a small department in the LCRA's enormous bureaucracy, their team of enthusiastic and devoted employees devises and implements plans for, among other things, restoring much-needed native grasslands, creating wildlife habitat, stabilizing slopes, reestablishing riparian buffers along waterways, and generally helping farmers, ranchers, and other landowners manage their land to conserve soil and water. While the work focuses on preventing soil erosion and protecting water quality, the benefits to the river as an ecosystem and the habitats of riverside creatures are profoundly positive.

For landowners like the Kaffies, the program is a winning combination. The work on their ranch has resulted in increased diversity of native grasses, herbs, trees, and shrubs which in turn are preventing erosion and rebuilding

topsoil, and nourishing the wildlife—from microbes all the way up to white-tailed deer and fishermen.

While we have been touring the ranch, the LCRA has begun releasing water from Starcke Dam. The river transforms into a shining curtain that draws over the myriad braided channels that traced the riverbed. The voice of the river, like the high-pitched voices of children at play, echoes through the canyon. The chattering of gravels and current as they collide reverberates against the stone walls as we walk toward the dam. We clamber over chunks of limestone and granite smoothed by the river. Slabs of aqua-colored fiberglass are pinned beneath Volkswagen-sized boulders.

In July 2007—when a rain bomb exploded over the city of Marble Falls and dropped 19 inches of rain in six hours—the river overflowed the dam, and the rocks below chewed up lumber, boats, docks, and trash before spewing it out into the 125-foot-deep Bluebonnet Hole. Harris laughs and tells me, "Who knows what is in the bottom of Bluebonnet Hole!" He guesses a car or two, refrigerators, stoves, washing machines, and a glut of tires. The Kaffies wanted to leave the fishing hole open to the people who'd been fishing there all their lives, but a few inconsiderate folk dumping trash and vandalizing the area forced the Kaffies to rethink their community offer. "It's a shame," he told me, "for so few people to get to enjoy this place, but we can't risk leaving it open anymore."

The river swirls through Bluebonnet Hole, then stretches out in the afternoon light, languid as a cat, along the tawny shoals and gravel bars. I recall a description by Georgina Earnest Klopple in a local history collection, *The Valley between the Colorado and the Pedernales.* She wrote about growing up on the banks of the river near Hamilton Creek: "I should call this section 'River Beloved,' because I loved that river, that Colorado River. I loved it because of its warm, natural feel. I loved it because of its wild river smell of willow and water weeds. It seemed to wash away my sins just to look at it."

I couldn't agree more.

Lake Travis and Mansfield Dam

For one summer, long ago, Lake Travis was a refuge for me, and its waters were a benediction and a blessing. I had just returned to Texas from a state with

wild whitewater rivers and tumbling streams to find the Colorado River below Austin smelly and uninhabitable. A friend convinced me that I could satisfy my aquatic needs by weekly pilgrimages to the lake. For several months, I built my Sundays around a fat newspaper, a bag of buttery pastries, and a large thermos of coffee. All were consumed slowly and with surfeit of contentment on a limestone ledge next to the cool waters of the lake. Occasional plunges into the water made the heat bearable, even pleasurable. I remember surfacing and watching saffron light play over the stair-step limestone walls, the water and sky the saturated blues and greens of a Maxfield Parrish painting. Lulled into tranquility by the drenched light, I even abandoned my irrational fears of deep water that I had developed growing up in Louisiana. For short periods, I did not worry about the imaginary creatures—alligators and giant catfish— lurking in the deep, waiting to snag an ankle. It was idyllic until heat, crowds, and the noise of powerboats chased me back to Austin.

I think of those long-ago mornings as Bill and I wait in line at the only boat ramp still open on Lake Travis. Even on a weekday morning there is a line of trucks, trailers, and boats. It takes me a moment to realize that about half of the trailers are there to haul boats away to another lake or into storage. With a record-breaking drought hanging around like an unwanted relative who won't take a hint, the lake's shores are lengthening every day.

We Texans know about drought; we scoff and kick our collective boot heels. This is Texas, and we take a perverse pride in our extremes of weather and terrain. Annual rainfall averages 51 inches on the east border of the state and drops in a steady attrition to the western extreme, where average yearly rainfall is no more than 10 inches. Here in Central Texas, we are supposed to average around 32 inches every year, but the drought of 2007–2009 rivaled the all-time record drought of the 1950s. The paltry 12 to 15 inches of rain in 2008 made it one of the driest years since the advent of weather record keeping in the mid-1800s.[6]

We launch our little jon boat next to Mansfield Dam. The receding water has left a pale stain on the dam's concrete face that matches the blinding white ribbon of exposed limestone snaking along the shores. The steep shores that once were hilltops gleam bone-white and bare in the morning glare. We circle under the monumental dam. It seems imperturbable, enduring, and ancient— an artifice of nature, not an artifact built by man. The Sometimes Islands hump up, out of the lake. Boat docks cant sideways, awkward and stranded on

rediscovered hillsides. Marinas huddle in the bottom of coves, the boats drawing closer together as the water diminishes. Massive tree stumps have emerged from the lakebed, reminders of the cypress and cottonwoods that collected along the vanished river. While others lament the shrinking lake, I am secretly thrilled to see the bones of the original river channel emerge. I feel a sudden affinity for the small coves with herons, for the grandeur of the dam restraining the green waters, and the long, curving loops of the lake—until a recklessly driven powerboat and water-skier cuts around us. They wave and smile but send our small boat wallowing through their wake and nearly swamp us. With the lake condensed, the boats are forced into tight paths that leave little room for small boats that putter along. I vacillate between glaring hatefully at the powerboats and lusting after their speed, grace, and self-generated breeze. If we were in such a boat, we could zip up to the confluence of the Pedernales River and see where the two rivers join. Property owners on the Pedernales arm of the lake (like lakeside residents on the Llano River section of Lake LBJ) contend with floods rushing past their property to dump an entire river basin's worth of rain into the main lake. With the drought, boat docks are high and dry, and the Pedernales rests in its channel at the bottom of a steep ravine.

There are people who believe Lake Travis should be a constant-level lake, a static fixture instead of a link in a complex system that balances water supply, recreational use, agricultural use, power plant demands, the environment, and flood control. Lakeside property owners and boat owners write heated comments in response to measured articles about water use in the newspapers. The worst of it is the attitude: "To hell with the people downstream, I want my lake full!" Things are getting ugly and the name-calling is getting worse— the fights over the river water developed long before the dams impounded the lakes, why should they stop now?

While some are clearly concerned with keeping the level of Lake Travis full for recreational purposes (and its economic importance), others worry about there being enough water for everyone and everything that depends on the river: the cities, towns, farmers, ranchers, power plants, industry, fish, animals, estuaries, and bays.

Many downstream residents, including the city of Austin, are deeply alarmed by the LCRA's seemingly uninhibited rush to supply water (along with wastewater facilities and electricity) to myriad developments in areas that would not support a housing boom without the LCRA's intervention. The

LCRA's interpretation of their legislative mandate as a requirement to sell their water (they hold rights to the majority of the water in the lower Colorado River Basin) to just about anyone that asks—including housing developments, nuclear power plants, and coal-fired power plants—has more than a few people worried. With the population of Central Texas booming and predictions that the population will more than double in the next fifty years, there are genuine concerns about whether there will be enough water.

LCRA Water Manager Jim Kowis is, however, unperturbed. A genial Texan chock-full of loquacious charm with a long career in water supply planning, he is confident that the gift of the reservoirs and the LCRA's planning will supply enough water for the future. "But," he adds, "There are two things. One is a quote by Eisenhower that says a plan is worth nothing but the planning is worth everything. The other is that I know that in 2100, people are going to look back and say, 'What the hell were they thinking?' I can tell you we used the best information available. Will the figures be wrong? Yes. Will they be in the ballpark? Yes, they will."

The water planning he references are the projections the LCRA and the Texas Water Development Board (TWDB) have worked out regarding future demands and available water. The crystal ball they use is called a WAM (water availability model), a computer-based simulation predicting the amount of water that would be in a river or stream under a specified set of conditions. As preparation, they use stream flow data from the 1950s drought as the benchmark for determining how much water there would be in another serious meteorological drought. The TWDB then issues permits for the predicted available water—unless they have already assigned permits and water rights for all the water. The Colorado River, among other rivers, is over-appropriated: the permits issued exceed the actual water supply. The LCRA holds the majority of permits (over 2.1 million acre-feet of water per year) in the Colorado. But they are drawing criticism for implementing an overdraft policy.[7] Much like an airline overbooking a flight, the LCRA depends on their customers to use less water than they have purchased. A few quiet voices have mentioned that evidence (tree rings and soil cores) proves that there have been localized droughts so long and hard they make the parched 1950s look downright soggy. Kowis acknowledges the evidence, but tells me that so far no one has been able to extrapolate the results of the studies for the entire river basin. Until there is sufficient data to prove otherwise, water planners will continue to use the

drought of the 1950s as the worst case scenario when apportioning our future water supplies. Meanwhile, they will tinker with the data, trust that the river won't dry up, and hope that the climate change predictions are wrong about rising air and water temperatures, increased evaporation, and the less frequent but more intense rainstorms that could result in floods. And test our dams.

Mansfield Dam, which creates Lake Travis, is the only flood-control structure in the string of lakes and dams along the Colorado. But, it didn't start that way; the original plans for Marshall Ford Dam (later named after Joseph J. Mansfield, congressional representative from Columbus and chairman of the House Rivers and Harbors Committee) were for a low, 190-foot dam. Although it was evident to many that it would take a much taller dam to control flooding on the Colorado, Buchanan initially solicited funding for the low dam. He insisted that the Bureau of Reclamation engineers copy the design for the Grand Coulee Dam in Washington State: a straight gravity-type dam built in two stages, a first low dam and then a larger dam built around the existing dam, creating a dam-within-a dam that would top out at 278 feet. The LCRA had the funding from the Bureau of Reclamation for the low dam, but it was on the books as flood control. The Bureau insisted that any additional height would be for power generation; by law, they could not pay for it.

The LCRA was out of money. They had used up all their borrowing power and had promised every cent of revenue from electricity generated by Buchanan and Inks Dams to pay interest and repay loans. Then, in 1938, floods slammed the basin from above the just-filled Lake Buchanan all the way through Austin and downstream to the Gulf, clearly demonstrating that Buchanan Dam alone was insufficient to control floods.

The public was enraged and levied charges that the LCRA had failed to plan for the flood and neglected to release impounded water from Lake Buchanan in time to protect the communities downstream. Federal and state investigations were launched.[7] After hours of hearings, the state senate ruled the LCRA was negligent in its operations of Buchanan Dam and Reservoir. Three actions followed. The first was that Alvin Wirtz, representing the LCRA, publicly testified that LCRA's goals were first and foremost flood control with power production, irrigation, and other purposes following. Second, the extensive flood damages gave the LCRA the leverage needed to pry necessary funds out of the government's pockets. Third, Alvin Wirtz and a brilliant PWA lawyer relabeled the dam so that the low dam was on the books

as power production, the top 45 feet was designated as flood control, and the 33 feet between covered both. Then they juggled federal grants and loans to fund the project. Construction proceeded with the dam designated for both flood control (jointly managed with the U.S. Army Corp of Engineers) and hydroelectric generation.

The designers of Mansfield Dam intended it—and Lake Travis—to withstand a flood as severe as the monumental floods of the 1930s. While there have been floods aplenty, nothing on the scale of the catastrophic 1935, 1936, and 1938 floods have put the structures to the test. The law of averages and hydrological data suggest such a flood is inevitable. The LCRA has been strengthening their dams in preparation, and a recent LCRA press release announced the successful completion of what they titled "a 'Katrina'-like flood scenario." For the drill, they replicated, via computers, a 1930s-style flood. In the enactment, water surges 40 feet above full elevation and overwhelms houses along the shores of Lake Travis. Massive flood runoff pushes over the top of the Mansfield Dam spillway. To protect the dam from failure, the LCRA follows the U.S. Army Corps of Engineers regulations and opens all of the floodgates. (The irony that the failures of the U.S. Army Corps of Engineers' levies and pumps caused the majority of damages in the Katrina disaster seems to have escaped the LCRA.) Downstream, Lake Austin and Lady Bird Lake overflow, flooding homes and businesses along the shores. Water pushes into downtown Austin, and shuts down or submerges the bridges across Lady Bird Lake. Below Longhorn Dam, East Austin disappears under a simulated blue that reaches all the way down to the Gulf of Mexico.

The LCRA's dams could minimize a catastrophic flood like the floods of the 1930s, but only if there is room in Lake Travis to catch the floodwaters. In the midst of a record drought, a 15-inch rain in 1952 flushed so much water, dirt, and debris into the river basin that Lake Travis rose an astonishing 57 feet in fourteen hours.

Jim Kowis summed up the situation, "You can't catch water in a full bucket."

Lake Austin and Lady Bird Lake

Below Mansfield Dam, I stand on a low-water crossing looking through the legs of the RR 620 bridge at a mountain of concrete that soars more than twenty-seven stories overhead. Water churns white and frothy from the power-house, creating a gentle current that causes the aquatic plants to sway in the crystalline water below the low bridge. To my right, a young girl paddles in the shallows while her parents lounge, reading beneath shady trees. The foliage billows in a rippling corridor along the lakeshore. A group of workmen, their clothes gray with dust, stand in the water, pants rolled up. One lean young man tosses out a hand line. His buddies supply a running commentary in English and Spanish. Their good-natured banter mingles with the river's gur-gling, the sharp pebbles of cardinals' calls, the liquid song of a mockingbird; it's a soundscape of July in Travis County, underscored by the buzzing rasp of a wren and the highway overhead.

Northern Cardinal

The sweet-voiced water emerges from the bottom of Lake Travis very cold and low in dissolved oxygen; before the LCRA installed aerators in the dam to whisk oxygen back into the inert water, insects, fish, and invertebrates in upper Lake Austin suffocated in the clear, icy water. In the stunning heat, the water is so inviting that I sit down on the edge of the bridge and dip my feet into the running water. It is shockingly cold; I find myself sitting with my brains and butt scorched by sun and concrete while goose bumps pepper my arms and legs. I am afraid my nervous system is going to short out from the conflicting information.

The sheer size of Mansfield demands respect and instills a sense of awe in me—but not in everyone. In the 1950s and 60s, daredevils invented a sport called "dam sliding." Small leaks in the concrete of the dam's flood outlets nourished thick coats of slick green algae. The adventurous few would climb up the dam's face to the outlets and then recklessly slide down the chutes before sailing out into space and plunging into the cold pool below the dam. Long ago, grout sealed the leaks and security was tightened. Now, LCRA employees and U.S. Army Corps of Engineers are the only people allowed on top of any of the Highland Lake dams or in the areas immediately below the structures.

Lake Austin backs up from Tom Miller Dam, built on the site of two ill-fated earlier attempts to dam the Colorado River by the city of Austin. When

the LCRA and the city of Austin finally wrangled an agreement to rebuild the dam and impound Lake Austin, the city claimed everything along the shores as city territory.[9] From Mansfield Dam down through the heart of the city and east, to below the dams and almost to the Travis County line, the city of Austin has jurisdiction over the shores of the lakes and the banks of the river.

Lake Austin, like Lady Bird Lake (formerly known as Town Lake) is riverine in appearance but not in character. Another of the "pass-through" lakes, the water level is remarkably constant regardless of drought. Development grew from the west side of Austin along the shores of the lake; now, housing tracts, roads, and lots infiltrate the limestone hills and creek valleys like the meandering track of a giant centipede, slowly overtaking the Hill Country. LCRA's Creekside Conservation Program Director Rusty Ray told me that when he flies over the lakes, just about the only undeveloped land left abutting the lakes is the LCRA parks and the lands held in the Balcones Canyonlands Preserves.

In 1987, the U.S. Fish and Wildlife Service (USFWS) listed the black-capped vireo, a migratory songbird, as endangered under the Endangered Species Act[9]; a year later, six invertebrates that inhabit the honeycombed karst limestone caves of the Edwards Plateau were emergency listed as endangered. Two years later, in 1990, another neotropical migratory songbird, the endemic golden-cheeked warbler, was added to the list. Cited in the petition to list the golden-cheeked warbler were threats from habitat loss and fragmentation due to urban encroachment, the clearing of Ashe juniper, and increasing problems with the nest-parasitizing brown-headed cowbird. Some property owners were enraged at the possibility of having endangered species in the area, much less on their valuable Hill Country land. The prospect of the federal government dictating what ranchers and developers could and couldn't do on their property prompted a rush of bulldozing as some landowners cleared cedar thickets in hopes of keeping the Feds at bay. Everyone ignored the fact that it was federal dollars and loans that created the lakes and highways that encouraged the urbanization in the first place. The proposed plan to set aside wildlands as preserves for the endangered species was in the eyes of many, outrageous—and

a misuse of public funds. As a rancher told me, in squinty-eyed frustration, "People and their needs should always come FIRST, before snakes, birds, and bugs." He walloped the table with his fist, and I threw my notebook and pen over my head in alarm.

The definition of *need* is what causes such strife. While some needs are obvious and easy to justify (safe roads, affordable food, et cetera) other needs are diffuse and difficult to define. I need wild places as refuges for spiritual regeneration and for learning about the natural world and exploring the intricate web of life. Indeed, the only thing that alleviates my gut-churning distress at the sight of another ranch shattered into one more subdivision is the phenomenal Balcones Canyonlands Preserves (BCP) system. Formed in 1996 by the city of Austin, Travis County, the LCRA, The Nature Conservancy, the Travis Audubon Society, and private landowners, it is a preserve system of approximately 28,000 acres of land in western Travis County designed to protect the eight endangered species found in the Hill Country and nowhere else in the world. The Balcones Canyonlands Conservation Plan (BCCP) is the habitat conservation plan that established the preserve system and determined funding and organization. U.S. Fish and Wildlife Service rules provide protection for endangered species habitat while still allowing land development to occur in western Travis County. While some would say that there isn't enough land preserved, others insist that too much is set aside for those pesky birds and creepy cave bugs. Here is how it works: a development corporation buys a 750-acre ranch that fronts onto Lake Travis or Lake Austin. Because the ranch contains golden-cheeked warbler habitat (or other listed species), the USFWS determines how many acres and what sites will be set aside for the warbler and where building can proceed. Presto, the developer has just increased the exclusivity of the project and added a valuable amenity—nature trails and a private nature preserve—while preserving habitat for the warbler. Some projects involve trade-offs of land, or mitigation banks: a block of land is set aside as a preserve that allows another tract to be developed. While the name "mitigation bank" is dry, the resulting large blocks of land are a boon to the plan. Not only do the preserves protect habitat, they protect watersheds, and, in the increasingly urbanized land west of Austin, they are refuges for rare enclaves of undisturbed native plants and wildlife. In a few short years, they may be the only undeveloped areas in much of the Colorado River Basin upstream of Austin.

There is one working ranch left on Lake Austin. Surrounded on three sides by city of Austin BCP lands, the Horseshoe Bend Ranch overlooks the lake just downstream of Mansfield Dam and the low-water crossing. Pam Murfin and her husband, Don Gardner, a respected arborist, raise angora and pygora goats and have recently switched the land from an agricultural designation to a wildlife exemption. From their home overlooking Horseshoe Bend, we look out over a landscape that has drastically changed in the last decades. Don and Pam tell me that as recently as the 1970s, when you looked out over the Hill Country landscape, it had a grayish-white cast from all the exposed limestone and gravel on the slopes. At that time, the ranchers were selling off cattle and land. Don, in contradiction to the prevailing view, does not regard cedars (Ashe juniper) as the villain of the Hill Country. He sees the trees as a pioneer species that came in to reclaim the land. "Nothing else," he says, "could take root in the nonexistent or thin soils of the overgrazed and eroded cattle ranches." He continues, "It's true that a cedar brake inhibits the growth of grasses—as would any dense thicket of brush or trees—but thinned cedars (either through natural competition or mechanical means) shade the ground, reduce erosion, and improve the soil. The annual needle cast builds a layer of mulch that retains moisture and encourages the development of humus, the rich topsoil dense with microbes and nutrients that is the foundation of a healthy ecosystem." I imagine a cedar shaking like a dog to shed old needles. "Heretic!" I reply. Don laughs and points out ridges on the ranch that have naturally transitioned in the last forty years from colonies of cedar into oak groves with surprising diversity. In his opinion, cedar colonization of the Hill Country is only one point in a cycle of natural forest succession. The dense infestations of mesquite, cedar, and other brush are symptoms of an ecosystem out of balance and are part of the system's regaining equilibrium. Allowed time, Don says, the cedar thickets would follow a natural succession that could end up with an extraordinary diversity of habitats including hardwood forests, savannahs, and prairies. These days, forced change on habitat is so rapid that nothing has time to adapt, including the biologists and managers trying to preserve wildlands. In order to protect habitat for the survival of animals, plants, and creatures deemed worthy of saving, we spend time and money trying to recreate what may be idealized interpretations of the past.

There is a pervasive idea that the Hill Country is a rough frontier—a hardscrabble land that requires fortitude and perseverance for basic survival; it

is land that demands taming, subduing, and managing. Along with that idea goes the belief that cedar is the enemy; we are in competition for the water it hogs. Yet what other plants could have successfully pioneered the desolate slopes and held the remaining topsoil on the stair-step hills? After the unintentional exploitation by the ranchers and farmers left the land devastated, I believe we were fortunate to have a plant that rendered triage, prevented the creation of deeply eroded badlands, and held the Hill Country in place.

Even with the buffer of the BCP lands around the ranch, it is a daily fight for Pam and Don to keep the river and the creek that runs through their ranch clean. Year after year of developers' bulldozers scalping the terrain along RR 620 to the west of the ranch has degraded Honey Creek. Formerly a pristine creek with limestone caves and grottos, it now runs chalky after a rain, because of all the soil washed down from the developments. White plumes of sediment flow into the lake and fill in the coves. Now Pam and Don believe someone is emptying retention ponds—created to keep sediment out of waterways—into the creek. Pam sighs and tells me that she has the city of Austin watershed hotline number memorized. The lake she grew up on has changed drastically in her lifetime, especially in the last ten years.

From their porch, we look over the wide curve of Horseshoe Bend. Multimillion dollar homes squat in expanses of green lawns on the opposite bank. I see few signs of habitation other than the gardeners and technicians attending to the lawns and pools. The majority of the development has been in the last ten years, and the largest homes built (over 10,000 square feet) in the Austin area are clustered around Lake Austin. On weekends, Don and Pam's home reverberates with the whine of personal watercraft and motorboats and the pounding bass of the stereo systems that are suddenly popular on boats. I'm amazed they haven't sold out and moved away, and I tell them so. Despite the encroachment by development and dramatic changes in land use, Pam and Don are, remarkably, optimists passionate about protecting the ranch and its heritage for their children. As I watch them describe their ideas for a "human-powered" boat race and parade on the lake—for a few hours no motors would be allowed—I'm filled with admiration. How do you do it? I want to ask. How do you stay optimistic and avoid giving into despair? Watching the two of them, the thought comes to me; if all you think of is defeat and failure, how can you recognize success—however large or small—when it appears? If I focus on what is lost, grief and anger could blind me to what still remains.

On an early July morning, Bill and I coast along the shores of Lake Austin in our little jon boat. Land on the lake is at such a premium that people have taken to creating it—home sites appear out of a sandy bank at the base of a bluff by virtue of steel plates and fill dirt. I gawk like a country rube, amazed by the size and opulence of some of the houses. A number of newer homes have adjoined boathouses so owners can walk from couch to boat without ever stepping outside. Older homes are crammed cheek to jowl with the new mansions, reminders that Lake Austin was the first of the lakes to attract home-buyers to its shores.

In 1893 when the Great Granite Dam was finished, there were no cars, and women dressed in long skirts. Not only was the construction of the dam a monumental engineering achievement, but, for a time, hydroelectric generators powered electric streetcars that carried passengers around the city, electric pumps that delivered water throughout the young city, and the arc lamps of the 150-foot Moonlight Towers that illuminated the night streets with a violet glow. Austin was the city with the Violet Crown. A spur rail line carted tourists out to Lake McDonald, the spot for recreation. *Ben Hur,* a triple-decked side-wheeled steamer and the small double-decked *Chautauqua* plied the water on moonlight cruises and sightseeing trips showing off Mount Bonnell and the springs along the lakeshore.

Unfortunately, the engineers had seriously overestimated the minimum flow of the river, underestimated evaporative loss, and failed to anticipate that over a third of the reservoir would fill with soil washed downstream in the first four years. Then there was a drought. The electricity was shut off. Wealthier citizens hired private utility companies to set up generators to pump water to their homes and businesses. Then there was a flood. A big flood.

It seems that the designers and builders did not understand that the geological features that made the site seem like a logical choice also placed the Great Granite Dam smack on top of a geologic fault zone. Austin Dam (and present Tom Miller Dam) sat where the Colorado River plunges out of the Edwards Plateau down the Balcones Escarpment. The balcony-like limestone escarpment, including Mount Bonnell, rises up on the west side of the city

along a line that runs northeast and southwest. Balcones Fault[11] is actually a collection of faults, or bedrock fractures—a 2-mile-wide strip of jumbled and crushed limestone that lies at the base of the uplift. However, with solid tiers of limestone underpinning the area, the dam site looked stable.

During the construction of the first two dams, the crews kept discovering what they believed were "leaks in the riverbed." Water kept appearing and disappearing in unwanted places. In 1915, one intrepid engineer, determined to find the source, filled a hole in the riverbed with laundry bluing and peppermint oil and then ordered workers to stand downstream of the dam sniffing and looking for blue water. The workers never saw blue water or smelled peppermint oil because the weight of the granite structure was altering the dynamics of the limestone in the fault zone. As the rocks shifted and settled under the rising dam, fissures opened in the limestone of the riverbed so that water drained through the porous rock, and springs erupted through the multiple faults. The engineers rebuilt sections, shored up others, and filled holes in the riverbed with sacks of clay.

On April 7, 1900, the soft limestone beneath the dam eroded under the pressure of floodwater and the weight of tons of silt. Whole sections of the dam slipped off the foundations, ending an era of prosperity. The wave of muddy water rushed downstream. Luckily, someone had the wits to telegraph the towns downstream and warn them about the wave of water coming their way.

The city contracted to rebuild the dam, but the new dam had poorly designed floodgates along the top of the structure. Because the gates were responsible for holding back half of the lake's volume and all of the water needed for electrical generation, it was a serious flaw. Flood debris destroyed the leaking gates in 1915. It wasn't until the LCRA was formed and the federal dollars were flowing that Austin had a chance to rebuild over the remnants of the second dam project—which wasn't until 1938. Protracted arguments finally resulted in the LCRA agreeing to build the dam with their PWA funds when the city contracted to lease the dam and its generating power to the agency (the LCRA currently has a lease for the dam until 2020). Construction crews dug deep into the soft limestone to pour footers to prevent the undermining that destroyed the first dam. Tom Miller Dam (named after the mayor at the time) entombed the remnants of the original granite dams in concrete. Today, pink granite blocks, the rumored remnants of the Austin Dam, shore up Red Bud Isle at the foot of Miller Dam.

As thrilled as the citizens of Austin were to have the Highland Lakes, the "string of pearls" supplying water (the city still pulls its water from Lake Austin) and recreation upstream, the river in the city's heart languished. The capricious weather patterns of the 1930s faded into a long period of quiet, and then drought, and the dams upstream controlled the river; yet city residents still regarded the river with distrust.

Although the city acquired Zilker Park and Barton Springs in 1918 and created its recreation division in 1928 to oversee the steadily expanding list of parks, the Colorado River from below Miller Dam downstream through the city was a no-man's-land. Adding to the historical distrust of the erratic river was the industrial development of the area. Gravel quarries (now the *Austin American Statesmen* headquarters), clay pits (first used as a dump and then filled to become Butler Park), brick kilns (Austin High School), cement plants (corner of Lamar Boulevard and Cesar Chavez Street), and chemical plants lined the river banks in the downtown area. The river was not the inviting place it is today, with its surrounding greenbelt, parks, and hiking trails.

The city not only neglected the river but also, like the rest of the nation, regarded the local creeks, streams, and rivers as natural extensions of their wastewater system. Sewage lines ran along creekbeds, and water from storm drains, raw sewage, and industrial waste was dumped directly in the river in the heart of town. Even today, in Austin's progressive era, the city's stormwater drains empty directly into Waller and Shoal Creeks, carrying all sorts of goodies into the river: dog feces, human feces, fertilizers and pesticides from homes and landscaping, oil from the streets, plastic water bottles, the ubiquitous plastic shopping bags, and miscellaneous refuse.

Not surprisingly, the river (and later Town Lake) developed a reputation as a cesspool. Meanwhile, citizens and tourists flocked to Barton Springs, Deep Eddy, and the other spring-fed pools the city offered.

The land around Town Lake was a combination of garbage dump and wild space surrounded by industry. In 1960, the city completed the Longhorn Dam at the old Longhorn Crossing site downstream and impounded Town Lake[12] to provide cooling water for the Holly Street Power Plant. Yet the city's indifferent attitude toward the river did not change. In January of 1961, the city's storm sewer system was flushed out with millions of gallons of water under high pressure to clean out the accumulated debris in the pipes and drains. The flushing resulted in a toxic stream of poisons emptying

Carp & Cabomba

into the lake. As Rachel Carson reported in *Silent Spring,* on the morning of January 15, people reported dead fish in Town Lake and below Longhorn Dam. A wave of poisoned water moved downstream—from Austin to the Gulf of Mexico—the lethal mix decimating the rivers' fish and other inhabitants. Rachel Carson estimated that for 140 miles downstream, the toxins killed all the fish, resulting in a thousand pounds of dead fish per mile of riverbank. The locks in the Intracoastal Waterway diverted the poisonous waters directly into the Gulf of Mexico—with unknown results. Investigations by the Texas Game and Fish Commission and the Texas Department of Health uncovered the disagreeable news that chemical plants had regularly washed spilled insecticides into the storm sewers where the poisons accumulated in the gravel, dirt, and refuse in the pipes. Forty years later, sediment cores taken from the lakebed contain evidence of the spill and confirm that concentrations of DDT and chlordane linger still in the layers of silt in the bottom of the lake.

The Austin City Council approved a comprehensive master plan for the Town Lake development in 1968, but in 1970 the area around Town Lake was referred to as Austin's backyard basin for refuse. The fecal coliform counts from human and animal wastes were so high that going in the water was a life-threatening prospect. The Town Lake Beautification Project, the city's gift to the nation on the bicentennial, began in 1971 with the enthusiastic leadership of Lady Bird Johnson. The project transformed the treeless shores of the lake into a string of shady parks, playgrounds, and ball fields connected by hike and bike trails. Yet the lake continued to catch the city's urban runoff, sewage spills, and industrial waste.

The parks enticed the public to the lake. Anglers lined the banks to try their luck at catching one of the bass, catfish, or sunfish stocked by the Texas Parks and Wildlife Department. Carp and native fish survived in the polluted lake as well. It wasn't until 1987 that the Austin-Travis County Health Department issued a health advisory warning people not to eat carp, striped bass, or shad taken from Town Lake because of high levels of carcinogenic pesticides in the fish.

Under pressure from environmental and citizen groups and downstream neighbors, in 1985 the city of Austin began renovating and upgrading the wastewater system. Leaking sewage pipes that ran through the urban streambeds were replaced and rerouted. Municipal dollars funded the expansion and updating of the wastewater treatment plants that formerly discharged inadequately treated sewage into the river downstream. When the level of pesticides

in the fish from the lake dropped below dangerous levels in 1999, the Health Department rescinded the fish advisory.

The string of parks and their hike and bike trails surrounding Lady Bird Lake (Town Lake was renamed in 2007) is one of Austin's most beloved features. Every day, thousands of runners, walkers, birdwatchers, paddlers, and bicycle riders use the parks. Strangers salute each other, families with young children feed ducks along the shoreline, and friends gather to exercise and relax along the shaded paths. Today the water in Lake Austin and Lady Bird Lake is surprisingly clean considering its history and the fact that the river runs through the heart of a metropolis, with all the attendant pollution issues. Rains continue to flush pesticides, herbicides, fertilizers, and animal feces from our yards; oil, asphalt sealants, and toxins wash from roads into the watersheds. Pollution from our homes and roads threatens not only the lakes and river, but also all of our streams, including Barton Creek and Barton Springs.

Standing on the dock at the Austin Rowing Center with a couple dozen eight- to twelve-year-old kids who eagerly eye the Texas River School (TRS) canoes, water quality issues are not on my mind (though they should be). Founded by Joe Kendall, the nonprofit Texas River School's[13] mission is taking urban kids (to date, over 4,000 elementary students) out onto the Colorado River and Lady Bird Lake to have fun, learn about the river, and experience nature. The trip leaders instruct the kids on canoe etiquette and paddling technique. We smear each other with copious amounts of sunscreen, and we load into the boats. I'm assigned a middle seat with young paddlers fore and aft. The boat zigzags across the lake with the exuberant and unbalanced paddling of an effusive young girl in the prow and a rather truculent young man in the stern. After a few minutes of bickering, they settle into a rhythm, and I lean back and watch the shore slip past. We paddle up Barton Creek and leave the canoes just below Barton Springs pool. The cold spring-fed water of the creek is exhilarating. The kids tour the Splash Exhibit in the Barton Springs bathhouse and race through faux caverns from exhibit to exhibit. They hit buttons to make lights sparkle on maps; water gurgles through clear tubes as they test

Barton Springs Salamander

the water from different creeks; bells ring as the kids giggle, shriek, and learn about the Edwards Aquifer and the springs. It is like being in a natural science video arcade. The kids love it, and the counselors make multiple runs to herd the group toward the pool.

Barton Springs is the miracle at the heart of the city of Austin. Water flows from the honeycombed limestone sponge of the Edwards Aquifer out through four springs at an average rate of 27 million gallons of chilly 68°F water per day. Water-smoothed limestone ledges and grassy slopes with pecan trees line the three-acre pool. The kids eagerly plunge into the water, then yelp, squeal, and splash in surprise at the coldness. Their infectious joy convinces me to join them as they dive to the natural limestone bottom to nab stones, try on masks and snorkels to look for fish, compete to see who can stay the longest underwater, swim the furthest, stand on their hands, or simply be the best at that moment. I float on my back with the strangely agreeable sensations of intense hot sun warming one side, goose-pimply cold on the other, and the underwater echoes of joyful voices thrumming in my waterlogged ears.

Barton Springs has drawn visitors for untold centuries: Native Americans considered the springs sacred; early settlers rhapsodized about them in letters and journals; and today they are a large part of the city's identity. So much, in fact, that over a third of all Austinites are convinced that their drinking water comes from the Edwards Aquifer and Barton Springs.[14]

While everyone loves Barton Springs Pool and can't imagine Austin without its spring-fed waters, the public battles over the protection of the Barton

Creek watershed and the designation of the Barton Springs salamander as an endangered species have divided the community and angered many.

The Barton Springs salamander is a peculiar creature. Spade-headed, nearly sightless, scrawny, lungless, pale amphibians that flutter their feathery red gills in the open, they have the temerity to show off their internal organs without shame. Found nowhere else in the world, the salamanders have evolved to live in the dark clefts of the springs and the vegetation growing at the bottom of the limestone pool. Regardless of whether you perceive the tiny salamanders as ugly creatures, or, if like me, you admire their otherworldly looks, the salamanders do not have the versatility to survive outside of their niche. A number of actions are being taken to protect the endangered amphibians: the parks department no longer drains the pool and uses bleach or other harsh chemicals to scrub the algae off the rocks; biologists carefully monitor the salamander population; the watershed feeding Barton Creek has building restrictions; tracts of land have been set aside to protect water quality; and the state set up pumping restrictions on the amount of water that can be pumped from the Edwards Aquifer. Will it be enough? Can we have our developments, our springs, and our salamanders too?

The trip leaders corral the kids and herd them back to the canoes. I am thoroughly content to lean back and let the boy and girl paddle the canoe smoothly and with almost no bickering back across the lake. I reflect that my husband and I, despite many years of canoeing, don't work together as well as these two (which is why we now have two kayaks). We disembark, unload, sort gear, and start hauling the canoes to the trailer. The kids should be exhausted from a day of paddling, swimming, and learning, but they are unfazed. I look at the group; they look like a school of brightly colored fish when they cluster around a counselor for a post-paddling treat of cookies. They flash through the green shadows of the trees along the Hike and Bike Trail. Day after tomorrow, I'll join them for a canoe trip from below Longhorn Dam to the TRS's land downstream.

If Lady Bird Lake and the beloved (and crowded) Hike and Bike Trail are the cultural heart of Austin, and if Barton Springs is her most enduring tourist

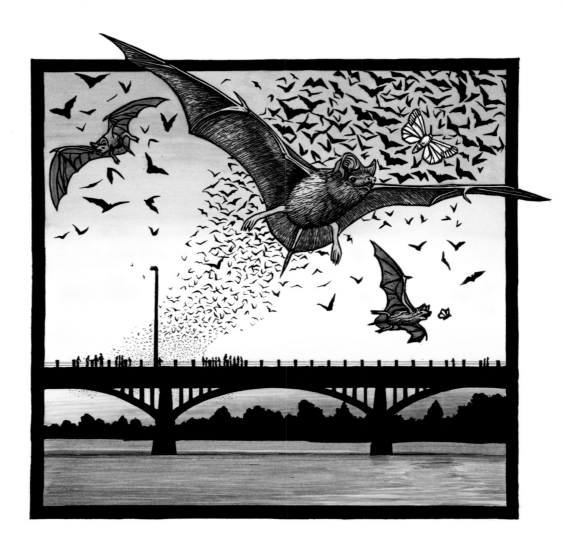

attraction, the Congress Avenue Bridge bat colony cements the city's reputation as quirky. Hosting what is touted as the "World's Largest Urban Bat Colony," the Ann W. Richards Congress Avenue Bridge spans Lady Bird Lake just south of historic downtown. A 1980 reinforcement of the bridge with concrete panels resulted in narrow, deep crevices that turned out to be perfect bat accommodations. On a sticky August evening, I wait with visiting friends Joe and Roz on the grass shoulder of a small park at the foot of the bridge. Sweat drips, vendors sell neon-colored light tubes as if we are at a concert, and we slap mosquitoes. The grass is full of fire ants. A couple behind us argues whether the rich ammonia smell is from the bats or a homeless man sleeping nearby. The sun dips below the horizon, the sky slowly deepens to indigo, and the streetlights turn on. The crowd shifts and waits, peering into the half-light.

I move under the bridge to block the streetlights. Faint against the east sky, I see a smattering of flickering dots. The stream of bats swells until we see hundreds of bats silhouetted against the blue; the soft leathery flap of their wings is barely audible. The cloud of bats shifts and turns following the course of the river downstream. I'm suddenly aware of moisture, a mist-like rain of digested moths, mosquitoes, and other flying insects. I look at the people around me, some wear hats, other stand in slack-jawed amazement watching over a million bats stream away into the night sky.

One and a half million bats consume 10,000 to 30,000 pounds of insects nightly—the math is daunting. The guano that collects in the limestone caves that these Mexican free-tailed bats normally colonize is a terrific nitrogen-rich fertilizer and—in the past—a component for making explosives. So far, the guano dropping into the lake below the roost has not caused problems with water quality. The concentrated nitrogen has not shown up in the water quality monitoring by volunteers, the LCRA, or the state, nor has it resulted in potentially harmful algal blooms. Roz nudges me, asks why I am smiling. "Guano abatement devices and guano mitigation projects," I tell her. "Imagine," I say, "thousands of yards of parachute silk swaddling the underbelly of the bridge to catch guano. A Christo-inspired diaper for the world's largest urban bat colony." "Guano? Bat poop? Is that what I'm feeling? Oh boy." She briskly steps out from under the bridge, and I follow.

As we leave, Joe and Roz quiz me, is it a river or a lake? Bill and I have referred to it as "the river" and as "the lake." "Both," I reply. "It is a river when we've gotten a good rain and some runoff, or when the LCRA releases water from Lake Travis for irrigation downstream. Then water flows through it like a real river, but the rest of the time, it acts like a lake. The Colorado has a whole series of dams and lakes upstream." "But," says Roz, "this can't be 'THE' Colorado River that goes through the Grand Canyon. That's geographically impossible."

"No, this is another Colorado," I answer, "My Colorado."

"YOUR river?" She asks, smiling.

Summer River

5: *Living Downstream*

EAST AUSTIN THROUGH THE BLACKLAND PRAIRIES

The river pours out of Longhorn Dam and starts a series of lazy, looping curves on its way to the coast. It changes in temperament and character. The way people look at it alters; there can be no mistaking that it is a river again, in name and nature. Just downstream from the last dam (for the present), the river glides underneath the soaring buttresses and pillars of the Montopolis Bridges. The river feels like an anachronism after the high-priced estates and manicured lawns bordering the reservoirs upstream. City of Austin parks bordering the river on either side (Guerro Park on the south and the Colorado River Preserve on the north) are not akin to the mowed and maintained hike and bike trails just upstream around Lady Bird Lake. Erosion eats at the banks of Guerro Park. In the Colorado River Preserve, eroded trails score the woods, heaps of dumped household and construction trash clog the gullies, and debris washed downstream laces the brush.

Under Montopolis Bridge, the ground is packed and gouged with tire tracks right up to the edge of the water. This is a jurisdictional no-man's-land: the City of Austin, the Texas Department of Transportation, Texas Parks and Wildlife, the LCRA, and Travis County have made no claim on it. Meanwhile, the local community loves the area to death. A truck and a van pull up next to our canoes; if we weren't here, they'd pull the vehicles into the river to wash them.[1] Young men with hand lines and boxes of worms wade into the river,

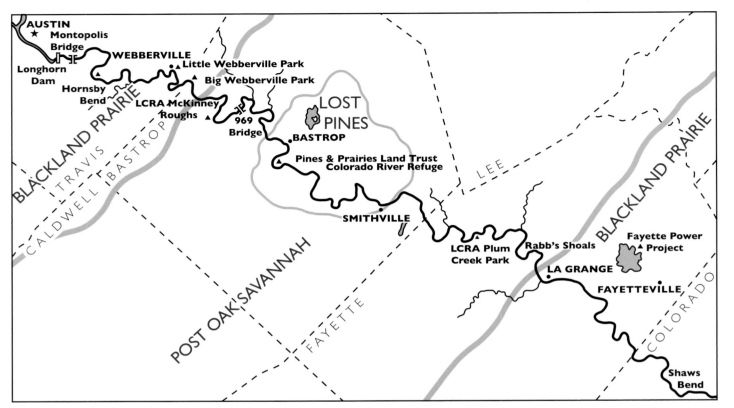

Longhorn Dam to Shaws Bend

laughing, to try their hand at fishing for mojarra (sunfish), while a woman teetering on platform heels walks hand in hand with a man into a tangled thicket of brush in the Colorado River Preserve. Spider webs and plastic bags shine in the branches of willows. Swallows dip and flit above the surface of the glittering, clear river. The forest of concrete piers soars overhead like a grove of frozen gray redwoods; the spans of the bridges are caulked with the rough brown beads of cliff swallows' nests. The soft murmur of the water at my feet mutes the rumble of the traffic overhead. The voices of the Texas River School students rise and fall, glittering and rushing current-like above the river. I am awash in sound and light watching the shining faces of the kids as they shift from foot to foot, dancing in anticipation of the moment they can launch the canoes.

It is a perfect late summer morning with bright sun, blue sky, and a clear river winding through east Austin and Blackland Prairie. Once again, I've been relegated to the position of passenger. Two well-matched and good-natured young men ply the canoe paddles while I loll in the center.

This is my river, the length I know best. The one I return to when the world is too much for me. From my first trip in the late 1970s, this stretch of river running from east Austin through Bastrop, Fayette, and Colorado Counties has meant warms days, cool water, abundant wildlife, and time for reflection. On that first trip, we were cautious about getting the polluted water on our skin, but having grown up on the banks of the Mississippi River, I took tainted water for granted. Today the paddlers and I dump hatfuls of cool water over our heads, dip our feet in the current, and let our hands trail over the sides of the canoe as it drifts over lush aquatic plants undulating in

Texas River School canoes under Montopolis Bridge

the stunningly clear flow. In the stern, a husky Hispanic boy of twelve powers the canoe with strong shoulders; in the bow, a gawky redhead—all elbows and freckles—matches stroke for stroke. They call back and forth to each other about video games, food, and superheroes while I supply a running narrative of birds, natural history tidbits, and river factoids. Red-eared sliders, river cooters, and the occasional map turtle sun on logs, their shells dry, chalky, and matted with algae in the blast of the summer day. They belly flop into the water when we paddle too close. A softshell turtle pokes her snorkel-like nose out of the water for a lungful of air. From 20 feet away we watch her frantically paddling to the bottom, looking for cover in shadows of the plants. Red-tailed hawks, turkey vultures, and black vultures circle overhead on vortexes of warm air. We paddle past broad faces of elephant ears lining the mud banks. Wild rice grows at the edge of sand and gravel bars, its rooted feet in the water; behind the rice's graceful swaying seed heads, tall, straight, invasive Johnson grass crowds the banks.

At a glance, the river corridor has a visual uniformity: a width of smooth water bordered by a plump roll of greenery interspersed with pastures, lawns, and occasional banks and bluffs that reveal striated sediment like exposed petticoats. Frederick Law Olmsted described it in 1855: "The scenery along the river is agreeable, with a pleasant alternation of gently sloping prairies and wooded creek bottoms" (Olmsted, *A Journey through Texas*). The Colorado River cuts a path southeast toward the Gulf through multiple layers of sediments deposited over millions of years by the continent's gradual erosion and leveling. The exposed edges of the strata create bands of distinctive soils that follow the arc of the Gulf Coast (imagine a layer cake cut at a sharp slant), each with historically unique plant communities that create long strips of habitat running from northeast to southwest. The river has lined its channel with sands, gravels, and topsoil gathered along its course from the High Plains through the granites, limestones, sandstones, clays, and fossils on its way to the Gulf of Mexico. The mixture of accumulated alluvial debris defines the river's character so that the varied soils of the rolling Blackland Prairie, Post Oak Savannah, and Gulf Prairies and Marshes beyond its banks only modestly influence the view. In fact, the view from the river still reflects the Spanish explorers' carefully recorded observations from the sixteenth and seventeenth centuries: elm, nogales (pecan), alamo (cottonwood), sabine (cypress), juniper, hackberry, and oak along the banks. Twisting wild grape vines, ropy and thick

as a man's arm, still snake up the trees along with the poison ivy that rated notice for sickening the soldiers (imagine dealing with ticks, mosquitoes, poison ivy, and chiggers while wearing armor). The fiery orange blossoms of trumpet vine blare from the canopies. The change over the centuries, not visible from my vantage in the canoe, is the reduction of the bottomland forest and prairie from an often miles-wide corridor to a thin, decorative border between the river and pastures, cropland and houses. The forests along the river were a larder for the Native Americans and early settlers, a one-stop shop for game, birds, wild fruit, nuts, fish, and turtles. When the river overflowed into the forests, the broad band of trees, shrubs, grasses, and plants slowed the water down, capturing soil and seeds from upstream. Fish swam in the flooded forests, and frogs, toads, and salamanders transitioned between land and water while the floodwater absorbed into the ground. Without these forests, the river now rushes downstream, digging narrow, deep channels, moving sand and gravel around like a bulldozer. Riverbanks collapse, and entire bends in the river shift overnight.

The TRS guides herd the canoes to a gravel bar where we clamber out with coolers and water bottles. After lunch, the kids gallop into the river. Wearing life vests, they bob in the water like brightly colored corks. I envy the utter joy and abandon of the kids splashing and playing in the clear water.

The river water seems so clean, yet I worry about what it might hold: the toxins, dissolved pharmaceuticals, pesticides, and all the other invisible chemicals that wash down the river from cities upstream and the city of Austin's wastewater plants. Current municipal sewage treatment systems cannot remove the slew of dissolved chemicals, drugs, and toxins that we routinely flush and wash down our drains and into our waterways. The Environmental Protection Agency (EPA) refers to these assorted chemicals as *Pharmaceuticals and Personal Care Products* (PPCP); it is a growing problem without an easy solution. We excrete the drugs we take for our well-being—antibiotics, hormones, antidepressants, and over-the-counter medications—and flush them away. Lotions, perfumes, sunscreen, and ointments wash down the shower drain when we bathe. For many years, a common solution was to discard old medications by flushing them down the toilet. The number of identified PPCPs is growing, and the chemicals are in any water body that includes treated sewage. The risk to humans is uncertain, but growing evidence indicates that, because of their continual exposure, effects on fish and other aquatic life are a

major concern. Endocrine disrupters, chemicals that mimic or interfere with normal hormonal functions such as reproduction, are potentially ruinous for fish populations.

I admonish myself—compared to its state in the 1980s, the current water quality of the river is nothing short of miraculous.

The city of Austin and the area around the city, especially to the north and west, has steadily grown since its founding in 1839 (except for a few downturns, such as when the first Austin Dam failed). In the late 1970s and early 1980s, the rapid growth of the city raised an alarm among its citizens. In response, the city council lapsed into a state of denial—a "See no growth, hear no growth, and speak no growth" approach to the rampant expansion of the city. The city's antiquated wastewater system was overwhelmed. Sewer pipes could not contain the waste, and the treatment plants literally over-flowed. Plumes of raw sewage flowed down Austin's creeks (including Barton Creek), and untreated waste poured directly into the river. Mark Rose, former general manager of the LCRA, described the river as "brilliant green" from the algal blooms. Austin's residents and downstream neighbors finally had enough. Environmental and neighborhood groups sued the city of Austin, the EPA, and the state to stop the city's continued sale of sewer taps into the overextended system. The city passed bonds to renovate and update the treatment plants.

For the most part, Austin does an exemplary job of monitoring the out-flows from the plants; surprisingly, this recently used water is cleaner—according to current standards—than much of the water pulled from Lake Austin into the city's drinking water treatment plants. The city returns millions of gallons of treated effluent from Austin's sinks, drains, and toilets to the river every day. Indeed, in the winter months, when the LCRA is not releasing water to downstream farmers, the river below Austin primarily consists of treated city wastewater.

The kids splashing in the water do not know and should not have to care about these issues—although the problems washing down the river today will be their inheritance.

The canoe pulls up to the dock at the Texas River School property. The TRS acquired two lots on the river (in the floodplain) and access to several others in a subdivision. The TRS land has an ignoble past as an illegal dump. For years, people dumped trash on the lots and on adjacent streets. Tons of old

Siren Song

furniture, appliances, garbage, and construction debris—225,000 pounds to be exact—covered the lots. With the help of volunteers (and the city of Austin), the TRS is transforming the property into a camp for the school. Crews removed the trash and an astonishing seven hundred tires. The TRS installed fences so the property is no longer accessible to freelance garbage men.

We haul the canoes, coolers, and paddles up the bank into the shade of hackberry trees, oaks, and pecans. The kids cluster, regroup, string out like beads, and then run together like water. Joe Kendall notices my dazed and exhausted look. He laughs and tells me, "You can't wear the kids out. You just

have to keep them busy and hope you can keep up." I totter off to my car wondering if today will be an anchor in these kids' lives, if someday they will return to the river.

If the river runs clean below the dams, it is not due to the oversight or regulation of any state or federal agency, it is the product of individuals, grassroots organizations, and the towns downstream. Groups like Clean Clear Colorado River Association, Bastrop County Environmental Network, Bastrop County Audubon Society, and Colorado River Watch Network were instrumental in drawing attention to problems and tenaciously pushing for change when Austin's sewage polluted the river. While some of the groups have retired, the Colorado River Watch Network (CRWN) evolved from a handful of Austin citizens, teachers, and students into a system of volunteers who monitor river water quality[2] from the upper Colorado River Basin to the Gulf of Mexico. Now managed by the LCRA, the data collected by "Crown," as its members call it, is an effective early warning system. Over the years, the volunteers have alerted officials about hazardous levels of phosphate (and successfully lobbied for ordinances banning detergents with more than 0.5 percent phosphates), sewage spills, harmful levels of dissolved oxygen, excess nitrates, and other potential threats.

On a brilliant September day, a group of ten high school juniors and seniors stand on the bank of the river performing water quality tests. They are members of the Austin Youth River Watch (AYRW), a nonprofit program supported by the Austin Water Utility, the city of Austin's Watershed Protection Department, and part of CRWN. This test site is just upstream from the city of Austin's Hornsby Bend Biosolids Management Plant. The late afternoon light gilds the shining faces of the River Watch kids as they tease each other, laughing and comparing results. They call, "Miss! Miss! Is this the right reading?" "Miss! Which tablet do I put in first for the nitrate test?" Elisabeth Welsh, Program Director of the AYRW, has the clear profile and rippling auburn hair of a Pre-Raphaelite painting. She calmly and cheerfully answers questions and gently prods the students into thinking for themselves. This group is from Johnston High[3] in far-east Austin. They live in neighborhoods of small

houses that perch on gentle hills. The neighborhoods are interspersed with warehouses, small factories, and industries. Most of the River Watch students are Hispanic or African American; many will be among the first in their family to go to college. Elisabeth explained to me that, in addition to collecting valuable water quality data on the state of the river for the city of Austin and the LCRA, the after-school mentoring program puts the students into a peer group that encourages achievements, especially academic ones. Experienced River Watchers mentor new students. Friendships develop, often long-term, in a group where the students hold expectations high. Because the kids have similar backgrounds, there is tremendous support and understanding.

Irene, who wears sultry slashes of black eyeliner like a 1950s movie siren, and tiny, spunky Anahi are pouring river water from a bucket into a 4-foot-tall clear tube to check for turbidity and clarity. Most of the cold water ends up on their feet (my ears ring from the squeals as the water soaks their shoes) but enough is caught in the tube to complete the test. Jesse shows me the conductivity test. He demonstrates the correct way to calibrate the electronic meter and take a reading. A pair of girls performs the complicated dissolved oxygen test. Juan is patiently trying to coax a series of consistent readings from the temperamental electronic pH meter. Joseph is holding up the results of the nitrate test—a tube of pale-colored water—and comparing it to a set of standardized results. He calls to Jessica to come help him. Side by side, they hold the black plastic holder up to the sun and slide the colored plastic squares until they decide on the color closest to their sample. Jessica, clear-eyed and serene, then has the group decide on the reading for the phosphate tests. Priscilla writes down the data that the other students call out. She and Elisabeth stand in a column of late afternoon light with their heads together as they quietly confer about the river characteristics and jot down observations. Jesse calls out that he sees a bunch of little fish close to shore. I've managed to squint into the light long enough to determine that the three trolling shorebirds are actually two killdeer and an unidentified peep. "A peep?" Priscilla eyes me warily. "Call it a shorebird," Elisabeth says.

Downstream, the Austin Water Utility's Hornsby Bend Biosolids Management Plant is renowned as one of the best bird-watching sites in Texas. The plant receives sewage solids, or biosolids, reclaimed from the millions of gallons of wastewater that Austin produces each day. The sewage sludge is treated and then composted with yard trimmings to create Dillo Dirt, a com-

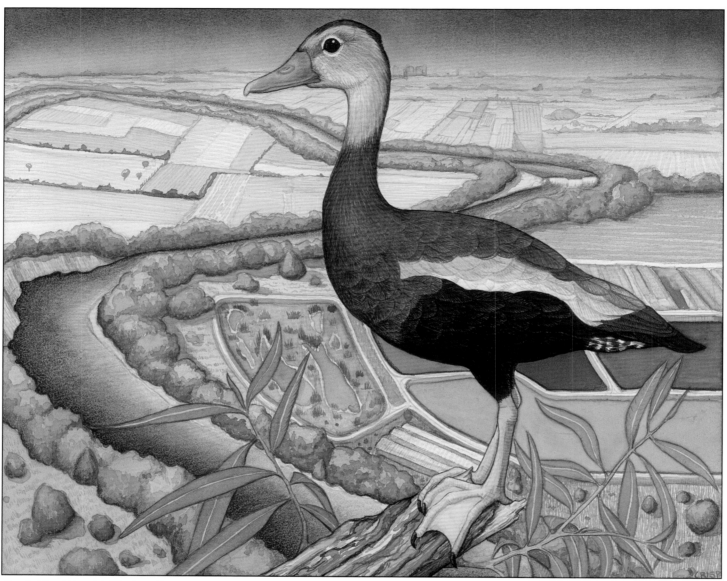

Dog's Head Bend & Black-bellied Whistling-Duck

post sold or donated for landscaping and gardening. Water extracted from the biosolids fills settlement ponds or irrigates hay fields. (Before renovation in the late 1980s, the plant also pumped water—sometimes contaminated—into the river.) Year round, the nutrient-rich settlement ponds attract birds and wildlife. Flocks of hundreds of shorebirds work the mudflats; wading birds like egrets, herons, and ibis frequent the edges and marshes. Enormous rafts of ducks float and feed on the ponds during the winter. The woods along the

river fill with songbirds during spring and fall migration. The flocks of birds and the river draw in osprey, bald eagles, hawks, and falcons. Surprisingly, the smell of the sewage treatment plant isn't overwhelming; it's a dusty, raw smell that is easily ignored once you are distracted by the birds.

John Wesley Wilbarger described Hornsby Bend in 1889 as "covered with wild rye, and looking like one vast green wheat field" (Wilbarger, *Indian Depredations*). The rich alluvial soils sustained crops of cotton, grains, and vegetables for years; now hay fields, gravel pits, and the rigid grids of housing developments fill the bend.

A 1709 Spanish reconnaissance expedition led by two church officials crossed the Colorado River somewhere between Hornsby Bend and the Travis County line downstream. Father Fray Isidro de Espinosa described the river: "We came to the river, which is sheltered on either side by luxuriant trees, nut trees [nogales], ash trees, poplars [cottonwoods], elms, willows, mulberries and wild grapevines much taller and thicker than those of Castile. The river has sand banks all along its margin, showing the high water mark, and it is a quarter of a league wide. Its water is the best we have found" (Espinosa, *The Ramón Expedition*).

Post Oaks and Lost Pines

Over the years, I've noticed that there are two approaches to floating the river in this stretch of gently rolling hills, slow curves, and—unless it is flooding—languid current. With river obstacles limited to occasional submerged logs, sweeper trees along the bank, and a few gravel riffles, it is possible to fall into a trance and passively become a serene component of the visual panoply of the elements: river, banks, sun, and breeze. The river unwinds like a panoramic scroll before you. The trees and plants along the shore blend into a billowing green curtain above the shimmering channel. Egrets fly before you or stand gracefully along the banks. There could be dozens of elegant long-necked and long-legged birds—or possibly they are the same few that fly downstream ahead of you. Sun and breeze compete to lull you into a profound relaxation. The bird song punctuates the murmur of trees and river; fish are shadows that slip away from your boat as it glides along.

Or, you can pick up your paddle and move close to shore, slipping from

the bright embrace of the sun into the cool shadows, following the track of the current around bends and past eddies. The songs and calls distill into individual voices that you can pick out of the surrounding greenery and trace to the jeweled birds that hop and flit among the trees. The symphony of the river is the murmuring current broken into a chorus of gravel riffle, the bass of muscular flow breaking against rock and log, the applause of sycamore leaves trailing in the stream, the slap of wavelet against boat hull, and the lowing of cattle. Woven into the melody is the incessant background to any summer day in Texas: shrill cicadas, the clattering of dragonfly battalions swooping past, the business-like hum of wasps and bees at work, and the dry rattle of grasshoppers in the brush on shore. Include the rotund notes of turtles diving to safety from driftwood in the river, the thin cries of hawks overhead, the cymbal crash of fish slapping the surface, and the splashes of paddles dipping into water. Over this constant hymn, add the occasional roar of a lawnmower or weedeater (especially on weekends, a *basso continuo* of 2-cycle engines will underscore the river sounds), the voices of fishermen calling out good day, the rumble of cars from nearby roads, the grating clash and metallic clangs of haybalers. Above the smell of sweat and sunscreen, the water ripples a pale green scent of algae, plants, and an almost anise smell of river bank; elephant ears give off a pungent sweet smell; grape vines are sharp and dusty; sycamores smell like warm toast; box elders give off the faintest odor of maple syrup; cypress is a sharp, bright note; oaks, whether from leaves piled around the roots or the trees themselves, give off a brown odor of compost and dark humus; hackberries are blandly sweet, with a touch of acridity. Flowers, from the overly sweet honeysuckle to the vaguely rank composites, weave highlights through the bold palette of tree, water, and mud. Gravel bars in the sun concentrate the river's underlying notes of decay—both plant and flesh—into stretches of cobble. Still pools ferment in the sun, smelling like beer, with thick layers of algae and a slew of industrious bacteria working the stagnant water into a heady brew. The opened and discarded shells of mussels collect along the bar, mother of pearl treasures iridescent in sunlight smelling corporeal. And never far away are the omnipresent cattle: the pungent fresh-grass smell of new cow pies, the darker fetid odor of older cow plops and cows too close to the river, and the dry hay-like smell of cow chips baking in the sun.

Passing one of the many quarries (there appears to be a land rush between mines and developers to see who can acquire the most riverfront land in east-

ern Travis and Bastrop Counties), a grinding roar of dump trucks follows the river corridor. Behind the levees of dirt piled up along the river's edge, the grating clatter of alluvial sand and gravel scooped up by machines feels like knives drawn along the long bones of my arms and legs. The chalky flavor of the dust floating in the air and the naked smell of the gravel levees drying in the sun stick in my throat.

When the river rises, the gravel pits' levees often dissolve into the river, turning the water almost white with copious amounts of fine clay and sand. It seems contradictory to criticize gravel mines and the LCRA's river management while lamenting the river's lost ability to transport sediment to enrich floodplains and build deltas and marshes at the mouth of bays. Truthfully, it is an equation based on time and place.

Take freshwater mussels, for example. These mostly ignored creatures are the most endangered group of organisms in North America[4]. An important part of the food chain (both terrestrial and aquatic), they are a link to water quality—not only because they require unpolluted water to live but also because they filter and clean a tremendous amount of water. Mussels suck in water, feed on the algae, bacteria, and miscellaneous organic particles, and flush out cleaned water. Sudden, out-of-season deluges of soft sediment can bury and suffocate the mussels before they have a chance to move (yes, some species can move—but not far and not fast). Cloudy, silty water inhibits photosynthesis in the algae that some freshwater mussels depend on for nutrition. Changes in water level will change the number and kind of fish in a section of stream or river. Mussels have developed close—and very peculiar—reproductive strategies between themselves and fish. A number of freshwater mussels can only reproduce if a certain species of host fish is available. Some species of mussels attract the host fish into close proximity with mantle lures resembling food or other fish; others expel tiny larval mussels (called "glochidia") that float until they find the right fish. When they do, they attach to the gills or fins, depending on species, to feed and grow until they drop off to the riverbed. If they try to attach to the wrong species of fish, the fish's immune system will reject the hangers-on. Without the partner species, the mussels do not reproduce, the population dwindles, and the river's filter brigade is lost.

From mid-March through mid-October, the LCRA releases water from Lake Travis (and Lake Buchanan) for environmental flows into the bays and estuaries, power plants, and rice farms. Although the LCRA freely admits that

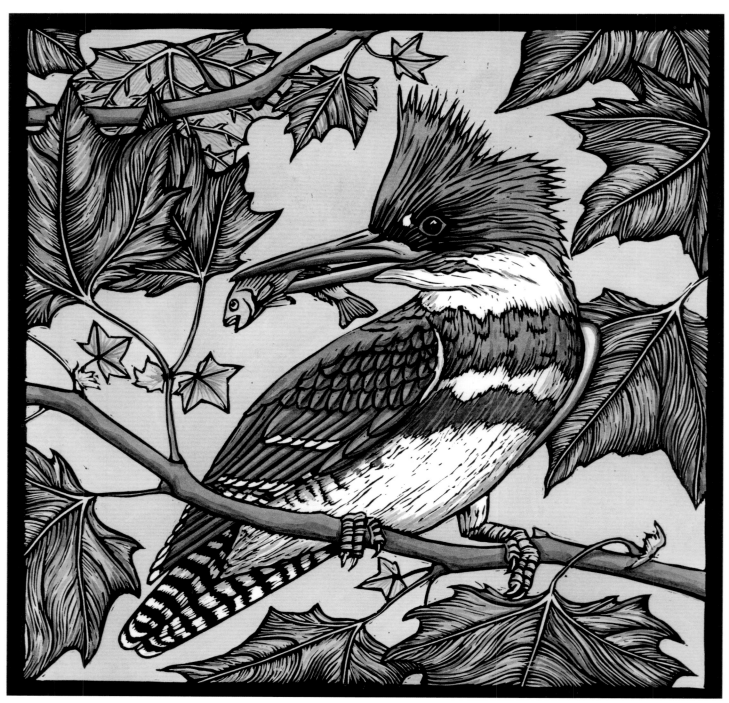

Belted Kingfisher

they generate little electricity from the hydroelectric turbines in the dams along the Highland Lakes, they still release water downstream in the on/off pattern common to hydroelectric-generation management. The river pulses with rapid changes in level and flow and, because the water is released from the bottom of the reservoirs, there are dramatic temperature changes. Changes in water level play havoc with boaters and anglers (and the canoe outfitters), and it can be harmful to the river inhabitants like mussels, fish, plants, and invertebrates. The most obvious effects are the steep, muddy riverbanks, undercut by the chronic ebb and flow. Invasive plants like elephant ear (taro), Arundo cane, and bamboo that can tolerate the rapid changes in water level and temperature thrive in the wavering line between river and shore.

Ongoing research by University of Texas (UT) geologists indicates that the pulsing of water releases may affect the river's most fundamental biochemical interactions. In a natural river system there is a constant give and take between the water in the river and the water in the aquifers below the riverbed (groundwater). In some areas, like parts of the Edwards Plateau, river water seeps through the honeycombed limestone along the riverbed, feeding the underground aquifers. In other areas, like the broad prairies below the Edwards Plateau, the river gains water, drawing it out of the aquifers it crosses (the big aquifers in the lower basin run roughly parallel to the bands of soils that form the Blackland Prairies, Post Oak Savannah, and Gulf Prairies and Marshes). Experiments conducted by UT student Audrey Sawyer revealed that when river levels artificially rise and fall daily, the fluctuations pump surprising quantities of water rapidly back and forth into the surrounding shallow alluvial aquifer. This may or may not be detrimental, but the health of the river system depends on interactions between water chemistry (dissolved oxygen, pH, and nitrogen) and microbes, bacteria, and other tiny creatures. If the water at this fundamental level is unstable—or changes too rapidly for adaptation—the first links in the food chain that supports the entire river, its residents, and the creatures that depend on the river may be imperiled.

After a century of allocating water from the state's rivers and lakes as if they were inert pipelines, the state has recently recognized that rivers, bays, and estuaries need minimum amounts of water to survive. In a spasm of well-intentioned enthusiasm, the state is in the process of determining environmental flows: how much water the river, bays, and estuaries need to live as functioning ecosystems. The LCRA (long before mandated by law) started de-

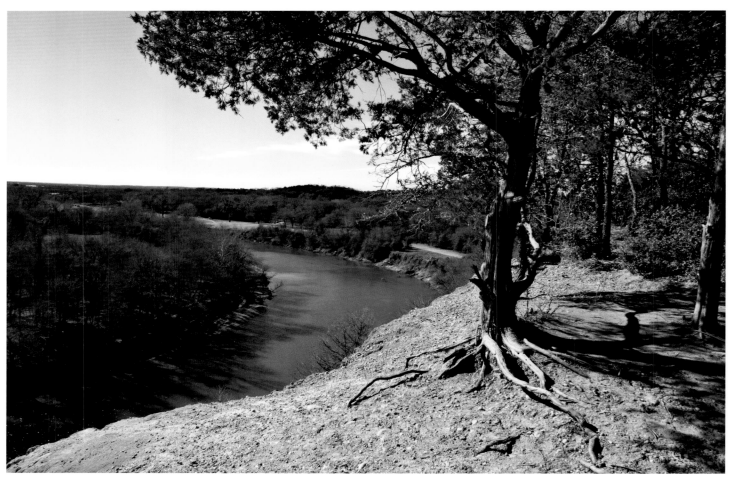

Lost Pines and Red Bluff below Bastrop

termining the quantity and timing of the water needed by the Colorado River. To their credit, they have allocated a portion of their firm water[5] (water available even during a severe drought) for instream flows below Longhorn Dam and for the nourishment of Matagorda Bay and its estuaries. No one knows if the 33,440 acre-feet (average) of freshwater allotted annually will be enough. Or if the current predictions of population growth, changes in water usage and re-use of wastewater (instead of returning it to the river), and climate change are accurate.

As I paddle toward Bastrop, I pass the sites of ferry crossings, bluffs, and creeks that I recognize from William C. McKinstry's 1840 pamphlet, *The Colorado Navigator.* Intending to prove that steamboats could run from the mouth of the river to Austin, he carefully documented all of the farms, ferries,

shoals, and bluffs from Austin downstream to near Matagorda. Many of the places and their settlers are immortalized on contemporary maps: names like Hornsby, Webber, and Wilbarger. Other sites are recognizable from the descriptions, such as the tall bluffs of McKinney Roughs (now an LCRA nature park and education center).

The river cuts through downtown Bastrop and past Fisherman's Park (built by the LCRA and TPWD, it is now owned and maintained by the city of Bastrop), under the highway, past the Old San Antonio Road crossing and the storm drain pipe emptying into the river that people commonly mistake for the historic Bastrop Springs. Just past another quiet bend, the deep sands of the Lost Pines surround the river. The Lost Pines are an out-of-place island of East Texas loblolly pine and oak woodlands in the Blackland Prairies eco-

Lost Pines Suite: Green-eyes, Eastern Flying Squirrels, Houston Toad, Sandy-land Bluebonnet

region. The pines whisper in the river breeze, adding a sharp turpentine smell to the air. For a century, the residents couldn't cut the trees down fast enough to supply timber to Austin and points west; now the pine forests shelter homes and golf courses. Pines and Prairies Land Trust has created a refuge on the banks of the river. Hiking paths amble through riparian forest down to the river. Sandstone hoodoos stand guard over the gravel bars and sycamores. Just downstream, the Lost Pines Nature Trail has a canoe launch.

Past the golf courses, riverside homes, and the noise of the residences, the river settles into a rural character again. Cattle pastures and small patches of forest border the river. A black bull standing in the shade of a box elder startles me by pawing the ground, snorting, and shaking his massive head. Spanish explorers remarked on the herds of bison east of the Colorado. In 1721, Padre Juan Antonio de la Peña (as part of the expedition led by Governor Marqués de San Miguel de Aguayo) describes his impressions of a bison: "The bison is what the first Spaniards called the Mexican bull. It is a monstrous animal; its horns are crooked, its back humped as that of a camel, its flanks lean, its tail short, and hairless as that of the pig, except the tip, which is covered with long hair. The entire skin, which is of a dark tanned color, resembling that of the bear, though not so fine, is also covered with long hair. It has a beard like that of a goat and, as the lion, its neck and forehead have hair a foot and a half long that almost covers the big black eyes. Its feet are cloven, and its forehead is armed [with horns] as that of the bull, which it imitates in ferocity, although it is much more powerful and swift. Its meat is as savory as that of the best cow" (Peña, *Peña's Diary*).

I've seen bald eagles along this stretch. Ducks raft in the slow stretches in the winter; migrating songbirds glean through the leaves in spring and fall. Ever-present cardinals and crows carouse all year round. A few lucky paddlers have chanced upon beavers out during the day. Raccoons leave only footprints and empty mussel shells along the banks.

But I'm lucky enough to have the acquaintance of a river creature unlike any other: a river rat by the name of Neal Cook. Weathered, lean, and prone to short, brusque statements growled in a deep voice coarsened by decades of cigarette smoke, he looks like he could paddle off down the river with nothing but a pocket knife and a ball of twine to live comfortably for as long as he liked. He tends to glower and curse the LCRA, the city of Austin, gravel quarries, and anyone else foolish enough to slight or endanger his river. It wasn't until

the second time I'd met him that I ventured near enough to catch a glimpse of sapphire blue eyes that positively twinkle in his sun-cured skin. Far from surly, he is the most kindly and generous of men, with a sly sense of humor delivered in a dry, often misunderstood, gruff manner. Proprietor of Cook's Canoes, a canoe and kayak livery just downstream from Austin in the hamlet of Webberville, Neal now works to introduce a reluctant public to the beauties and recreational possibilities of the river. He gallantly offers to celebrate Earth Day with me on a trip in his trolling motor-propelled canoe from Smithville downstream to LCRA's Plum Creek Park. With our friend Suzette in the seat of honor in the middle of the canoe, I'm stationed in the prow. I immediately get distracted while trying to start my new GPS unit. Neal politely growls I might want to paddle or we'll have a very short trip. I drop my GPS, paddle wildly, and we make it past the first obstacle in the river, a ridge of concrete or stone that requires a quick maneuver to the far bank and steady paddling to resist the current's pull into overhanging trees. Neal pops the top on one of his tall boys in celebration, Suzette snacks on a kolach, and I frantically push buttons on the GPS unit, cursing quietly. It is 10:30 A.M. and we are on our way.

We pass gravel riffles where spotted gar spawn. The males swarm over the bigger females, their gold-green backs out of the water as they swim madly, jostling each other for a spot next to the female's flank. Each female has a retinue of half a dozen or more male suitors competing to fertilize her eggs as she releases them onto the rocky bottom. One female has had enough. She turns and with a powerful flick of her tail drives her suitors away—and sends an arc of water into the air. Neal has seen it before, "Just like the endangered blue suckers spawning in Onion Creek." He has a rasping laugh that could come from the throat of a raven. He says, "I bet the LCRA would have liked to see that since they're paying for a bunch of biologists to look for those fish. The (indistinct words) . . . don't know where to look." His words ebb into a chest-deep, bearish mumble that dissipates into his white ruff of a beard.

Blue suckers (*Cycleptus elongatus*) are big torpedo-shaped fish that live in the lower Colorado River. The adults prefer deep, fast currents running over gravel, cobble, and bedrock, where they feed on aquatic insects and algae. Once common, the state-listed threatened species is the subject of intense study because we know little about this sensitive fish, their reproduction, or living requirements. To date, the scientists haven't caught a single juvenile blue sucker, though spawning congregations have been reported in the riffles below

Blue Sucker

Longhorn Dam and in several sites downstream. Scientists believe these fish are good indicators of the ecological condition of the river. In other words, healthy blue suckers mean a healthy river. However, without solid data about the blue suckers' life cycle, preferred habitats, and populations in the Colorado River, it is impossible to know if the fish are truly rare, or just elusive.

Wildflowers blanket the shores; a cool breeze tempers the sun's glare, and the tranquility of the surroundings and company lull me into a sensual trance. Neal's reminiscing rumble brings me back—he's telling us that he hasn't been on this section since his first trip down the Colorado on a Boy Scout canoe trip in 1962. "It was the year after the big fish kill that started in Town Lake. It just wiped out the river," he says. "There wasn't a fish left; the river was dead, just dead." I'm stunned into silence by the image of a troop of Boy Scouts paddling their way down a barren, pesticide-laced river.

"Nothing like living downstream," Neal rumbles.

We glide past a farmhouse teetering on the edge of a high bluff, the river below full of detritus from the yard. The channel runs between tall sand banks. Landowners on the cutback sides battle the river's inexorable erosion with con-

crete slabs, tires, steel, whole automobiles, brush piles, and metal crosses that look like giant jacks.

Suzette silently points out a wood duck hen with chicks floating in the shadows near the bank. The hen sees the canoe and thrusts her head forward so her bill is level with the water and swims with her eyes just above the surface. The ducklings bunch next to the hen and swim with their necks stretched out. They look like beavers or muskrats skimming close to the bank. In the silence, apropos of nothing, Neal announces, "The river is better now." Drugged by the tranquility, I agree and silently compose florid prose to describe the moment and its loveliness until Neal adds, "Especially since the city of Austin quit sending their shit downstream." Suzette and I hold onto the gunwales of the canoe, doubled over in laughter. The duck and her chicks have fled. I look back. Neal sits in the stern, drinking a beer and beaming like a benevolent river god at two hysterical women in the middle of his river on a gorgeous spring day.

Blackland Alchemy: Coal, Fire, River, and Air

From my vantage high on a bluff in the town of La Grange, I look down and over the river curling around Rabb's Prairie. At the base of the looping bend, a shimmering riffle, Rabb's Shoal, or The Ripples, catches the afternoon light. No one is sure, but it is a likely spot for the original Indians' and explorers' crossing. Fray Gaspar Jose de Solís was full of praise for the area: "This stream is very large and full of water; its banks and margins and meadows are very pleasant." He also noted that "from this river began the bison, and the deer continued" (Solís, *Diary of a Visit*). Bison were essential sustenance for the Indians and the Europeans, including René-Robert Cavelier Sieur de La Salle on his ill-fated journeys. Henri Joutel, who served as post commander for the French explorer, described their camp and meals on the river: "La Maligne[6] is wide like the Seine at Rouen, and its current is nearly the same. Thus, it is navigable and not obstructed with wood. It flows through very beautiful country. The open country that we had just crossed goes along one side of the river. On its banks are trees of different species and sizes. In the wet locations and entirely along the banks are willows, linden trees, and the like and a little farther inland there are oak, elm, pecan trees, and several other kinds of trees" (Joutel, *The La Salle Expedition to Texas*).

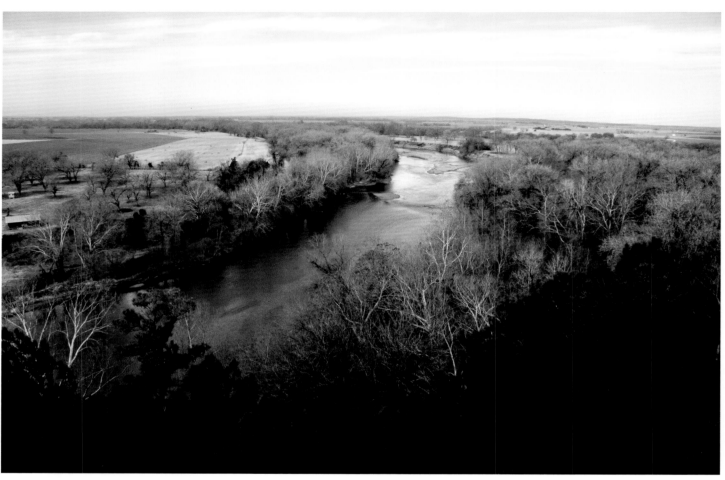

Rabb's Shoals and Rabb's Prairie outside of La Grange

Seven miles east of La Grange, a town renowned for historic painted churches and the Chicken Ranch (a long-closed brothel), the smokestacks of the Fayette Power Project (FPP) loom over Lake Fayette. Parks border the 2,400-acre reservoir (topped off with river water to keep it full), and record-size bass thrive in its warm depths. The FPP, a three-boiler, 1,641-megawatt plant that can power 1.5 million homes, is jointly owned by the LCRA and the city of Austin. It burns Powder River Basin coal hauled in by the trainload from Wyoming. FPP's compliance record is commendable under present standards; they abide by the laws for air pollution control and win industry awards for exceeding environmental standards.

But, coal-burning power plants are significant sources of air pollution—especially sulfur dioxide and mercury emissions, and the FPP is no exception.

To their credit, the LCRA has invested in technology to reduce (but not eliminate) pollutants from reaching the air and set up recycling programs for the toxic by-products of burning the coal. However, the hidden costs of running thermoelectric plants, especially coal-burning plants, are quickly becoming an issue.

Thermoelectric, or steam-generated, plants require substantial quantities of fresh water to run whether they are powered by nuclear or fossil fuels (coal, lignite, oil, or natural gas). Each kilowatt-hour (kWh) of electricity generated in Texas from steam-electric generation requires up to 30 gallons of water—and the average Texas home uses more than 1,100 kWh a month. At FPP, burning coal heats water with the purpose of producing steam to turn a turbine that generates the electricity. Excess heat not converted to electricity dissipates in water (e.g., the lake or a cooling pond). Lastly, the scrubber process used to clean the smoke produced by burning coal uses water.

Theoretically, power plants only "borrow" water for generating electric-

ity, returning most of it to the river or a reservoir (less than a half gallon is actually "consumed" per kWh), but the traditional scrubber process produces highly contaminated water that contains mercury and other poisons. According to a *New York Times* analysis of EPA data, "Power plants are the nation's biggest producers of toxic waste, surpassing industries like plastic and paint manufacturing and chemical plants" (Duhigg, "Cleansing the Air"). Standard wastewater treatment regulations in Texas do not remove these toxins from the water. Are we cleaning the air at the expense of our rivers and lakes?

We need water to produce energy, but we also use energy for water. Electricity is needed to drive the pumps that deliver water to treatment plants and then to homes, schools, businesses, and industry. We consume *more* power treating the wastewater, so clean water can be returned to lakes and rivers.

The interdependency of energy and water is especially clear during periods of drought. Water use rises during a drought but, without sufficient water, the plants can't produce energy; in turn, this hampers the ability to treat and distribute water. If temperatures rise, as is often the case during a drought, there is increased demand for electricity to run air conditioners.

As growing populations in Central Texas increase the demand for the Colorado River's water, who gets priority? The LCRA, because it owns the power plants, the water rights, and manages the water supply, has been able to juggle the current demands between cities, farmers, industry, power plants, and the environment. But can they act as effective environmental stewards of the river when the need for water exceeds the available supply? By relying on the LCRA to manage the river and the water supply of the lower river basin, are we, in effect, asking the fox to guard the henhouse?

Mark Rose, the former general manager of the LCRA, worries that the LCRA is on the verge of losing sight of their mission. Again. During the 1960s and 1970s, the rapid growth of the LCRA's electrical services, including the construction of multiple power plants, culminated in a giant electric utility company that did a great job of providing cheap electricity but ignored its mission of conservation, reclamation, community service, and stewardship of the river from the Highland Lakes downstream to Matagorda Bay. The agency alienated the communities downstream with their plan to strip-mine huge swaths of Bastrop and Fayette Counties for lignite, a low-grade coal (which has about the same BTUs as cow manure and burns about as cleanly) to power the planned FPP. Corruption scandals (including contractor-funded brothels)

and repeated confrontations with downstream communities over the agency's proposed partnership with the South Texas Nuclear Project, a for-profit nuclear plant downstream, severely damaged the agency's reputation. The LCRA board hired David S. Freeman from the Tennessee Valley Authority to come in and straighten things out. Under his leadership, and then Mark Rose's, the LCRA shifted their focus and did their best to move toward management of the entire river basin, stewardship of the river, and community involvement.

Yet current demands for cheap energy and the LCRA's eagerness to supply power contracts to cities throughout south Central Texas will lead to the construction of more power plants. The demand for more water for the new plants, the current needs of the cities, and environmental degradation from the rampant development of land around the lakes and downstream, as well as pressures from within the agency may be too much for the LCRA's fragile legacy of oversight. It will be a challenge for them to maintain their commitment to the environmental health of the river, its surrounding lands, and the communities along its banks as they focus on their duties as an electric utility.

Below Fayetteville, the river's slow course over the gradual slope down to the Gulf Coast results in it writhing over the land like a snake pinned by the head. Abandoned river channels curve around the present river, punctuated by the commas and parentheses of oxbow lakes. A few miles downstream, the river crosses back into the historic Post Oak Savannah, into Colorado County and the site of a river project that lumbers to the surface every few decades like an arthritic turtle: the Shaws Bend Reservoir.

Over the years, there have been multiple schemes to build a dam near Columbus, but the LCRA didn't get involved until the 1950s when they came up with a plan for a reservoir upstream of the town. In the 1960s, local ranchers and farmers halted the project by actually going to Washington D. C. to confront lawmakers and testify against the project. Twenty years later, in the early 1980s, the project reemerged as the Shaws Bend Reservoir. In the words of John Scanlan, a former LCRA board member: "The fact of the matter is that this Shaws Dam was going to be only about 4 or 5 foot deep, and it was going to be basically a mud flat most of the time, depending on how the water was allocated and stored on there. The idea was to store water in there when we had a great surplus and to use it to provide the rice farmers with water." The project was sidelined and finally de-authorized by President Reagan after a legal battle that divided the local community. Unbelievably, the Shaws Bend

Pileated Woodpecker

Reservoir project is still lurking. While Barney Austin at the Texas Water Development Board (TWDB) assured me that the project is "way down the list of recommended reservoir sites," a review of the list has Shaws Bend ranked at No. 20. The TWDB designated the top nineteen sites for protection or acquisition. How would the LCRA use water stored in such a reservoir? For irrigation in the lower basin so Lake Travis levels could stay higher for recreation? Would the water get pumped across country to thirsty San Antonio or Austin? Or would another thermoelectric power plant appear, ready to send electricity to any of a half-dozen rapidly growing Texas cities?

When I paddle this section of my river and admire the clear water, the wood duck hens, the kingfishers, and the spotted gar, I remind myself that it was the hard work of people who live along the river, who banded together to clean up, protect, and keep the river free flowing that allows me to enjoy all of this. It isn't due to the benevolent oversight of state or national agencies, it is the collective result of the quiet passion—and hard work—of the people and towns that live downstream.

New World

6: Into the Gulf (almost)

GULF PRAIRIES AND MATAGORDA BAY

Tiny whitecaps run upstream against the current, slap the kayak hull, and explode into my face. If I stop paddling for a second, sweeper trees reach out and tangle branches in my hair. After disengaging myself from an amorous willow tree, I have had enough. In a snit, I yell at the wind, "I give up!" and hold my paddle high overhead. The wind grabs the kayak and spins me dizzily up stream where I'm deposited on a gravel bar under a high sand bank. The cold blast and the relentless whistling is blocked; I hear the rumble of traffic on nearby roads, the squeals and keening of killdeer, lesser yellowlegs, and spotted sandpipers as they dodge and bow along the banks. A peevish cry catches my attention. Above me, an adult bald eagle hunches miserably in the crown of a dead cottonwood, feathers ruffled for warmth and looking less than dignified. The giant bird seems just as irritated as I am with the sudden drop in temperature and the onslaught of stiff wind. Buoyed by the eagle's grumpy camaraderie, I head back into the wind and fight my way downstream.

A glorious fall day and a pleasant paddle around the town of Columbus was transformed into an endurance test when a blue Norther funneled a Canadian cold front into Central Texas via the Great Plains—several hours earlier than predicted. I am slowly making my way around the Great Bend of Columbus, a 6-mile loop of river that curves into an almost complete circle, with the town tucked into the narrow neck. Logic would insist that at some

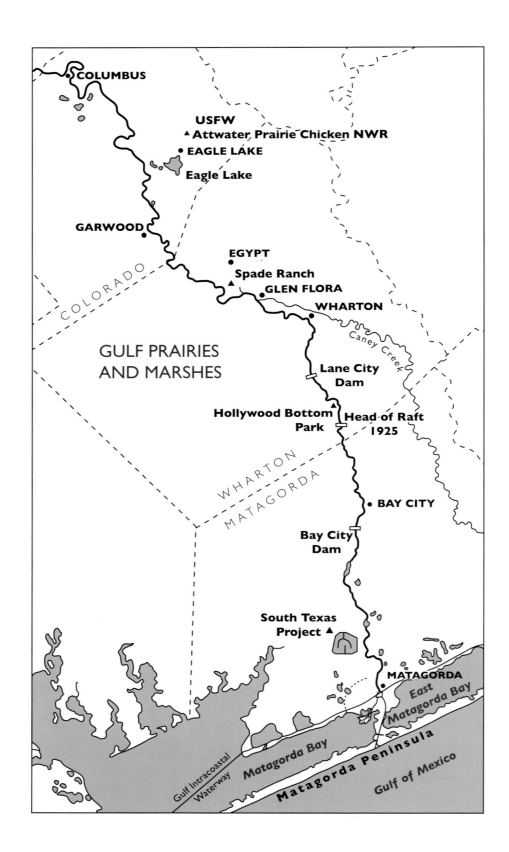

Columbus to Gulf of Mexico, including Matagorda Bay

point, the wind would be at my back, but the gusts are capricious, and it seems like I battle a headwind the entire time.

The river and I have entered the Gulf Prairies and Marshes, a band of rich soil eroded from mountains and deposited by Texas' rivers over the past few million years in a thick wedge that runs into the Gulf of Mexico. In this last arc of land where Texas meets the Gulf, the river traverses myriad bands of sediment gleaned from ancient and modern mountain ranges that time has leveled; wind and water scraped down the high points and filled in the low spots, just as I measure a cup of flour for baking.

The coastal prairie was a fusion of forest, grassland, and natural wetlands—a mosaic of trees, meadows patterning the river terraces, and surrounding softly rolling hills. Creeks meandered across the prairies, and seasonal wetlands hosted vast flocks of migratory birds. The aristocrats of the grasses grew here: big bluestem, Indiangrass, and wild rye. In a year with sufficient rain, the blades of grass reputedly grew so tall that only the humps of grazing bison were visible to a rider on horseback. Early descriptions are rife with the names and phrases of the sea: islands of trees in oceans of grass, coves and points of forest like the shores of a lake, and rippling waves of grass. No doubt some of this was due to early travelers' recent sea voyages, but the combination of forest and grassland did not instill awe, fear, or dread in its viewers (unlike the High Plains). Instead, the flower-laden meadows and small forests of live oak and pecan drew rapturous responses that compared the tall grass prairies to European estates, parks, and orchards. Ferdinand Roemer, a geologist and man of science, was so impressed with the pastoral quality of the landscape around Columbus (originally named Montezuma) that he wrote with surprising nostalgia, "The open prairie began again beyond this house, but the ground rose in higher undulations. Here and there a single live oak stood among the tall yellow grass, presenting a view which reminded me very vividly of regions in Southern Germany where fruit trees grow in the midst of ripening grain" (Roemer, *Roemer's Texas*). Herds of bison, antelope, and white-tailed deer were abundant, as were tasty prairie chickens, ducks, geese, cranes, quail, turkeys, and other game birds.

Unlike the heavily forested river corridor of the Brazos and San Bernard Rivers to the east, the bottomlands of the Colorado, by many accounts, included prairies. Early explorers and travelers all noted that in Columbus, the bottomland forest bordered one side of the river and the prairie began immediately on the opposite riverbank. Below Columbus, Ferdinand Roemer noted

Barn Swallows I & II

that "immediately passing this farm the bottom of the Colorado begins, which is only one and half miles wide at this point. The growth of the trees showed great similarity to those found in the Brazos bottom. Under the trees, among which the sycamores were again conspicuous on account of their height, the ground was covered with impenetrable cane . . . fifteen feet high." The cane thickets that he mentions grew thick and lush in the bottomlands of the Colorado, Caney Creek, and the San Bernard and Brazos Rivers.

Another characteristic frequently remarked upon was the "evidences of inundation" that were noticeable in the forests. Collected driftwood, limbs, and mud marked the high water mark on the riverside trees. Although we now count plastic shopping bags, Styrofoam coolers, and empty plastic bottles as

evidence of inundation, seeing a driftline of any sort 25 feet up the trunk of a cottonwood requires a moment of reflection. Today, the National Weather Service calculates that the high riverbanks at Columbus can safely contain a 30-foot river rise before roads and buildings are affected. However, this number may not be accurate. Because the dams upstream suppress the natural cycles, floods no longer regularly scour out the river channel clearing away debris and vegetation. Sediment that previously built deltas at the mouth of the river and refreshed soil on the floodplain slowly fills the riverbed and reduces the capacity of the river channel.

The assumption that the LCRA's dams will protect the downstream counties from floods has yet to be tested. While the majority of floods and floodwaters start in the Hill Country tributaries of the Colorado (the San Saba, Llano, and Pedernales Rivers) and there have been large floods aplenty, we have yet to experience a repeat of the weather patterns that led to the extraordinary floods of 1869 (the flood of record for Austin), 1900, 1913, or the 1930s. In 1900, the *New York Times* reported on the flood that destroyed the Austin Dam: "It is below Austin for a distance of 200 miles that the greatest havoc has been wrought by the Colorado River flood which started here yesterday." The deluge destroyed every bridge between Austin and Columbus. At Columbus the river crest was only 34 feet, nothing compared to the 51.60-foot crest of the 1869 flood or the devastation of the 1913 flood.

The autumn of 1913 was a rainy one for the Colorado River Basin but especially between Austin and the coast. The saturated soil could not hold any more moisture, and early November brought additional rains that resulted in flooding around Columbus and down to the coast. No sooner had people started to clean up and repair damaged property when heavy rains in the upper watershed and additional rains in the lower basin resulted in a second flood wave. At Columbus, the river cut across the neck of the bend and turned the town into an island. People escaped over the railroad bridge until river water undermined the tracks and the only avenue of escape collapsed. The saturated soils of the prairies and coastal plains shed water. According to a U. S. Army Corps of Engineers report filed in 1919, both the Colorado and the Brazos Rivers escaped their banks and broke through their levees more than 40 miles above the coast to merge into a vast lake covering over 900 square miles. Wharton, Matagorda, Fort Bend, and Brazoria Counties were almost entirely underwater. The rivers spread 63 miles wide at the Gulf of Mexico.[1]

In 1938, the LCRA had just completed Buchanan Dam, and the public believed that devastating floods were a thing of the past—that the new dam and reservoir would control floods. But the rains that pounded the upper basin filled the new reservoir, and the river overflowed its banks.

The river slammed through the city of Austin and downstream to the Gulf. The deluge caused extensive destruction in the communities and farms downstream. The farmers were especially hard hit because floods the previous years had destroyed crops and left the farms in debt. The newly deposited layers of fertile soil from the deluges had refreshed tired fields and renewed the farmers' optimistic hopes for a generous harvest. They watched as their crops, hope, and livelihood disappeared under another wave of floodwaters.

The flood of 1938 forced the LCRA to prioritize their goals as flood control first, with power production, irrigation, and other purposes secondary. It also demonstrated the need for better monitoring of the river and weather conditions throughout the basin. The LCRA installed fifty rain gauges and signed up volunteers to call in readings. Combined with the existing U.S. Geological Services system of river gauges, this created the first comprehensive watershed reporting system in Texas and is the basis of today's public, Internet-based Hydromet system.

Before leaving for my Columbus trip, I had checked the Hydromet Web site (hydromet.lcra.org). The river gauges reported that the current stage and flow of the river in Columbus were normal. The meteorological information had no reports of recent rain that could indicate the river level might change. It is late October, so the LCRA is not releasing pulses of irrigation water. With data transmitted via radio equipment, the Hydromet is a great resource for an accurate river report, but unfortunately it can't predict the weather.

I am so cold that I check my feet—my numb toes, though still firmly attached are unnaturally pale. I paddle past Cummings Creek and under bridges. On the left side of the river stands the shattered "Great Wall of Columbus," a creosote-soaked wall of wood. A "fender," or current deflector, it was built in the 1940s to turn the current away from a vulnerable bank. The hanging, splintered timbers silently demonstrate who won this round. Someday, the Great Bend of Columbus will become the Great Oxbow Lake when the river succeeds in cutting through the narrow neck of land to straighten out the channel. I pull into Beason's Park where Frank Howell, owner, with his wife, Evelyn, of Howell's Canoe Livery, is waiting for me. Frank is just one of the

many quietly passionate river people I've met along my travels. In addition to shuttling my gear, he has assembled a stack of printouts about the town's intertwined history with the river, and fixed a flat tire on my truck. Frank cheerfully waves off any offers of payment, insists that fixing the flat was no trouble, sets the thermostat on sweltering when he notices me shivering, and then loads my kayak into the back of my truck. I drive off, warmed by his generosity and kindness.

From Austin and the foot of the Edwards Plateau to Columbus, the river descends almost 300 feet in elevation in 167 miles, enough for a steady current. Once the river cuts into the coastal prairies, the slope levels out to a barely perceptible drop of just over a foot per mile of snaking river. It is virtually level, especially when compared to the 4-foot drop per mile along the Highland Lakes.

As the river snakes sideways across the coastal plain, it bites into bluffs, chews away at cut banks, shoves gravel bars downstream, and cuts across loops, creating oxbow lakes. It leaves behind old stream channels and deep deposits of sand and gravel.

The Rice Belt

Eagle Lake is likely a remnant of the river's ancient path—a 1,400-acre abandoned footprint just east of the Colorado's present course. In 1896, inspired by Eagle Lake's rich clay soils, Captain William Dunovant, a sugarcane grower, experimented with cultivating rice irrigated with lake water. The trial crop was a success, and after the boll weevil decimated cotton fields, farmers converted existing cropland and coastal prairie to rice fields. Today, a network of pipe-

Rice Bowl

lines and irrigation canals stretches from the Colorado River to Eagle Lake and fans out north, east, and south into the former prairies, defining the Lakeside Irrigation Division, one of four LCRA-owned irrigation divisions. The angular filaments of the LCRA's 1,100 miles of irrigation canals run east and west from the river, from the edge of Matagorda Bay north through Matagorda and Wharton counties and into Columbus County. Eagle Lake and the Lakeside Division mark the northern edge of the Rice Belt that extends from Louisiana through the coastal counties and ends just west of the Colorado River Basin in Jackson County.

The Rice Belt is an area where creative land management is the rule rather than the exception. Because growing rice requires very fertile soil (or lots of fertilizer), most farmers rotate their fields, growing rice only one out of every three years. The other two years, the fields either revert to rangeland for cattle grazing or other crops are planted. When the fields go fallow, native grasses regenerate, and, unless the land has been laser-leveled to an even flatness, the shallow pools of temporal wetlands reemerge as havens for wildlife and native plants.

Even these altered prairies are few. For the most part, the natural freshwater wetlands are gone: they have been drained, plowed, and planted with crops, improved pasture grasses, or turf grass farms. Rice fields are by far the most abundant type of wetlands in the Gulf Prairies. And the rice industry is one of the biggest water consumers in the entire Colorado River Basin.

Whenever there is a drought or soaring population predictions pop up (the population along the Colorado River from the Highland Lakes to the Gulf Coast is expected to double by 2060), one of the first ideas promoted by folks upstream is to cut off the water to the rice farmers. Granted, until I visited the area I'd considered rice farming an extravagant relic—a needlessly subsidized and out-dated industry squandering water for the sake of a few farmers.

I learned it just isn't that simple.

As we drained, plowed, or built over the historic freshwater wetlands, wildlife moved to the surrogate habitats of the rice fields. The agricultural operations do not have the diversity of invertebrates, insects, or plants common to the native prairie pothole marshes, but they are the most abundant wetlands in the lower river basin. The rice fields, managed wetlands, and the ponds, sloughs, streams, and marshes that drain excess irrigation water, provide food and habitat for mammals, reptiles, amphibians, overwintering birds,

Green Treefrog: Daytime

and migratory birds following the Central Flyway. One of four major North American aerial highways, the Central Flyway funnels millions of birds along the Great Plains from nesting grounds in the north to wintering grounds that extend from Texas into South America.

Every fall, flocks of geese: snows, blues, Ross's, Canadas, and specklebellies (white-fronted) show up to forage on the rice left in the fields after harvest as well as other grains and sprouting vegetation. Wintering and migrating flocks of ducks such as redheads, pintails, teal, shovelers, gadwall, wigeons, and mallards arrive to stock up on calories. Texas winters 90 percent of the duck populations and 75 percent of the snow goose populations that use the Central Flyway. Migratory and resident shorebirds including long-billed curlews, black-necked stilts, avocets, sandpipers, and plovers work the flooded fields for invertebrates. Rails, bitterns, herons, egrets, ibis, and other wading birds hunt frogs, crawfish, and invertebrates. Flocks of sandhill cranes glean seeds from the fields. Whooping cranes are regular visitors.

The management and preservation of the complex system of natural and surrogate wetlands is in the hands of an intricate and not always conciliatory alliance. Farmers, ranchers, hunters, biologists, environmentalists, birdwatchers, nonprofit groups like Ducks Unlimited and The Nature Conservancy, power plants, industry, Texas Parks and Wildlife, and the LCRA are the guardians and caretakers of the extraordinary and irreplaceable coastal prairie.

On a cool November morning, I wake to the sound of car doors and voices. The muffled words are sharp with excitement as the hunters pack up guns, dogs, and gear. It is still dark; I burrow back under the pile of wool blankets in the guest room at the Spade Ranch in Egypt, Texas. At first light, I hear shotguns booming across the prairie. The clamor of sandhill cranes agitated into flight drowns the second volley of shots. I pull on jeans, coat, and boots and slip outside. I look out over the misty fields from the shelter of moss- and fern-draped live oaks. Flocks of geese and ducks take to the air from their night roosts, circle, and descend to likely spots to feed only to explode back into the air as shotgun blasts reverberate in the pale morning light. A flock of blackbirds settles onto the lawn then skitters like water in a hot skillet, taking

off in waves just seconds after landing. Red wing patches flash like hundreds of warning lights as the birds settle into the oak trees around me. The flock rustles through the branches, making small creaking noises until an alarm sounds. The mass of birds shrieks; the hiss of thousands of feathers fills the air as the birds lift off as one. The cloud shifts and streams away like black ink dispersing in water.

Hours later, when the frost is burned off and the hunters have retired, Genny Duncan and I load up her dogs for a drive out to the rice fields and pastures. Genny and the Spade Ranch can trace their lineage back to 1872—

making them relative newcomers along the river. The land from the coast all the way to Columbus was the first claimed by the "Old Three Hundred"—the Anglo families brought in by Moses Austin and his son, Stephen F. Austin—to settle lands along the Colorado and Brazos Rivers in a program sponsored by the Spanish, and then the Mexican, governments. The Spade Ranch is a long strip of land that begins in the deep shade of bottomland forest on the banks of the Colorado River, then runs northeast across sandy loam to Blackland Prairie. Both Caney Creek and Peach Creek run thorough the ranch: Caney Creek drains directly into the Gulf and East Matagorda Bay; Peach Creek joins the San Bernard River on its way to the Gulf. On the blackland soil, cattle, sandhill cranes, and geese forage in the stubble of the harvested rice crop. Native grasses sprout in the fallow fields. Ruler-straight irrigation canals run through the fields.

Genny and I walk with the dogs to a roost pond leased and maintained by a local hunting outfitter. A line of trees borders a slough behind a pond filled with rainwater and irrigation water. The surrounding fields are roughly plowed and ready for a new crop. Specklebelly geese (white-fronted) happily—and loudly—graze on grass and plant shoots. I train my binoculars on a crow-sized bird standing in the field; my breath catches in my throat. With a sharp tug, it swallows a last beakful of pink flesh and regards me without alarm. Though I've never seen this bird before, I recognize the distinctive dark cap extending in dark "sideburns" below the eye from my field guides. Effortlessly, the peregrine falcon lifts into flight on slender, muscular wings; within seconds it is gone over the horizon.

The duck roost pond has no live ducks, only decoys, but shorebirds and wading birds line the edges of the pond. Black-necked stilts work the shallows with lesser yellowlegs and assorted peeps. A flock of white ibis probes the mud for invertebrates while great egrets, snowy egrets, and great blue herons patrol the edges for frogs and crawfish. American pipets are almost invisible in their streaked brown feathers even as they prance on the roadside, bobbing their tails up and down. Sparrows pop out of clumps of McCartney rose to sing and dive back in when I try to get a good look. Loggerhead shrikes perch on skimpy brush to scan for a meal. Mockingbirds and cardinals fly along the tree line and caracaras, black vultures, turkey vultures, and red-tailed hawks fly overhead.

Prior to 1900 and the beginning of rice cultivation, there were small

populations of geese on the pothole prairies and in the coastal marshes. Ferdinand Roemer, on his way from Houston to Austin, remarked on their presence on the prairie: "Because of the heavy spring rains, the water had collected in numerous puddles. The only living thing we saw on this broad expanse were Canadian Geese . . . a chattering flock of which were grazing in the wet grass" (Roemer, *Roemer's Texas*). There was not enough habitat or food for big flocks of geese (although the more adaptable flocks of puddle ducks foraged from the coast throughout the prairie wetlands). At that time, Wharton County was part of the "Texas Sugar Bowl." However, the sugar industry was not profitable enough, and infestations of boll weevil devastated the cotton industry. In 1903, the U.S. Department of Agriculture invited a group of Japanese farmers to immigrate to Texas to introduce new rice strains. With the introduction of the higher-yielding rice strains and the installation of multiple pumping plants and miles of irrigation canals, rice soon took over as one of the principle crops. By the late 1930s and 1940s, the advent of thousands of acres of rice cultivation fueled by a steady source of water from the river (supplemented, as needed, with additional water from the Highland Lakes) resulted in larger flocks of geese moving in to take advantage of the abundant food source. As the total number of acres of cultivated rice exploded, so did the flocks of geese, to the point that they were becoming serious pests. As long as there is sufficient waste rice and grain for the geese to feed on, things are fine, but the huge flocks can rapidly decimate a coastal marsh, churn a natural wetland into a muddy mess, or ruin an early rice crop. The pinnacle of rice production was 1954, but that was also the era of mass poisonings of geese and other wildlife by poorly understood and regulated pesticides and repellants. Although the height of the goose "invasion" was the 1970s and early 1980s, as the cultivation of rice declined, the goose populations shifted their wintering grounds to the rice fields of the Mississippi Valley in Arkansas and Missouri. Todd Merendino of Ducks Unlimited stressed that the overall population of geese in the United States has not decreased, but, with fewer acres planted in rice combined with hunting pressure, the flocks are certainly shifting away from the Texas coast. "Geese", he says, "will only come as far as needed for food".

Agricultural irrigation (including rice, row crops, turf grass, and pecans) is currently the biggest water consumer in the lower basin, using about 56 percent of the water the LCRA parcels out annually. On average, irrigation consumes 380,000 acre-feet of water per year. The majority of the water comes

Green Treefrog: Nightime

from the river's natural flow; less than a third comes from water stored in the Highland Lakes. Although the LCRA has yet to deny farmers enough water for a first crop of rice, they do not guaranteed water for irrigation. When Wirtz, Buchanan, and Mansfield first proposed the legislation creating the agency, the farmers traded their political support for a promise of stored water to irrigate their crops when the river's natural flow was not sufficient. Unlike the firm water that the city of Austin and other customers buy, irrigation water is "interruptible": there has to be a minimum quantity of water in the Lake Travis reservoir for the sale and delivery of water to the downstream farmers. In the event of a severe drought, the LCRA would cut the water to the downstream farmers. The agency is currently investigating and promoting water conservation methods for the rice industry, including laser leveling of fields, new strains of rice that require little or no flooding, and substitute crops.

As the population of Central Texas increases, cities and power plants (among others) will compete with the rice farmers for the river's water. The future looks dry for the rice farmers—and bleak for the birds, insects, and mammals that depend on the surrogate wetlands.

Below the Spade Ranch, the river rounds a big loop and then runs past the town of Glen Flora. Just above the town, Caney Creek (or its bed, at least) joins the river. They run together for a short distance, and then Caney Creek starts up again—but a few hundred yards from the river's channel. Looking on the geological atlas at the width and depth of the broad alluvial deposits under the meanders of the creek, it seems clear that Caney Creek was once the river's main channel or a major branch of the Colorado. When and why the river changed course is not known. From Glen Flora to the coast, the river runs through what was one of Texas' primeval forests, the former heavily timbered bottomlands. The first Spanish and Anglo settlers quickly recognized the fecundity of the lands between Caney Creek, the Colorado, and the San Bernard River. These were among the first lands claimed and settled by S. F. Austin's "Old Three Hundred". The bottoms were thick with what the settlers called "cane and peach" forests, the creek's namesake. (The peach trees were actually native laurel trees that grew in the canebrakes under oaks and hackberries.) The settlers prepared the land for cultivation by burning out the cane. Then it was relatively easy to either plow up the roots or let livestock graze on the tender young shoots.

Downstream, the town of Wharton is pinned between the Colorado River and Caney Creek. A park stretches along the river in old downtown. Neatly mowed grass slopes down to piers, which extend over the river for fishing. Walls of heavy creosote-soaked timber stand sentry to deflect floodwater from eating into the town's heart. The drop is too steep to launch my kayak, but my goal in Wharton is to fulfill a childhood dream: I'm going to sleep in a concrete teepee.

I don't know where I saw my first teepee-shaped motel, but I've been determined to stay in one since about the age of six—and now is my chance. Built by the Civilian Conservation Corps in the 1930s, the row of cement cones on

the outskirts of Wharton was lovingly restored by the current owners. I check in and unlock the door of my teepee: tiny shower tucked into the curve of the building, toilet wedged by the sink, and double bed in the main room. Small but functional, I happily drop my gear and make myself at home.

Pierce Ranch

The morning is frosty, and unlike previous trips when I could hardly wait to get my kayak on the river, I'm almost relieved that I'll spend the morning on land instead of water. Just west of Wharton, the Pierce Ranch stretches along the Colorado River. Although the ranch is only a shadow of its former self—it once extended from the town of Garwood through three counties to the coast—it is an impressive place for more reasons than its still considerable acreage. Laurance Armour, a descendant of "Shanghai" Pierce, operates the ranch with a sharp eye on the future. We drive down an alley of live oaks past the historic homes, outbuildings, and barns as we head toward the rice fields. He points out a prairie lush with rust and brown grasses: tall bluestems, Indiangrasses, and paspalums. As an experiment a few years ago, they removed cattle from some pastures and discovered, to their surprise, that thick prairie grasses, flowers, and herbs grew. Now they manage a significant amount of rare, untilled prairie and harvest the seed for restoring other prairies on the ranch and in the area. As we drive, he notes spots along the road where invasive King Ranch bluestem is growing. Someone will be back to spray with herbicide before it infiltrates the prairie grasses. The sound of geese and sandhill cranes is the persistent background to our conversation. Geese, ducks, and shorebirds cover the flooded fields. The sheer quantity of life is stunning. At Big Waters, the 190 acres of land set aside for an integrated system of organic rice farming, bird roost pond, and crawfish farming, the shimmering flats teem with dozens of species of shorebirds, duck flotillas, and every species of heron or egret found in the area.

What makes rice unique is not its need for water, but that it can grow in a flooded field.[3] The water suppresses weeds, and the rice gets a head start. When the fields dry out, any unwanted aquatic plants die back. After the first harvest, the fields are often re-flooded to produce a second crop of "ratoon" rice from the plants. While the yield from the plants is not as high as the first

crop, it is a relatively inexpensive way to get a little extra out of the investment. Many farmers leave the second crop for the birds—and hunters.

An important benefit of the flooded fields is that wetlands—natural or constructed—act as efficient biological filters. Studies comparing pesticide, fertilizer, and herbicide residues in rainwater runoff from fields found significantly lower amounts of chemicals in the waterways surrounding seasonally flooded rice fields compared to traditional crops, even though rice crops require high doses of such "agrichemicals." At the Pierce Ranch, the organically managed fields are flooded for waterfowl roost ponds and crawfish production. The birds deposit lots of rich manure; the crawfish use the same water as the roost pond and are a cash crop. It is an elegant system, which benefits both native wildlife and the land. On the conventionally managed fields, the ranch alternates seasons of rice with row crops like corn and letting the fields revert to grassland for grazing the ranch's famous Brahman-Hereford cattle. Indeed the ranch has been home to experimental farming and ranching since its inception. "Shanghai" Pierce, in addition to being a larger-than-life Texas settler (with an ego to match, by all accounts) was an adventurous spirit. He was convinced that Brahman cattle would thrive in the heat and humidity of the Texas coast, and his son-in-law imported the first Brahman cattle from

India after "Shanghai's" death. The Pierce Ranch participated in the USDA's program to invite Japanese farmers to introduce new rice strains and manage the ranch's labor force of Mexicans, Chinese, and Russians. Later, he allowed the USDA to set up experimental fields growing tea, poppies, and camphor trees. So it is no surprise that the Pierce Ranch is working with the LCRA on a project for an off-channel reservoir for floodwater.

The LCRA has been planning to dig big, shallow reservoirs on land along the river downstream of Columbus for years. These off-channel reservoirs will fill with "excess flows" or "scalped" floodwater pumped from the river. Levees would contain the reservoirs, but the lakes would not provide any wildlife habitat or recreation benefits. Short grass along the levees would be the only vegetation, with no riparian plants along the edges of the ponds or aquatic plants for wildlife. The water from these reservoirs might be for irrigation, sold to the water-hungry power plants and chemical plants downstream, or even pumped across country to a thirsty city like San Antonio. San Antonio has been angling for Colorado River water for decades; for a while, there was an enormously expensive agreement between the LCRA and San Antonio Water Supply (SAWS) to sell water to the distant city. As part of the project, a 4,200-acre reservoir was planned on Pierce Ranch land. While the LCRA-SAWS project is technically defunct, chances are that since the studies have been completed and paid for, there will likely be a 4,200-acre reservoir on the Pierce Ranch someday.

Laurance Armour and I stand on the high sandy banks of the river where the intake pipes are destined to sit. Ten 6-foot pipes in the river. "Big enough to drive a 4-wheeler through," he tells me. "Big enough to pump the entire river out of its channel." We walk above the river, sycamore leaves flutter bright yellow, sumac burns red, and rattlebean rustles dryly along the bank. Without my asking, he explains why the Pierce Ranch agreed to the LCRA deal, "It seemed like the least intrusive way we could ensure the longevity of the rest of the ranch and its resources." His statement has the cadence of a speech oft repeated, but a tiredness in his voice belies the confidence of his words. We drive into the area I'd wanted to see—the 6,000-acres of bottomland hardwood forest the ranch has protected from logging and clearing.

But Armour has done more than just protect the woods on the Pierce Ranch. In 1996 he was instrumental in gaining public approval for the Austin's Woods Initiative (also called the "Columbia Bottomlands") a system of

federal, state, and private refuges along the Brazos, San Bernard, and Colorado Rivers. The bottomland hardwood forests are a waystop for an estimated 29 million birds (over 230 species) that migrate through, overwinter, or breed in the area. After long flights—some are nonstop across the Gulf of Mexico—the shelter, water, and food provided by the forest are essential to the survival of the neotropical migrants. There is no way to make the forests economically "productive," but their value as habitat is incalculable. Someday we'll be able to put a dollar value on ecosystems and their benefits and find ways to allow property owners to preserve riparian woodlands, prairies, and other habitats. Most property owners can't afford to set aside 6,000 acres of bottomland hardwood because of its value to wildlife; it simply doesn't pay the bills.

Bill and I spent a warm spring weekend in a cabin in the Pierce Ranch woods with my brother Chris, and his two sons. We walked the trails through the woods and along the river. Spiderwebs spun across the paths induced a steady parade of Kabuki-theatre gestures and yelps as we scraped the sticky strands off of our faces and out of our hair. Deer, wild hogs, armadillos, raccoons, and squirrels ran through the woods. The boys chased crawdads in the cabin's pond and juvenile broad-banded water snakes and turtles along the river. We followed mussel tracks in the river beaches and dug up the shellfish—always returning them to their sandy home. Fat, greasy-looking water moccasins were everywhere. Live oaks festooned with bright Virginia creeper, gray Spanish moss, and crowns of vermilion trumpet vine anchored the forest. Slender hackberries stood straight and tall with their own complements of moss and ferns. The understory in the forest was thick with yaupon, cherry laurel (the peach trees of the cane and peach lands), poison ivy, tall grasses, and sedges. Wild grapes covered whole trees with a drapery of dark leaves, creating a rolling green line of Dr. Seuss shapes along the river. During the daylight hours, the soaring canopy resounded with songbirds and woodpeckers. At night, the mosquitoes chased us indoors where we stuffed paper to block the holes in the screens and ate by lantern light. Astonishing numbers of green tree frogs called from the pond and from high in the tall trees. The calls were deafening, and we fell asleep with rising waves of their competing metallic "rink, rink, rink" calls washing over us.

The next day, Bill and I paddled the river from the TPWD David S. Hall boat ramp south of Wharton down to the LCRA Hollywood Bottom Park below Pierce Ranch. It is one of my favorite sections of the river: ten or so

miles of high sandy banks with white beaches in the big, slow bends; grape-vine draped forest; rolling pastures—and all of it teeming with wildlife. The river floods often enough that most people are smart enough to build their homes away from the river's edge, and a thin strip of riparian forest looms over the east bank. On the west bank stretch the Pierce Ranch's acres and acres of woods. There is enough current to make it a lazy paddle, and a breeze keeps us cool in the spring sunshine. After 6 miles of profound bliss, we come to the Lane City irrigation pumping center and dam. The dam is marked as a hazard on the LCRA's *River User's Guide* and, supposedly, there is a portage for haul-ing boats around the dam. Before we left home, I had called the LCRA's num-ber for Colorado River Trail information. They had no information about the condition of the portage. After a long string of calls, I finally spoke with a

Lane City Dam LCRA canoe portage on the Pierce Ranch

friendly LCRA engineer who assured me that although the portage had long ago washed away (leaving a 20-foot-tall sheer bank), the river was running at a level where we could easily carry the boats around the shoulder of the dam. He confessed that in all his years running the Lane City Dam and pump station, he'd never seen anyone kayaking the river "just for fun."

The low dam sits in a bend of the river, constructed to pool water for the irrigation pumps. As the engineer predicted, we easily haul the kayaks over the concrete shoulder.

Deeply eroded sand and a jumble of pipes, nets, and multiple patterns of concrete retaining blocks are a timeline of the struggle to keep the dam in place. Where the water pours over the edge, riprap—large chunks of concrete—creates shelter in a deep pool. Several fishermen stand on the faux boulders and toss out lines for catfish. The 4 miles to Hollywood Bottom Park are serene. The river throws big languid loops and curves downstream. The channel is narrower, and the sandy beaches are larger. I relax and lean back in the kayak and watch Bill lazily cast a fishing line under the shade of willows. As we haul the boats up the beach at Hollywood Bottom Park, a crow swoops behind Bill cawing loudly. Bill drops the handle of the kayak and turns around. "What," he says, "are you yelling about?" Then he wants

to know why I'm laughing, and I try to explain that he's mistaken me for a crow. I take it as a compliment.

The Raft

The Colorado River has always been an erratic stream, prone to temperamental bouts of violent flooding followed by puny trickles that barely wet the streambed. While the river's extraordinary rising and falling have always been a spectacle, a massive natural phenomenon quietly grew downstream for centuries. Virtually unnoticed by the people living upstream, the state and the nation, the "Raft" shaped history, geography, land use, and settlement of the river basin.

The Raft was an anomaly. No one had ever seen anything like it on such a dramatic scale. Sure, small accumulations of driftwood and debris are normal in any river, but the Raft could be measured in miles, and it completely blocked the river channel. Driftwood, whole trees including crowns and roots, buildings, bridges, fences, waste, trash, garbage, and odds and ends that washed down from the entire river basin ended up in a tangled 20–40-foot-tall heap cemented into a solid mass by fine silt, sand, and soil. Trees, shrubs, and vines sprouted and grew on the logjam. A 10- to 12-mile-long lake of dead water backed up the river channel behind the cork-like raft. While some rivulets threaded their way through the network, most of the river overflowed for miles onto the surrounding floodplains. Every low area, creekbed, oxbow, or stream meander became a pond or lake surrounded by marshes and permanently flooded swamps for miles on either side of the river channel.

By 1924, the "Big Raft" had crept upstream to a mile or two below today's Hollywood Bottom Park and stretched 20 miles downstream to Bay City. The naturally impounded lake at the head of the Raft reached upstream past Wharton. Water surrounded and nearly submerged the Lane City pumping station built 20 feet above the river. Lower Wharton County and much of Matagorda County were a vast series of broad marshes, lakes, swamps, and standing water, with the river shattered into dozens of thin, slow streams. Timber covered scattered patches of high ground. Estimates of the total acreage flooded—during normal flow levels—ranged in the tens of thousands of acres. The standing water drowned much of the bottomland hardwood forests, replacing the oaks,

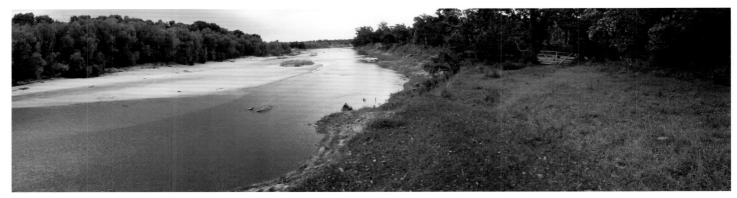

Colorado River in Wharton County near Hollywood Bottom Park

pecans, and other trees with willows and other water-loving trees. A 1922 article from Bay City's *The Daily Tribune* describes the scene as "the most desolate waste imaginable . . . a deep, silent impenetrable swamp" that extended back from the river as much as 3 miles. Irrigation companies took advantage of the flooded bottomlands and plunged the maws of pumps into the oxbows and deep pools far from the river. On the west side of the river, enough water backed up that irrigators were able to use systems of gravity-fed canals to flood rice fields.

The first mention of the Raft was in 1690 when an expedition of alarmed Spaniards rushed from Mexico to locate and rout La Salle's French fort on Matagorda Bay. At this time, the river had an expansive natural delta with multiple branches of the river flowing into the bay—and there was no land bridge dividing East Matagorda Bay from Matagorda Bay. The ship's captain reported that of the multiple branches of the Colorado River flowing into the bay, a collection of logs and debris blocked the west branch.

In 1815, one hundred and twenty-five years later, the Raft was still there and growing upstream from its origin in the slack, tidal waters. The head of the Raft grew upstream at the rate of a mile or more per year, while the foot or tail of the Raft gradually rotted and washed downstream at a slower rate.

The Raft flooded land as it grew. This benefited the rice farmers, but Matagorda County had to construct expensive levees to protect Bay City, farms, and pastureland. As the Raft continued upstream, the citizens of Wharton County began to fret as valuable farmland was submerged, and the clogged channel exacerbated seasonal flooding. Some predicted that the Raft would continue to grow upstream past Wharton, and eventually the river would divert down the town of Caney or Wilson Creek to flow to the Gulf.

It was not until 1925 that a solution presented itself to the citizens of Wharton and Matagorda Counties in the form of a civil engineer by the name of J. P. Markham. Unlike most of the proposed plans that required digging hugely expensive new river channels *around* the Raft, his elegant and surprisingly simple solution was to let the river do the work. By removing key logs, the river's flow, even at its reduced rate, would flush out the accumulated silt. Other engineers scoffed at the Markham Plan, but the Matagorda County Reclamation Board decided it should have a trial—especially since no one had the money for an $8 million by-pass channel.

The Markham Plan rapidly proved successful, but not everyone was pleased. Irrigation companies and rice farmers had invested money in pumping stations on the flooded oxbows and lakes away from the river's channel; on the west side, the irrigation canals were gravity fed. With the Raft gone, the floodplains and the lakes would drain, leaving their pumping stations high and dry. A skirmish ensued—grandly titled the "Twenty-Minute War"—between the rice farmers on the west bank who needed water for their current rice crop and the County Sheriff's men backed by the Texas Rangers. The two sides squabbled, blew up each other's dams, and ultimately resorted to shooting at each other. The gun battle ended with arrests, but the participants came to a gentlemen's agreement in court and all charges were dropped with a vow to never discuss the incident again. An irrigation company installed pumps in the main channel of the now-flowing river to irrigate the rice fields and save the harvest.

The river returned to its main channel, water receded into sloughs and oxbow lakes, and thousands of acres of silt-enriched bottomland re-opened to grazing and farming.

Alternate Endings: Bay City to the Bay

Standing with landowners David and Marilyn Sitz and looking down into a 40- or 50-foot sand canyon at the LCRA's Bay City Dam, I'm deeply disappointed. I found a 1963 newspaper article rhapsodizing about the inflatable rubber dam that the LCRA was installing ("Largest in Existence!" the headline trumpeted), and I imagined something along the lines of a giant, bulbous black rubber prophylactic. But this doesn't look like much of anything. David

tells me that the original "Fabridam" is long gone, though the dam still uses an inflatable bladder system to raise and lower the reservoir level for the LCRA's Gulf Coast Irrigation Division's pumps. The last dam on the Colorado, it is enough to block migrating fish, like eels, from traveling upstream during normal stream conditions. (In fact, not a single dam on the Colorado River has a boat chute or a by-pass structure for migration of fish up and down the river.) Downstream, twisted steel girders emerge from the riverbed, remnants of former dams, and a toothy smile of destruction. The portage for canoes and kayaks has mostly washed away.

We drive along the bank; 40 feet below us the river winds through the sand canyon. If the dam was disappointing, the constructed wetlands on the ranch are a pleasant surprise. Marilyn tells me that the Texas Parks and Wildlife

Pond Cycle

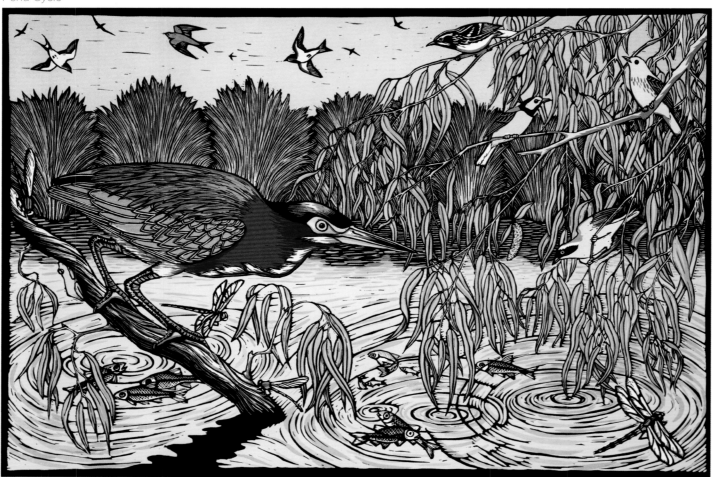

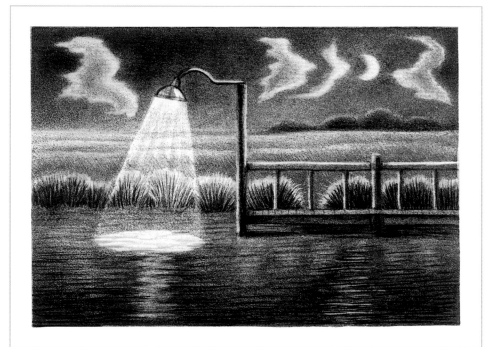

Department approached them about building a wetland in the pastures and pecan groves above the river. In cooperation with Ducks Unlimited, NRCS, and the USFWS, a system of ponds, sloughs, and dams was installed to create freshwater wetlands. Wintering and migrating birds visit, wood ducks nest in the sloughs, and alligators breed in the ponds. "No telling how many ducklings the alligators have eaten," Marilyn dryly notes. Hunters thin the alligator population every year. Marilyn points out a bald eagle nest she monitors on a neighbor's property.

The river from below the Bay City Dam to Matagorda Bay barely resembles the original meandering stream described by explorers and early settlers. By 1960, the county and the U.S. Army Corps of Engineers had tidied up, straightened, dredged to an even depth, and widened the last 17 miles of river down to the Gulf Intracoastal Waterway (GIWW) for commercial barge traffic.

Heading downstream from the FM 521 River Park boat ramp in our jon boat, Bill and I are going into the teeth of the wind. In seconds we are soaked with spray. Bank swallows and northern rough-winged swallows dance over the dark green water. The trees and brush next to the river form a narrow corridor populated with dozens of egrets and herons of all different sizes and colors. Not far downstream from the boat ramp, the low banks transform into

rolling lawns. Each house seems to have a fishing dock with lawn chairs. Some of the docks have big stadium-sized lights to attract fish at night.

We pass the intakes for the South Texas Project (STP, formerly the South Texas Nuclear Project). The power plant squats on the edge of its cooling pond just 10 miles from the coast. STP is expanding and building additional reactors. Upstream, a private company has plans for a new coal-fired power plant. There are rumors that the city of Austin (as well as the LCRA) has options on land to build additional power plants along the river. Why would Matagorda County need all this electricity? It doesn't, but its neighbors are hungry for cheap power. Conveniently situated between Houston, Austin, San Antonio, Bryan-College Station, and Corpus Christi, STP transmission lines already stream across the countryside, ready to carry generated power from STP and new power plants. The Colorado appears to be a ready source of water and the LCRA an amenable ally.[4]

The earliest maps of the Colorado River and Matagorda Bay describe a river delta that bears little resemblance to the current system of channels, locks, and canals near the small town of Matagorda. When Stephen F. Austin's settlers first laid claim to the lands along the Colorado, the river split into multiple branches that fanned out to create large islands that still bear the first settlers' names (though they are no longer recognizable as islands). Frederick Law Olmsted noted, "On approaching its estuaries . . . the Colorado forms a multitude of bayous and its current lessens without increasing in depth. Its width does not vary greatly: it is some hundred paces wide at most. Its course is over sandstone, and the waters are clear when it is not flooded" (Olmsted, *A Journey through Texas*).

In 1829, the town of Matagorda was a tidy rectangle of plotted streets on a high sandy bluff overlooking the port on the east branch of the Colorado with the bay at the town's back. The east branch curved away and emptied into Matagorda Bay nearly 2 miles west of the town. St. Mary's Bayou, a small stream that diverged from the river, meandered through the western end of town. Today, the river cuts a jagged border on Matagorda's west end, and the Intracoastal Waterway runs south of the town. But the bay is nowhere in sight.

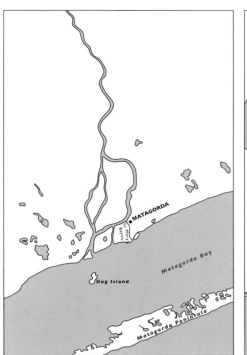
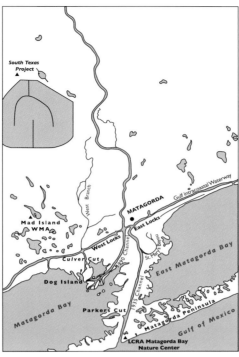

In 1875, during a spring flood, the river tempestuously sent its main current down St. Mary's Bayou into the bay, shearing off the western edge of town. By the late 1920s, as Markham's crews successfully disassembled the Raft upstream, the debris and sediment washed downstream. No one, it seems, had considered where the remains of the Raft would end up. The timber snagged on the shoals at the mouths of St. Mary's Bayou and the East Branch, and gradually clogged the rivers' mouths at the bay. Water backed up in front of the new obstruction. For the next ten years, even a moderate river rise caused flooding in Matagorda and as far upstream as Bay City.

In the summer of 1929, a flood rushed through the lower river with such force that it swept almost the entire remains of the Raft down the East Branch and St. Mary's Bayou and out into the bay. In the shallow waters of Matagorda Bay, the mass of slowly rotting logs continued to catch silt, and the emerging delta grew at the astonishing rate of 500 acres a year. The Intracoastal Canal, then located in the open waters of the bay, was completely filled with silt and abandoned. The town of Matagorda became virtually landlocked.

By 1934, the emerging delta had grown over 6 miles across (on the west)

the Bay, creating a land bridge to the Matagorda Peninsula—and cutting the bay in two: East Matagorda Bay and Matagorda Bay.

Frustrated and annoyed by the devastating floods and the mired navigation channels, in 1935 county officials diverted the river directly to the Gulf by dredging a 6.4-mile channel from St. Mary's Bayou at Matagorda through the land bridge and across the peninsula. With the completion of the river channel and the blocking of most of the natural waterways (all except Parker's or Tiger Island Cut into Matagorda Bay), the river's freshwater, silt, and nutrients bypassed the bays to pour directly into the Gulf.

Meanwhile, the entire shoreline of the Gulf Coast, from Florida to the Rio Grande, was undergoing significant alteration by the U.S. Army Corps of Engineers as they built the system of canals, locks, floodgates, and channels that we now know as the Gulf Intracoastal Waterway (GIWW). Originally, the canals were dredged through the open bays, but in 1923 a drastic change was proposed and approved. The change moved the channels to *inside* the shoreline. The landlocked route would be easier to maintain, and ships would have additional protection from storms. The U.S. Army Corps of Engineers did not consider the potential consequences of the plan on the coastal marshes and bay; they approved the plan, and dredges ripped into the estuarine marshes. The canals cut into the freshwater marshes along the shores of the bay, enlarging the narrow necks of the freshwater sloughs, creeks, and lakes so that tidal water flowed inland, altering the salinity of the marshes. By 1942, the GIWW ran along the Texas coast from the Louisiana border to Corpus Christi. The Corps cut the GIWW along the bay's original shore next to the town of Matagorda, took over management of the new river channel, and installed floodgates, and later, locks where the Intracoastal and river intersected.

On an early December morning, in dense fog, Captain James Arnold steers his oyster boat through the river locks. I stand on the prow, bundled in multiple layers that begin with wooly thermal underwear and end with a rain coat. Mist settles on me, collects in the creases of my coat and drips to the deck. The damp cold has numbed my feet and turned my nose icy. I protect my binoculars from the mist with one hand, and hold onto an all-weather notebook with the other. The fog condenses on my glasses. I wipe them repeatedly, wondering if I'd be better off putting them away. The captain wipes his glasses with a red bandana and guns the engine as he wrestles the boat through the opposing currents at the junction of the Colorado and the Intracoastal. We plow past

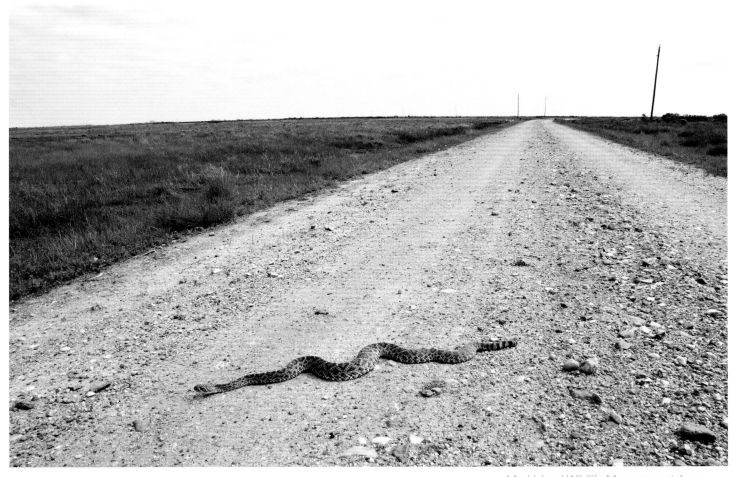

the smashed and gouged timbers lining the locks. The intense currents make this a dangerous transit for barges and boats. Ghostly brown pelicans perch on the beams, interspersed with gulls and terns. Even the normally raucous gulls are quiet in the smothering fog. We leave the turbulent locks behind and follow the Intercoastal Waterway to the narrow and peaceful West Branch, which runs along the Texas Parks and Wildlife Department's Mad Island Wildlife Management Area.

We hear Brent Ortego calling out to us long before we can see him in the fog. Brent, one of the founders of the Matagorda County-Mad Island Marsh Christmas Bird Count (MCMIMCBC) has been out looking for owls since midnight, the official start of the count. The National Audubon Society's Christmas Bird Count, or CBC, is an annual volunteer event. Birdwatchers

set out to tally number of species and total number of birds in 15-mile-wide circles all over the world. The Mad Island CBC consistently ranks number one in the nation with the highest number of species counted, usually around two hundred and thirty-three (and it might also have the longest name as well). The high count is due in no small part to dedicated volunteers like Marilyn and David Sitz who organize the event; Captain Arnold who donates his time, fuel, and the use of his boat; and the birdwatchers that slog through marshes, drive beaches, paddle kayaks, walk miles through prairie, and peer relentlessly through spotting scopes.

Centered on the Colorado River, and incorporating both the Mad Island Wildlife Management Area and the adjoining Texas Nature Conservancy Clive Runnells Family Mad Island Marsh Preserve, the CBC area covers rare coastal prairie, freshwater marsh, coastal marsh, spartina (salt grass) marshes, rice fields, brush land, bottomland hardwood forest, tidal marsh, Gulf shoreline, bays, estuaries, and backyards. The variety of habitats supports a diversity of wildlife and plants unimaginable to most people. Over two hundred and fifty species of birds rely on the prairies, wetlands, rice fields, and marshes for feeding, resting, and roosting. Alligators, bobcats, white-tailed deer, armadillos, reptiles, amphibians, and coyotes live on the preserves. The bays and estuaries are teaming with fish, crustaceans, mollusks, invertebrates, and plankton.

Brent loads his gear onto the boat. Optimistically, we assume the fog will burn off, and we will see—and count—scores of birds. The hand-built boat slips down the Intercoastal. The fog, instead of lifting, has gotten denser; the water is smooth and reflects the gray so that there is no horizon, no delineation between water and air. When the sun sneaks through fissures in the clouds, the light refracts off billions of suspended water particles, and everything is at once illuminated but wrapped in bright, dense cotton. We feel our way along the edge of the channel, keeping the gray-green smudge of shoreline as our visual anchor. The fog condenses onto us, our gear, and the boat. My vision is as blurred with the mist-coated lenses as without. I give up wearing my glasses.

Figuring out where a river ends should be easy, but all the engineering of the last century has given the Colorado River what I'd call alternate endings. Like many, Captain Arnold, a retired commercial fisherman, calls the 1935 channel the "Old River Channel" and its opening to the Gulf, the "River's Mouth." Biologists insist that the 1990 diversion channel sluicing the river's freshwater into Matagorda Bay is the mouth. The LCRA has it both ways: they

advertise their Matagorda Bay Nature Center as located on the mouth of the river (with two miles of river frontage) although it sits at the junction of the old channel with the Gulf; but they also refer to the new channel in Matagorda Bay as the Colorado River delta. Since deltas only form at the mouths of rivers, it causes confusion about where the river really ends.

Before the Raft clogged the river, and before channels sluiced and diverted the waters, the river emptied into the bay, spreading a fan of nutrient-rich water directly into the bay. The plume of freshwater nourished plankton, invertebrates, fish, and shellfish in the shallow waters of Matagorda Bay. Even as the Raft disintegrated and debris built up in the bay, freshwater continued to seep through the emergent marshes in a network of bayous and cuts. After the land bridge split the bay, the construction of the 1935 channel sealed off all the seeps, cuts, and natural channels (except for Parker's Cut) so that the river, with all of its sediment and nutrients, poured directly into the Gulf of Mexico. By the late 1980s, biologists, commercial fishermen, recreational anglers, and the U. S. Army Corps of Engineers recognized that without the river's freshwater inflows, the bay's ability to support life had diminished. So the Corps, in an attempt to invigorate the bay's fisheries and rectify the problems caused by the 1935 river channel, dug *another* channel, this one diverting the main flow of the river into Matagorda Bay. At the same time, they blocked off Parker's Cut.[5]

As far as I'm concerned, the old river channel between the town of Matagorda and the peninsula is not the river. The water that flows down the angular canal is primarily salt tidal water with a little freshwater pulled through the GIWW. My money is on the latest channel and the emergent delta building in Matagorda Bay.

As Captain Arnold steers the boat through the new delta in the thick sea fog, we can hear thousands of birds—a cacophony of keens, squawks, honks, croaks, oinks, and squeals—but see only the vague shapes of marsh grasses. The fog thins and for a few moments it lifts, revealing a surreal and primal landscape: tangled masses of white-spattered black driftwood loom, racked with pelicans, cormorants, gulls, and terns. Flocks of long-billed curlews, plovers, avocets, black-necked stilts, and sandpipers industriously work mudflats. Gangs of gulls and terns hunker down on mudflats in rows, all pointing due south. Oyster reefs peek above the surface of the bay, bedecked with flocks of black skimmers. White ibis, roseate spoonbills, and hundreds of herons and

Pelicans in the Mist

egrets wade along the edge of the marsh grasses, feeding. Kingfishers and osprey patrol up and down the canal. A stranded steel sailboat lists heavily in the center of the channel.

Around us, the sediment- and nutrient-rich river water mixes with seawater to create habitats that sustain the entire bay's ecosystem. The river's freshwater is the key ingredient in an estuarine soup simmering with life in Matagorda Bay. Crabs, oysters, shrimp, redfish, flounder—they all depend on the river's water. The salinity gradient caused by the freshwater mixing with bay saltwater creates a nursery for nearly all species of the commercially and recreationally important fish and shellfish in the Gulf. The sediment flushed into the bays contains nutrients and detritus that support the plankton and bacteria that are the bottom links in the food chain. The sediment drops out of the water, creating mudflats that sustain a variety of organisms, including bacteria and tasty invertebrates for birds and fish to feast on. Then, as salt grass colonizes the mudflats, tidal marshes form, full of nooks, crannies, and niches for life to flourish above and below the waterline.

The mist closes in again but, just before I lose sight of the rich pageant, I recognize the network of branching freshwater streams cutting through the mud flats and salt grass: it is the mirror image of the slender branching streams of the headwaters. In the midst of this salty expanse, I find the conclusion of more than 850 miles of wholly Texas waterway. Before me, the river trans-

forms once again, this final time into a primordial mix of earth and water, into a new world.

From its inception as narrow, intermittent streams beneath the Caprock, the river changes character like an actor flinging off costumes: muddy reservoir, polluted and ignored waterway, rushing Hill Country stream, spring-fed river, deep reservoir with a boat-cluttered surface, liquid placeholder for Austin's heart, and languid deep channels. Throughout the journey, it is primarily a freshwater ecosystem. All its other characters are dependent upon this principal and essential identity. To some, the river is nothing more than a water supply—a commodity and resource reserved entirely for people's use and benefit. To others, the river is a living entity with an inherent right to survival.

After many years of ambivalence about where my home lies, I've found certainty in the pushing, shoving, looping curves running from the brink of the Great Plains to the rich waters of Matagorda Bay. My river.

And yours.

Notes

Chapter 1

1. The USGS officially locates the source of the Colorado River at Latitude 32° 40' 47" N, Longitude 101° 43' 51" W, which puts it at the foot of the Caprock Escarpment. Because maps of the Colorado River Basin, or watershed, extend across the Panhandle and into New Mexico, some writers have mistakenly reported the Colorado's source as near the New Mexico–Texas state line.

2. While there is considerable confusion over the difference between the terms, I refer to *plains* as primarily flat expanses of grasslands that are practically treeless. I use *prairies* to describe areas with a fusion of grasslands and forests. The proportion of forest to grassland varies; a prairie can have grasslands with scattered single trees or small clusters, like the oak mottes found on the Edwards Plateau, or a prairie can also be bottomland forests along rivers interspersed with small meadows.

Chapter 2

1. Texas is divided into ten distinct ecoregions, or ecological regions. Each ecoregion contains characteristic, geographically distinct assemblages of natural communities (plants and animals) and is defined by its environmental conditions, especially climate, landforms, and soil characteristics. The ecoregions are the High Plains, the Rolling Plains, the Cross Timbers and Prairies, the Edwards Plateau, the Blackland Prairies, the Post Oak Savannah, the Gulf Prairies and Marshes, the South Texas Plains, the Piney Woods, and the Trans-Pecos. The Colorado River flows through seven of the ten ecoregions.

2. As of October 31, 2011, Lake J. B. Thomas is 1.64 percent full. The CRMWD stopped pulling water from the reservoir in 2008.

3. When water is stored in open lakes, a significant portion is lost to evaporation. The estimated 72 inches per year is the average that takes temperatures, wind, and rainfall into account.

4. The other Superfund sites in the Colorado River Basin are Rogers Delinted Cottonseed Co., also in Colorado City; Bailey Metal Processors in Brady; contaminated groundwater in Kingsland; and Hu-Mar Chemicals in Palacios.

5. In 2008, as part of the delisting process, the U.S. Fish and Wildlife Service entered into a Memorandum of Understanding (MOU) with the CRMWD to provide for minimum flow releases from Spence and Ivie in perpetuity to ensure habitat for the Concho water snake.

6. The CRMWD ceased pumping water from E. V. Spence Reservoir in July 2011. By October 31, 2011, the reservoir measured less than .05 percent full.

7. The use of acre-feet as a measurement standard reflects the historical agricultural basis of our water rights system. An acre-foot of water is enough to cover one acre of land with one foot of water, or 325,851 gallons. One acre-foot of water is enough water to last a family of four for up to two years.

8. CRMWD General Manager John Grant predicts that by December 2012 the CRMWD will have pumped all the water out of O. H. Ivie Reservoir. Conditions on October 31, 2011 gauge the reservoir at less than 20 percent full.

9. The extreme drought conditions of 2010–2011, including the record heat and evaporation rates have spelled disaster for the CRMWD. The District is in the process of expanding its groundwater supplies with up to twenty-one additional wells in their Ward County well field. A $140 million pipeline to deliver the water to customers is under construction. Additionally, a water reclamation place (for processing wastewater for reuse) is being built in Big Spring. General Manager John Grant continues to advise customers to conserve water.

Chapter 4

1. The Vanishing Texas River Cruises operate from the dock of the LCRA's Canyon of the Eagles Nature Park. Approximately 800 of the 940 acres of the park are a nature preserve and managed for endangered black-capped vireos and golden-cheeked warblers. There is a privately managed resort and lodge along with RV and tent campgrounds.

2. Paraphrased from LCRA promotional materials including "Ready for the Next Flood" video; "The Water Never Got This High Before" (promotional DVD); and Buchanan Dam Museum displays.

3. The Insulls' Middle West Utilities Company also surveyed the Rio Grande River with an eye to developing hydroelectric power. Potential dam sites included Santa Elena Canyon and Boquillas Canyon in the Big Bend region.

4. The official appraisal of the property was $3,798,058. After the debts were settled, some $1.2 million remained as profit for the Colorado River Company. What happened to the profits remains a mystery. The records indicate that the majority of the settlement was divided among Ralph Morrison, his son-in-law C. G. Malott (president of the Colorado River Company) and Alvin J. Wirtz.

5. Floodplains are the areas along a waterfront (lake, river, or stream) that are likely to be inundated in the event of a major flood. A 100-year floodplain has a 1 percent chance of being inundated by a 100-year flood in any given year. 100-year floods can occur at any time. It is possible to have two 100-year floods in one year. There is a 1 in 500 chance of a 500-year flood occurring in a given year. The USGS predicts the levels of 100-year floods (and floodplains areas) through analysis of stream flow and other records. On Lake LBJ, the 500-year floodplain is 841 feet above mean sea level.

6. The twelve months from October 2010 through September 2011 have been the driest on record. The summer of 2011 also ranked as the hottest ever with 90 days of 100-degree temperatures. The combination of record low rainfall and extreme heat resulted in exceptional drought conditions throughout the lower Colorado River basin. As of October 2011, Lake Travis and Lake Buchanan (combined) were 37 percent full. All boat ramps on Travis and Buchanan are unusable and closed due to the low water levels. Public boat ramps on the pass-through lakes (Inks, LBJ, and Marble Falls) remain open.

7. Because city and industrial customers typically buy far more water than they will actually use as a way to prepare for long-term growth, demand for LCRA water is not expected to outstrip the nonprofit utility's supplies until around 2080. This assumes that no droughts will occur that exceed the 1950s drought of record.

8. The federal investigation by engineer Harry W. Bashore concluded that "better preparations should have been made for emergency operations at Buchanan Dam, yet it is doubtful if any careful forethought would have had much effect in reducing the damage covered by the flood."

9. Initially the LCRA had insisted that the city deed the dam and all adjacent properties to the Authority. The public and city officials rejected this plan outright. Mayor Tom Miller appealed directly to the head of the PWA for a lease plan, which was eventually approved, in spite of the requirement that the LCRA own any projects funded by the PWA.

10. To the U.S. Fish and Wildlife Service, "Endangered" is "The classification provided to an animal or plant in danger of extinction within the foreseeable future throughout all or a significant portion of its range."

11. A Spanish explorer named the Balcones Fault for its balcony-like topography. Not, as I've heard, after a mythical Edward Balcone.

12. Town Lake was renamed Lady Bird Lake on July 26, 2007 to posthumously honor former first lady Claudia Alta "Lady Bird" Johnson. She was honored for her legacy of beautification efforts that are still evident today along Town Lake, highway roadsides, and at the wildflower center that bears her name. Johnson died on July 11, 2007.

13. Formerly known as the Chautauqua River School.

14. Austin draws its water out of Lake Austin. The Thomas Green Water Treatment Plant on Lady Bird Lake, which closed in 2008, was downstream of Barton Creek, so some of the city's drinking water did come from the Edwards Acquifer in the past.

Chapter 5

1. After a series of articles in the *Austin American Statesman* in October 2009, a response by the Texas Department of Transportation, Texas Parks and Wildlife Department, the city of Austin, and the LCRA has resulted in the area getting cleaned up. Improvements include parking areas, concrete barriers to prevent driving to the river's edge, more trash cans, increased numbers of trash pick-ups, and frequent visits (and tickets) by game wardens. Local residents are pleased. Hopefully the changes will be lasting.

2. Colorado River Watch Network volunteers conduct monthly tests for several key water quality indicators including dissolved oxygen (DO), water temperature, pH, *Escherichia coli,* specific conductance, nitrates, transparency, and the presence of plants and aquatic life. The data is managed by the LCRA.

3. Repurposed in the 2008–2009 school year as Eastside Memorial High School.

4. In October 2011, the U.S. Fish and Wildlife Service decided that five central Texas mussel species qualified for listing as threatened or endangered under the Endangered Species Act. Currently the mussels are considered candidate species; it is likely they will be listed for protection in the future. All five species historically occurred in the Colorado River basin. Visit the USFWS web site for additional information

5. Water supplies managed by LCRA are divided into "firm" and "interruptible" stored water. Firm water is available even during a severe drought. Cities, industries, and electric power plants rely on firm water supplies. During water shortages, interruptible water, which is mostly used for agriculture, is subject to rationing or curtailment first—before firm water supplies.

6. *La Maligne* was La Salle's name for the Colorado River after a servant was drowned by an alligator while crossing the river. The French also referred to the river as *La Sablonniere,* which means "sandy."

Chapter 6

1. The presence of the Raft, the clot of logs and sediment clogging the Colorado River channel in Wharton and Matagorda County likely added to the overflow and the commingling of the Brazos and Colorado Rivers near the coast.

2. Some varieties of rice must grow in flooded fields or paddies. Current research indicates that high-yield strains of rice that require minimum flooding or no flooding at all are possible. These strains unfortunately require higher levels of herbicides, pesticides, and insecticides to produce crops comparable to those grown using traditional methods.

3. The Colorado River is over-appropriated: the permits issued exceed the actual water supply. The LCRA holds the majority of permits (over 2.1 million acre-feet of water per year) in the Colorado. According to LCRA's statistics, there are only 43,000 acre-feet of unreserved firm water in the river basin, the proposed coal-fired power plant, White Stallion, would remove 36,000 acre-feet alone.

4. You just can't make everyone happy. While most agree that the diversion channel has helped the bay and increased its productivity, some would like to open up Parker's Cut and dig canals between East Matagorda Bay and Matagorda Bay. And there are some who really don't want that to happen—the LCRA for one. They have spent enormous sums of money analyzing the salinity gradients to determine required freshwater inflows to protect the health and productivity of the bay. Opening up Parker's Cut would change all of those carefully calibrated equations and would likely require the LCRA to release more freshwater into the Bay. At this point, LCRA believes they know exactly how much water the bay requires, and they have plans to utilize the rest.

Further Reading

Books and articles

Adams, Jr., John A. *Damming the Colorado.* College Station: Texas A&M University Press, 1990.

Banks, Jimmy, and John E. Babcock. *Corralling the Colorado.* Austin: Eakin Press, 1988.

Baumgartner, Dorcas, William C. Foster, and Jack Jackson. *Frontier River: Exploration and Settlement of the Colorado River.* Austin: Lower Colorado River Authority, 1997.

Bedichek, Roy. *Karánkaway Country.* Garden City, N.Y., 1950.

Blackburn, Jim. *The Book of Texas Bays.* College Station: Texas A&M University Press, 2004.

Brune, Gunnar. *Springs of Texas.* vol. I. Arlington: Gunnar Brune, 1981.

Burnett, Johnathan. *Flash Floods in Texas.* College Station: Texas A&M University Press, 2008.

Caro, Robert A. *The Years of Lyndon Johnson: The Path to Power.* New York: Vintage Books, 1982.

Carson, Rachel. *Silent Spring.* Boston: Houghton Mifflin, 1962.

Clay, Comer. "The Colorado River Raft," *The Southwestern Historical Quarterly,* vol. LII, no. 4 (1949): 410–426.

Duhigg, Charles. "Cleansing the Air at the Expense of Waterways," *New York Times,* October 13, 2009.

Espinosa, Isidro Félix de. *The Ramón Expedition: Espinosa's Diary of 1716.* Translated by Gabriel Tous. Texas Knights of Columbus Historical Commission, 1930.

Foster, William C. *Spanish Expeditions into Texas 1689–1768.* Austin: University of Texas Press, 1995.

Glennon, Robert. *Water Follies: Groundwater Pumps and the Fate of America's Fresh Waters.* London: Island Press, 2002.

———. *Unquenchable: America's Water Crisis and What To Do About It.* London: Island Press, 2010.

Goyne, Minetta Altgelt. *A Life among the Texas Flora: Ferdinand Lindheimer's Letters to George Engelmann.* College Station: Texas A&M University Press, 1991.

Graves, John. *Goodbye to a River.* New York: Curtis Publishing Company, 1959.

Johnson, Lyndon B. "A Program for All the People in the Colorado River Valley: To be Undertaken by their servant The Lower Colorado River Authority." Letter to Orville Buttery, LCRA Director, 1947.

Joutel, Henri. *The La Salle Expedition to Texas: The Journal of Henri Joutel, 1684–1687.* Edited and with an introduction by William C. Foster. Translated by Johanna S. Warren. Austin: Texas State Historical Association, 1998.

Leopold, Luna B. *Water, Rivers, and Creeks.* Berkeley: University of California, 1997.

Long, Walter E. *Flood to Faucet.* 1956.

Lower Colorado River Authority. "LCRA Business Plan: Fiscal Year 2010." http://www.lcra.org/about/overview/financial/business_plan.html and http://www.lcra.org/library/media/public/docs/business_plan/FY2010LCRABusPlan.pdf (accessed June 26, 2009).

Morris, Jane Anne. "Board and Staff: An Ethnography of the Lower Colorado River Authority of Texas." Phd diss., University of Texas at Austin, 1987.

McKinstry, William C. "The Colorado Navigator, Containing a Full Description of the Bed and Banks of the Colorado River, from the City of Austin to Its Mouth." Printed at the Colorado Gazette, 1840.

Olmsted, Frederick Law. *A Journey through Texas.* Austin: University of Texas Press, 1978.

Outwater, Alice. *Water: A Natural History.* New York: Basic Books, 1996.

Pearce, Fred. *When the Rivers Run Dry.* Boston: Beacon Press, 2006.

Peña, Juan Antonio de la and Rev. Peter Forrestal. *Peña's Diary of the Aguayo Expedition.* Austin: Distributed under the auspices of the Texas Knights of Columbus Historical Commission. 1934.

Postel, Sandra, and Brian Richter. *Rivers for Life: Managing Water for People and Nature.* Washington: Island Press, 2003.

Roemer, Ferdinand. *Roemer's Texas: 1845 to 1847.* Translated by Oswald Mueller. Austin: Eakin Press, 1983.

Sansom, Andrew. *Water in Texas.* Austin: University of Texas Press, 2008.

Scanlan, John, interview with David Todd and David Weisman, October 14, 2003. *The Texas Legacy Project.* Conservation History Association of Texas. http://www.texaslegacy.org/bb/transcripts/scanlanjohntxt.html (Accessed October, 1, 2009).

Schmidly, David J. *Texas Natural History: A Century of Change.* Lubbock: Texas Tech University Press, 2002.

Solís, Fray Gaspar José de, and Margaret Kenney, "Diary of a Visit of Inspection of the Texas Missions Made by Fray Gaspar José de Solís." The Southwestern Historical Quarterly. July, 1931. http://texashistory.unt.edu/ark:/67531/metapth101092 : accessed February 09, 2011.

Spearing, Darwin. *Roadside Geology of Texas.* Missoula: Mountain Press Publishing Company, 1991.

Starcke, Max. "Water Conservation in the Lower Colorado River Valley." Speech presented to the Governor's Water Board Conference, July, 1948. Austin: Lower Colorado River Authority.

Thompson, Mary Albers, and Madolyn Frasier. *The Valley between the Colorado and the Pedernales.* Spicewood Springs: Spicewood Area Historical Focus Group, circa 1996.

Weniger, Del. *The Explorers' Texas, Volume 1: The Lands and Waters.* Austin: Eakin Press, 1984.

———. *The Explorers' Texas, Volume 2: The Animals They Found.* Austin: Eakin Press, 1997.

Wilbarger, John Wesley. *Indian Depredations in Texas.* Austin: Eakin Press, Statehouse Books, 1985.

Zelisko, Larry. "*Waves of Conflict Mar Ivie's History,*" Abilene Reporter-News. July, 14, 2000. Accessed November 18, 2008. http://www.reporternews.com/news/2000/jul/14waves-of-conflict-mar-ivies-history/

Internet Resources

Austin-Bastrop River Corridor Partnership. *Discovering the Colorado: A Vision for the Austin-Bastrop River Corridor*
http://www.ci.austin.tx.us/water/programsandpartnerships.html

Colorado River Municipal Water District
http://www.crmwd.org/

Environmental Protection Agency
Water quality, river basins, pollutants, air quality, and other relevant information
http://www.epa.gov/

Texas Coastal Wetlands
A field guide to the different wetlands and where to find examples.
http://www.texaswetlands.org/index.htm

Lower Colorado River Authority
The LCRA has a comprehensive site that is worth exploring.
http://www.lcra.org

The Lower Colorado River User's Guide
http://www.lcra.org/community/ecodev/crt/river_users_guide.html

Hydromet data Web site.
Interactive map with near real-time data from LCRA's network of gauges
http://hydromet.lcra.org/full.aspx

Texas Legacy Project
An archive and documentary series sponsored by the Conservation History Association of Texas
http://www.texaslegacy.org

Texas Parks and Wildlife Department
http://www.tpwd.state.tx.us/

Texas River Guide: Texas Public Boater Access
http://www.tpwd.state.tx.us/landwater/water/habitats/rivers/access/access.htm

Texas Paddling Trails
http://www.tpwd.state.tx.us/fishboat/boat/paddlingtrails/

Texas Rice Industry Coalition for the Environment
http://www.karankawa.com/rice

Texas Water Matters
This site has a wealth of information about water use, environmental flows, the energy-water nexus, and links to regional water plans. The project is a collaborative effort of the Lone Star Chapter of the Sierra Club, the National Wildlife Federation, and the Environmental Defense Fund.
http://www.texaswatermatters.org

US Global Change Research Program
Global Climate Change Impacts in the United States
http://www.globalchange.gov/usimpacts

US Fish and Wildlife Service
Rice, Water, and Birds
http://www.fws.gov/birds/waterbirds/rice/rice.html

Texas Refuges
http://www.fws.gov/refuges/refugeLocatorMaps/Texas.html

The Texas Mid-Coast Refuge Complex
http://www.fws.gov/southwest/refuges/texas/texasmidcoast/index.htm

List of Artwork

Early Spring in the Basin (p. xviii)
Hand-colored linocut and lithograph
17" x 22½"

Oil & Water (p. 7)
Lithograph
8" x 11"

Song Sparrow I & II (p. 12–13)
Hand-colored lithograph
6" x 5" each

Wood Rat (p. 15)
Linocut
2⅝" x 2½"

Chloride rings in the Upper Colorado
(p. 18)
Digital color photograph

Roadrunner (p. 24)
Hand-colored linocut
Detail from Arbor Vitae

Barn Swallow (p. 26–27)
Hand-colored linocut
Detail from Arbor Vitae

Stork's Bill Geranium (p. 28)
Hand-colored linocut
Detail from Early Spring in the Basin

Yellow Bladderpod (p. 29)
Hand-colored linocut
Detail from Early Spring in the Basin

Reserved Beauty (p. 30)
Hand-colored linocut and lithograph
17" x 22½"

Meadowlark (p. 34)
Hand-colored linocut
Detail from Arbor Vitae

Lubber Grasshopper (p. 35)
Hand-colored linocut
5 5/8" x 7 3/8"

Killdeer & Chick (p. 36)
Hand-colored linocut
Detail from Arbor Vitae

Checkered Garter Snake & Leopard Frog
(Big Gulp)(p. 37)
Hand-colored Relief print
5 ¾" x 5"

River and Saltcedar, Colorado City (p.40)
Digital color photograph

Cottontops (p. 43)
Hand-colored linocut
8" x 8"

Prairie Dog (p. 44)
Linocut
2¾" x 2½"

Colorado River above E. V. Spence Reservoir (p. 46)
Digital color photograph

Invasion (p. 49)
Silkscreen
9 ¾" x 14½"

Damselfly (p. 57)
Silkscreen
Detail from Pond Cycle

Beaver (p. 59)
Hand-colored linocut
Detail from Reserved Beauty

Great Blue Heron (p. 61)
Hand-colored linocut
Detail from Helianthus & Heron

Thistles & Buttonbush (p. 62)
Hand-colored linocut
Detail from Reserved Beauty

Renegade (p. 65)
Hand colored lithograph
9¼" x 14½"

River Revealed (p. 66)
Hand-colored linocut and lithograph
17" x 22½"

Raccoon (p. 69)
Digital color photograph

Scissor-tailed Flycatcher (p. 72)
Hand-colored linocut
Detail from Arbor Vitae

River above Renfro Dam (p. 74)
Digital color photograph

Spotted Gar (p. 75)
Hand-colored linocut
26½" x 7½"

Dry Riverbed above the Confluence with
the San Saba River (p. 80)
Digital color photograph

Titmouse (p. 82)
Hand-colored linocut
Detail from Arbor Vitae

Cliff Swallows (p. 85)
Hand-colored lithograph
16" x 11½"

Eyed Elator (p. 90)
Hand-colored linocut
6" x 6"

Near the Town of Bend (p. 92)
Digital color photograph

Armadillo (p. 94)
Hand-colored linocut
Detail from Opuntia & Caracara

Mosses in Gorman Falls (p. 97)
Digital color photograph

Black-capped Vireo (p. 99)
Hand-colored linocut
Detail from Selah: Pause & Reflect

In the Shadow of Buchanan Dam (p. 100)
Hand-colored linocut and lithograph
17" x 22½"

Great Egret (p. 105)
Hand-colored Ł lithograph
17½" x 13"

Painted Buntings (p. 114)
Hand-colored linocut
Detail from Arbor Vitae

Devil's Waterhole at Inks Lake State Park
(p. 115)
Digital color photograph

Prickly Pear (p. 120)
Hand-colored linocut
Detail from In the Shadow of the Dam

Head of Lake Travis (p. 121)
Digital color photograph

Northern Cardinal (p. 129)
Hand-colored linocut
Detail from Arbor Vitae

Golden-cheeked Warbler (p. 131)
Hand-colored linocut
Detail from Selah: Pause & Reflect

Cedar or Ashe Juniper (p. 132)
Linocut
2⅞" x 3¼"

Nighthawk in flight (p. 134)
Hand-colored linocut
Detail from Arbor Vitae

Carp & Cabomba (p. 137)
Silkscreen with handcoloring
18" x 14"

Barton Springs Salamander (p. 140)
Hand-colored Linocut
2¾" x 7¾"

Bats and Congress Avenue Bridge (p. 142)
Hand-colored linocut
11¼" x 11½"

Summer River (p. 144)
Hand-colored linocut and lithograph
17" x 22½"

Texas River School Canoes under Montopo-
lis Bridge (p. 147)
Digital color photograph

Siren Song (p. 151)
Hand-colored lithograph
9" x 10"

Dog's Head Bend & Black-bellied
Whistling-Duck (p. 154)
Mixed media
8" x 10"

Cicada (p. 156)
Hand-colored linocut
Detail from Helianthus and Heron

Belted Kingfisher (p. 158)
Hand-colored linocut
8½" x 8½"

Lost Pines and Red Bluff below Bastrop
(p. 160)
Digital color photograph

Lost Pines Suite (p. 161)
Hand-colored linocut
8" x 14½"

Pine Warbler (p. 163)
Hand-colored linocut
8" x 6"

Blue Sucker (p. 164)
Hand-colored linocut
4" x 8"

Rabb's Shoals and Rabb's Prairie outside of
La Grange (p. 166)
Digital color photograph

Eastern Kingbird & Scissor-tailed Flycatcher
(p. 167)
Hand-colored linocut
Detail from Arbor Vitae

Pileated Woodpecker (p. 170)
Hand-colored linocut
9" x 9"

New World (p. 172)
Hand-colored linocut and lithograph
17" x 22½"

Barn Swallows I & II (p. 176)
Hand-colored linocut
9" x 6" each

Rice Bowl (p. 179)
Hand-colored linocut
5¾" x 25⅞"

Green Treefrog: Daytime (p. 180)
Hand-colored linocut
4" x 4"

Red-winged Blackbirds (p. 182)
Hand-colored linocut
Detail from Opuntia and Caracara

Loggerhead Shrike (p. 184)
Hand-colored linocut
Detail from Arbor Vitae

Green Treefrog: Nighttime (p. 185)
Hand-colored linocut
4" x 4"

Crawdad (p. 188)
Hand-colored linocut
4⅛" x 6"

Lane City Dam LCRA Canoe Portage on
the Pierce Ranch (p. 191)
Digital color photograph

Crow & Beetle (p. 192)
Hand-colored linocut
Detail from Arbor Vitae

Colorado River in Wharton County near
Hollywood Bottom Park (p. 194)
Digital color photograph

Pond Cycle (p. 196)
Silkscreen with handcoloring
14" x 22"

River Dock at Night (p. 197)
lithograph
3¼" x 4½"

Mad Island Wildlife Management Area
(p. 201)
Digital color photograph

Pelicans in the Mist (p. 204)
Lithograph
4³⁄₁₆" x 11¾"

Index

NOTE: Page numbers in *italics* indicate images and maps.

agriculture. *See also* irrigation
 and cedar clearing, 78
 and the Family Land Heritage Program, 78
 and groundwater contamination, 29
 impact on biodiversity, 180
 impact on grasslands, 106–8
 and origin of the LCRA, 122
 and the rice belt, 179–87
 rice cultivation, *179,* 179–87, 187–88, 189, 194
Aguayo, Marqués de San Miguel de, 162
air pollution, 166
Alexander, Charles H., 107–8, 119
algal blooms, 48, 71, 75, 143, 150
alkaline minerals, 47
alluvial deposits
 below O. H. Ivie, 67
 and the Blackland Prairie, 148
 and Hornsby Bend, 155
 and mining on the river, 156–57
 and native grass seeds, 120
 and Rancho Escondido, 51–52
 and soil quality, 73
Alvin Wirtz Dam, 116–18, 185
Anderson, Barbara Clayton, 8–9, 23, 24
Anderson, Rich, 8–9, 23, 24
Anglo settlers, 118
Ann W. Richards Congress Avenue Bridge, 142
antelope, 21, 23
Apache Indians, 22
aquifers, 10, 20, 22, 159

archaeological sites, 73, 117
Armadillo, 94
Armour, Laurance, 187, 189
Arnold, James, 200–203
Audubon Society, 131, 152, 202
Austin
 and Balcones Canyonlands Preserves, 131
 and floods, 178
 and Lake Austin impoundment, 129–30
 and pollution, 124, 149
 and power plants, 198
 and riverside parks, 145
 and Tom Miller Dam, 108
 and water quality, 165
Austin, Barney, 169–71
Austin, Moses, 183
Austin, Stephen F., 2, 76, 183, 186, 198
Austin American Statesman, ix, 136
Austin Chamber of Commerce, 110
Austin Dam, 134, 135. *See also* Great Granite Dam
Austin Rowing Center, 139
Austin's Woods Initiative, 189–90
Austin-Travis County Health Department, 138
Austin Water Utility, 152, 153
Austin Youth River Watch (AYRW), 152

Balcones Canyonlands Conservation Plan (BCCP), 131
Balcones Canyonlands Preserves (BCP), 130–32

Balcones Escarpment, *102,* 106, 134
Balcones Fault, 135
bald eagles, 89, 101, 162, 173
Ballinger, 54
Barefoot Camp, 81, 91
barge traffic, 197
barn swallows, 26, *26, 27, 176*
Barn Swallows I & II, 176
Barton Creek, 139
Barton Springs, ix, 136, 139–41
Barton Springs Salamander, 140
Bastrop County, 5
Bastrop County Audubon Society, 152
Bastrop County Environmental Network, 152
bats, *142,* 142–43
Bats and Congress Avenue Bridge, 142
Bay City, 193–94, 195–205
Bay City Dam, 195–97
Beason's Park, 178–79
Beaver, 59
Beaver, Frank, 8, 16–20
Beaver Ranch, *2*
beavers, 58, *59,* 162
beetles, 89, *90*
Belted Kingfisher, 158
Bend (city), xii, 88, 92, *92*
Ben Hur (steam ship), 134
Big Gulp, 37
Big Spring, 47
Big Waters, 187
biodiversity
 and bottomland hardwood forests, 190

biodiversity (*cont.*)
 and coastal habitats, 202
 impact of agriculture on, 180
 and impact of dams, 55–56
 and native grasslands, 35
 and soil conservation programs, 122–23
 and Wildcat Creek, 52
birdwatching, 86, 101–11, 154–55, 201–3
bison, 17, 21–22, 25, 162, 165, 175
black-bellied whistling ducks, *154*
blackbirds, 35, 47, *182*
Black-capped Vireo, 99
black-capped vireos, 99, 130
Blackland Prairie, 2, 146, 148, 159, 161, 165–71, 183
black willows, 41–42
Bluebonnet Hole, 120, 123
Blue Sucker, 164
blue suckers *(Cycleptus elongatus),* 163–64, *164*
bobwhites, 35, 44
boll weevils, 179, 184
Borden County, 16, 23, 24
bottomland forests, 79–80, 189–90, 193–94, 202, 207n2
Boy Scouts, 93, 95, 164
brachiopods, 63
Brahman cattle, 188–89
Brazos River, 3, 106, 175–77, 190
Brownwood Dam, 108
Brune, Gunnar, 19
Buchanan, James P. "Buck," 109–10
Buchanan Dam, *100,* 111–12, 127, 178, 185
buffalo. *See* bison
Bureau of Reclamation, 127
Burnham, Reagan, 76–78
Burnham, Stanley, 76–77, 79–81, 99
Burnham, Theodore C., 76
buttonbushes, *62, 63*
Byrne, J. H., 21

cabomba, *137*
cacti, 15, 44, *120*
Camp Longhorn, 113
Camp Swift, 8
canals, 179–80, 183–84, 194–95, 198
cane thickets, 176
Caney Creek, 176, 183, 186, 194
canoe portages, *191,* 191–92, 196
canoe trips, 5
Canyon Lake, 117
Canyon of the Colorado, 119
Caprock Escarpment, *2*
 and cedar (Ashe juniper), 3, 10–11, 22
 and the Colorado headwater, 1–4, 7, 9–10
 and Lake J. B. Thomas, 31
 and Muleshoe Ranch, 21–23
 and Native Americans, 11, 22, 27
 and saltcedar, 6, 17
 and springs, 19
carp, 68, 72–73, *137*
Carp and Cabomba, 137
Carson, Rachel, 136–38
cattle ranching
 and headwaters of the Colorado, 3–4
 and Horseshoe Bend Ranch, 132
 and Lost Pines, 162
 and overgrazing, 35, 52, 98, 106–7, 120
 and the Pierce Ranch, 187–89
 and saltcedar, 17
 and Spanish missions, 22
cedar (Ashe juniper)
 and the Caprock Escarpment, 3, 10–11, 22
 and E. V. Spence Reservoir, 45
 and endangered species, 130
 Gardner on, 132
 and native grasslands, 93
 and Rye Valley Ranch, 78
 and soil conservation efforts, 121
 and topsoil quality, 98

Cedar or Ashe Juniper, 132
Central Flyway, 181
Central Texas, 15, 106, 168, 169
Central Texas Hydroelectric Company, 108–9, 110
Champion Creek, 42, 44
Chatauqua (steam ship), 134
Checkered Garter Snake & Leopard Frog (Big Gulp), 37
checkered garter snakes, 36–37, *37*
Cherokee Creek, 88, 92–93
Chicken Ranch, 165
chlordane, 138
chloride pollution, *18,* 19–20, 47–48
Chloride Rings in the Upper Colorado, 18
Christmas Bird Count (CBC), 202
Cicada, 156
Civilian Conservation Corps, 186–87
Clark, Hugh, 118
Clean Clear Colorado River Association, 152
Clean Rivers Program, 56
Cliff Swallows, 85
climate change, 127
Clive Runnels Family Mad Island Marsh Preserve, 202
Clovis archaeological sites, 117
coal, 104, 166, 168
coastal marshes, 202. *See also* Gulf Prairies and Marshes
coastal prairie, 175, 179, 181, 202
Colorado Bend State Park, 95–99
Colorado City, 38–42, *40*
The Colorado Navigator (McKinstry), 160–61
Colorado River above E. V. Spence Reservoir, 46
Colorado River Authority, 110
Colorado River Company, 109, 110–11
Colorado River Improvement Association, 110

Colorado River in Wharton County near Hollywood Bottom Park, *191*

Colorado River Municipal Water District (CRMWD)
 and E. V. Spence Reservoir, 46–48
 and Lake J. B. Thomas, 32
 and O. H. Ivie Reservoir, 58
 and saltcedar management, 50
 and water quality testing, 54–55
 and water rights conflicts, 60–62, 64–65, 80
 and water shortages, 71

Colorado River Preserve, 145, 146

Colorado River Watch Network (CRWN), 152

Col-Tex Petroleum Refinery, 41

Columbia Bottomlands, 189–90

Columbus, 169, 173, 175–76, 177

Comal River, 29

Comancheros, 22

Comanches, 22, 73–74

composting programs, 153–54

Concho River, 3, 55–56, 58–59

Concho water snakes, 54–57, 60

Congress Avenue Bridge, *142*, 142–43

Connally, Tom, 109

conservation efforts. *See* restoration and conservation efforts

Conservation Reserve Program (CRP), 10–11, 42

Cook, Neal, 162–65

Cook's Canoes, 162–63

Cordova, Jacob de, 93

cotton, 179, 184

Cottontops, 43

cranes, 44, 181, 183, 187

Crawdad, 188

Creekside Conservation Program (CCP), 120, 122, 130

Cretaceous-era formations, 67

Cross Timbers and Prairies, 31, *68*, 207n1

Crow and Beetle, 192

The Daily Tribune (Bay City), *194*

daisies, 39

dams. *See specific dam names*

damselflies, 26, 57–58

Damselfly, 57

Davis S. Hall boat ramp, 190

Dawson County, 5

DDT, 138

Deep Eddy, 136

delta of the Colorado, 198, *199*, 203–5

Devil's Waterhole, 114–16

Devil's Waterhole, 115

Dillo Dirt, 153–54

diversity. *See* biodiversity

Dog's Head Bend & Black-bellied Whistling-Duck, 154

Double Ford, 77, 79

dragonflies, 57–58

drought
 and E. V. Spence Reservoir, 48
 and Lake J. B. Thomas, 33
 and native grasslands, 14, 21, 25, 35, 52
 and overgrazing, 120
 and wastewater treatment, 168
 and wildflowers, 28

Dry Riverbed above the Confluence with the San Saba River, 80

ducks, *154*, 165, 183, 187

Ducks Unlimited, 181, 197

Duncan, Genny, 182

Dunovant, William, 179

E. V. Spence Reservoir, 45–51
 character of, xii
 and the Concho water snake, 55–56
 river below, 53–58
 and the Rolling Plains, 31

Eagle II, 101

Eagle Lake, 179–80

Early Spring in the Basin, xviii

Earth Day, 163

Eastern Kingbird & Scissor-tailed Flycatcher, 167

East Matagorda Bay, *174*, 194, *199*

economic impact of rivers, 81. *See also* agriculture

Edison, Thomas, 108

educational programs, 152

Edwards Aquifer, 140

Edwards Plateau
 and aquifers, 159
 and the course of the Colorado, 31, *32, 68, 102*
 and dam sites, 134
 and E. V. Spence Reservoir, 45
 and Flash Flood Alley, 106, 107
 geology of, 103
 and limestone formations, 52, 130
 and Rancho Escondido, 51–52

Eisenhower, Dwight, 126

electric power generation
 coal-burning power plants, 166–68
 hydroelectric power, ix, 101–11, 121, 127–28
 nuclear power, 103, 126, 167–69, 198
 and water requirements, 166–71

elephant ears, 96

endangered species
 and the Balcones Canyonlands Preserves (BCP), 130–32
 Barton Springs salamander, *140*, 140–41
 black-capped vireos, 99, 130
 blue suckers (*Cycleptus elongatus*), 163–64, *164*
 Concho water snakes, 54–57, 60
 Endangered Species Act, 130
 freshwater mussels, 42, 71, 157, 159
 golden-cheeked warblers, 98, 130
 and habitat preservation, 35, 130–31
 karst invertebrates, 130

endocrine disruptors, 149–50
environmental damage. *See* pollution
environmental flows, 157–60, 207n4
Environmental Protection Agency (EPA),
 41, 168
Environmental Stewardship Award, 29
erosion, 44–45, 88, 98, 114, 133, 149
Espinoza, Fray Isidro de, 155
estuaries, 159, 200, 202
evaporation, 45
The Explorers' Texas (Weniger), 16, 21
Exxon, 11, 20
Eyed Elater, 90
eyed elaters, 89, *90*

Fabridams, 196
Family Land Heritage Program, 78
Farm and Ranch Improvement Program,
 121
Fayette Power Project (FPP), *146,* 166
feral hogs, 53, 120
Ferguson, Miriam A. "Ma," 110
53rd District Court, 60
firm water, 160, 185
Fisherman's Park, 161
fishing
 above Colorado Bend State Park, 95
 above Sulphur Springs Camp, 84–86
 and coastal habitats, 202–3
 at Inks Lake, 112–13
 at Lake J. B. Thomas, 31
 at O. H. Ivie Reservoir, 58–59
fish kills, 48, 138, 164
flash floods, ix, 106, 116–17
floods and flood control
 and Bluebonnet Hole, 123
 and the Canyon of the Colorado,
 119–20
 and dam failures, 134–35
 dams as protection from, 177–78
 and early inhabitants, 117–18

and environmental impact of dams, 71
flash floods, ix, 106, 116–17
and hydroelectric generation, 107,
 127–28
and invasive species, 71, 159
and O. H. Ivie reservoir, 91–92
and off-channel reservoirs, 189
and the Ogallala Aquifer, 10
and the Regency Suspension Bridge, 70
settlers' accounts of, 176–77
and Shaw Bend, 77
silt and sedimentation from, 177
Texas rivers compared, 106
and "the Raft," 193–95, 199–200,
 208n1
flow rates, x, 126, 157–60, 178, 203, 207n4
forest succession, 132
fossils, 57, 63, 88
Fox Crossing Bend, 78
Freeman, David S., 169
Freeman, Joe, 73
freshwater marshes, 200, 202, 204
freshwater mussels, 42, 71, 157, 159
Frio River, 106
frogs, 14–15, 27, 36–37, *37, 180, 185*

gallery forests, 21
Gardner, Don, 132–33
gars, 64, 68, *75,* 75–76, 163
geese, 181–84, 187
General Land Office, 42
Glen Creek, 21
Glen Creek School, 17
Glen Flora, 186
glochidia, 157
Gold Creek, *2,* 6, 21
golden algae *(Prymnesium parvum),* 47, 48
Golden-Cheeked Warbler, 131
golden-cheeked warblers, 98, 130, *131*
Gorman Falls, 96–98, *97,* 99
Gorman Springs, 96–98

Grand Coulee Dam, 127
granite, 103, 118
Granite Shoals Dam, 116
Grant, Ulysses S., 72
Grape Creek, 21
grasslands, native
 and alluvial deposits, 120
 and coastal prairies, 175
 and drought, 14, 21, 25, 35, 52
 explorers' accounts of, 25
 and invasive species, 35, 78
 and overgrazing, 106–7
 and restoration efforts, 11, 23–25, 29,
 42, 52–53, 98, 120–21
 and rice cultivation, 180
grassroots organization, 152
gravel mining, xii, 16–17, 136, 155–57, 162
Great Bend of Columbus, 173, 178
Great Blue Heron, 61
great blue herons, 26–27, 59–60, *61*
Great Depression, 109
Great Egret, 105
Great Granite Dam, 134. *See also* Austin
 Dam
Great Plains, 1
Green Treefrog: Daytime, 180
Green Treefrog: Nighttime, 185
Guadalupe River, 106, 117
Guadalupe River Basin, 117
Guerro Park, 145
Gulf Coast Irrigation Division, 196
Gulf Intracoastal Waterway (GIWW), 138,
 197, *199,* 199–200
Gulf Prairies and Marshes, 148, 159, *174,*
 175

Hamilton Creek, 123
Hamilton Dam, 109–10
Hansen, Laura, 52
hardwood forests, 189–90
Head of Lake Travis, 121

headwaters of the Colorado River, 1–6, *2,* 6–8, 29
herons, 14, 26–27, 59–60, *61*
Highland Lakes, *102. See also specific lakes*
 and dam security, 129
 and environmental flows, 159
 and floods, 117–18
 and flow rates, 179
 and hydroelectric power, 2, 104, 168
 and irrigation, 184–85
 and the Llano Uplift, 67
 origin of, ix, 2
 and "pass-through" lakes, 112
 and water supplies, 135–36, 180
High Plains, *2,* 31
Hike and Bike Trail, 141
Hill Country, 84, 98, 104–6
hognose snakes, 83
hogs, 53, 120
Holly Street Power Plant, 136
Hollywood Bottom Park, 190–91, 193, *194*
Honey Creek, 133
Hornsby Bend Biosolids Management Plant, 153–55
Horseshoe Bend Ranch, 132, 133
Houck, Bob, 51–53
Houck, Janie, 51–53
Howell, Frank, 178–79
Howell's Canoe Livery, 178–79
hunting, 181–83
hydroelectric power, ix, 101–11, 121, 127–28
hydrogen sulfide, 39–40
Hydromet system, 178

Inks Dam, 127
Inks Dam Fish Hatchery, 116
Inks Lake, 112–16, *115*
Inks Lake State Park, 113, *115*
insecticides, 138
Insull, Martin, 108–9, 110

Insull, Samuel, 108–9, 110
In the Shadow of Buchanan Dam, 100
Intracoastal Waterway, 138, 197, *199,* 199–200
Invasion, 49
invasive species
 carp, 72–73
 elephant ears, 96, 159
 and flooding, 71, 159
 Johnson grass, 41–42, 148
 King Ranch bluestem, 187
 and native grasslands, 35, 78
 saltcedar *(Tamarix),* 6, 17, 33, 37–42, *40,* 45–50, *49,* 71
irrigation
 and Buchanan Dam, 185
 Gulf Coast Irrigation Division, 196
 and Lake Travis, 171, 185
 and Mansfield Dam, 185
 and off-channel reservoirs, 189
 and rice cultivation, 179, 183–87
 and Shaws Bend Reservoir proposal, 171
 and water shortages, 71
 and wells, 14, 17, 29
Ivie, O. H., 62

Johanson, Lamar, 79–80
Johanson, Marilynn, 79–80
Johnson, Adam Rankin, 107, 108
Johnson, Claudia Alta "Lady Bird," 138
Johnson, Lyndon Baines, x, 109, 116, 121–22
Johnson grass, 41–42, 148
Jo-Mill oil field, 20
Jo-Mills Oil Field, 5
A Journey Through Texas (Olmsted), 106
Joutel, Henri, 165
Jumano Indians, 22

Kaffie, Harris, 120, 122–23
Kaffie, Lynda, 120, 122–23

karst limestone formations, 95, 99, 130
Kendall, Joe, 139, 151
Killdeer and Chick, 36
killdeers, 26, 35, 36, *36,* 88–89, 153
King Ranch bluestem, 187
Klopple, Georgina Earnest, 123
Kowis, Jim, 126–27, 128

Lady Bird Lake, ix, xii, *102,* 112, 128, 129–43
La Grange, 165–66, *166*
Lake Austin, ix, 112, 117, 128, 150
Lake Buchanan
 and the Concho water snake, 55
 and environmental flows, 157–59
 and floods, 93
 river channel in, 103
 as storage lake, 112
 and the Vanishing Texas River Cruise, 101
 and water temperatures, 114
 and white bass, 95
Lake Fayette, 166
Lake Granite Shoals, 116
Lake J. B. Thomas, *2,* 31–38, *32*
Lake LBJ, 112, 116–17
Lake Marble Falls, 112, 116, 117, 118
Lake McDonald, 108, 134
Lakeside Irrigation Division, 180
Lake Travis, 123–28
 and Bluebonnet Hole, 120
 character of, xii
 and environmental flows, 157–59
 and flood control, 117, 127
 head of, 120, *121*
 and irrigation, 171, 185
 and storage lake, 112
 and water temperatures, 129
La Maligne, 165
Lamesa, 8, 10
Lampasas, 93

Lane City, 191, 193

Lane City Dam, 192

*Lane City Dam LCRA Canoe Portage on the
Pierce Ranch, 191*

La Salle, Rene Robert Cavelier de, 165, 194

leopard frogs, 36–37, *37*

levees, 194

lignite, 168

limestone
 and dam failures, 135
 and the Edwards Plateau, 52, 130
 and fossils, 63
 and Gorman Springs, 98
 and karst formations, 95, 99, 130
 and Marble Falls Formation, 84
 and Marble Falls Lake, 119, 120
 and Sulphur Springs, 93

Lipan Apaches, 22, 73

livestock. *See* cattle ranching; sheep ranching

Llano Estacado (Staked Plains), 1, 21–23,
 29

Llano River, 106, 116, 177

Llano River Basin, 117

Llano Uplift, 1–2, 67, *68, 102,* 103, 106

Loggerhead Shrike, 184

Longhorn Dam, *102,* 136, 138, 145, *146,*
 160

Lost Pines, 146, 161–62

Lost Pines and Red Bluff below Bastrop, 160

Lost Pines Nature Trail, 162

Lost Pines Suite, 161

Lower Colorado River Authority (LCRA)
 and Balcones Canyonlands Preserves,
 131
 and Bay City Dam, 195–96
 and blue suckers, 163
 criticism of, 162–63
 and environmental flows, 157–60
 establishment of, 110–11
 and flood controls, 107, 177–78
 and the Highland Lakes, 2, 101

and Hollywood Bottom Park, 190–92

and hydroelectric power, x, 104–7, 111

and irrigation water, 180, 185

and Lake Buchanan, 112

and Montopolis Bridge access, 145

and the mouth of the Colorado, 203

and off-channel reservoirs, 189

and Plum Park, *146,* 163

and power generation, 166–71

Reclamation and Conservation Districts,
 120–23

and river-level reporting, 93

and Tom Miller Dam, 130, 135

and wastewater facilities, 125–26

and water rights conflicts, 60–65

and water-use permits, 126

and wetlands, 181

Lubber Grasshopper, 35

Maclean, Norman, 77

Maddin, Alfred, 42

Maddin Prairie Preserve, 42–45

Mad Island Wildlife Management Area,
 201–2

Malott. C. G., 207–8n4

Mansfield, Joseph J., 109, 117, 127

Mansfield Dam, 123–28, 129, 185

Marble Falls (city), 84, 119, 123

Markham, J. P., 195, 199

Marshall Ford Dam, 127

marshes. *See also* wetlands
 coastal marshes, 202
 freshwater marshes, 200, 202, 204
 Gulf Prairies and Marshes, 148, 159,
 174, 175
 salt grass and tidal marshes, 202

Matagorda Bay
 and Anglo settlement, 2
 and confluence of the Colorado, *174, 199*
 and environmental flows, 160
 and estuarine habitat, 204

and freshwater inflows, x, 203

and the Intracoastal Waterway, 197

land bridge through, 194

Matagorda Bay Nature Center, 203

Matagorda (city), 198, 199–200

Matagorda County-Mad Island Marsh
 Christmas Bird Count, 202

Matagorda County Reclamation Board, 195

Max Starcke Dam, 116

McKinstry, William C., 160–61

Meadowlark, 34

meadowlarks, 25, 34, *34*

Merendino, Todd, 184

mesquite trees, 10–12, 15, 22–23, 27–28,
 34, 52

metamorphic rocks, 103

Mexican Persimmon, 15

Mexican settlers, 22

Middle West Utilities Company, 207n3

Midland, 65

migratory birds, 175, 181, 190, 197

Miller Dam, 136. *See also* Tom Miller Dam

Miller Ranch, 13, 16–20

Millican, Elsie, 81–82, 93, 96

Millican, Kay, 93, 96

Millican, Winston, 81, 93

mineral springs, 93

mining, 88, 136, 156–57, 168

Mississippi River, 5

Mississippi Valley, 184

mixed-grass prairies, 42. *See also* grasslands,
 native

mojarra (sunfish), 146

Montgomery, Bill, 4, 58, 71, 84–86

Montopolis Bridge, 145, *147*

Morris, Jane A., 104

Morrison, Ralph W., 109, 110

Mosses in Gorman Falls, 97

Mount Bonnell, 134–35

mouth of the Colorado, 198–99, *199*

Muleshoe Ranch, *2,* 20–29

municipal sewage treatment, 149–50, 153–55

Murfin, Pam, 132–33

Mushaway Peak, *2*, 20, 24

mussels, 42, 71, 157, 159

National Audubon Society, 202

National Cattlemen's Association, 29

National Weather Service, 106, 177

Native Americans
 and archaeological sites, 73–74
 and Barton Springs, 140
 and bison, 165
 of the Caprock Escarpment, 11, 22, 27
 and river forests, 149

Native Prairies Association of Texas (NPAT), 42, 45

Natural Dam Lake, 47–48

natural gas, 104. *See also* oil exploration

Natural Resource Conservation Service (NRCS), 29, 51, 120, 197

Nature Conservancy, 131, 181, 202

Near the Town of Bend, 92

New Deal, x, 104–6

New World, 172

New York Times, 168, 177

Nighthawk in Flight, 134

Northern Cardinal, 129

nuclear power, 103, 126, 167–69, 198

Nueces River, 106

O. H. Ivie dam, 68, 80, 91–92. *See also* Stacy Dam

O. H. Ivie Reservoir, 31, *32,* 55–58, 58–65, 81–82

oak mottes, 98

off-channel reservoirs, 189

Ogallala Aquifer, 10, 22, 29

oil exploration
 and chloride pollution, *18,* 19–20, 47–48

and the Colorado headwaters, 3–4, 7, 17–19, 22

and contamination of water sources, 11, 36–37

and E. V. Spence Reservoir, 48

and hydrogen sulfide gas, 39–40

Oil & Water, 7

and saltcedar, 37–38, 39–42

and Superfund sites, 41–42

Oil & Water, 7

Old Three Hundred, 186

Olmsted, Frederick Law, 106, 148, 198

Onion Creek, 163

Ordovician-era formations, 67

Ortego, Brent, 201–2

overgrazing, 35, 120

oxbow lakes, 179

oyster reefs, 204

Paint Creek, 46–47

Paint Creek Marina, 46

Painted Buntings, 114

Parker's Cut, 203, 209n4

pass-through lakes, 116–17, 130

Peach Creek, 183

Pecan Bayou, 78, 80, 108

pecan trees, 81, 82, 120

Pedernales River, x, 125, 177

Pelicans in the Mist, 204

Peña, Juan Antonio de la, 162

Pennsylvanian-era formations, 67, 87

Pentachka Comanches, 22

peregrine falcons, 183

Permian Basin, 20

Permian-era formations, 52, 67

permits for water use, 60, 62, 108, 126

persimmons, 15, 98–99

pesticides, 138–39

Pharmaceuticals and Personal Care Products (PPCP), 149

phosphates, 152

Pierce, "Shanghai," 187

Pierce Ranch, 187–93, *191*

Pileated Woodpecker, 170

Pines and Prairies Land Trust, 162

Plum Creek, *2,* 21

poison ivy, 149

poisonous gases, 19

pollution
 air pollution, 166
 and algae blooms, 48
 below Austin, 124, 149
 contamination of water sources, 11
 and fish kills, 138
 and Lady Bird Lake, 139
 Pharmaceuticals and Personal Care Products (PPCP), 149
 and Superfund sites, 39–41
 and trash dumping, 145
 and water quality testing, 47–48, 56–57, 152–53

Pond Cycle, 196

population growth, 125–26, 150, 168

Post Oak Savannah, 146, 148, 159, 169

Poverty Flats ranch, 10

power plants. *See* electric power generation

Prairie Dog, 44

prairie dogs, 42–45, *44*

prairie rattlesnakes, 44

Prairies ecoregion, 21, 31. *See also* Blackland Prairie; coastal prairie; Gulf Prairies and Marshes

Precambrian-era formations, 103, 118

Prickly Pear, 120

prickly pear cacti, 15, 44, *120*

pronghorn antelope, 21, 23

Public Works Administration (PWA), 109, 110, 135

quarries, 156–57. *See also* mining

Rabb's Prairie, 165, *166*

Rabb's Shoals, *166*

Raccoon, 69

raccoons, 14, 68–69, *69,* 91

"the Raft," 193–95, 199–200, 203

rainfall. *See also* drought; floods and flood
 control
 average rate of, 124
 and evaporation rates, 45
 and the Ogallala Aquifer, 29
 "rain bombs," 106, 123
 and rainwater catchment, 23, 25–26

ranchers. *See* cattle ranching

Rancho Escondido, 51–53

ratoon rice, 187

Rattlesnake Creek, *2,* 21

rattlesnakes, 6, 7, 34, 44

Ray, Rusty, 130

Reagan, Ronald, 169

Reclamation and Conservation Districts,
 110–11, 121–22

Reconstruction Finance Corporation, 109

Red Bed Plains, 16

red berry cedar, 52

Red Bud Isle, ix, 135

Red River, 3

red-winged blackbirds, 35, 47, *182*

Red-Winged Blackbirds, 182

Regency Suspension Bridge, 69–70

Renegade, 65

Renfro Dam, *74,* 75

Reserved Beauty, 30

restoration and conservation efforts
 and endangered species, 98
 and the Maddin Prairie Preserve, 42–45
 and native grasslands, 11, 23–25, 29, 42,
 52–53, 98, 120–21
 and Rancho Escondido, 51–53
 soil conservation, xvi, 23, 121–23
 and Superfund sites, 40–41
 and water use, 65

Rice Bowl, 179

rice cultivation, *179,* 179–87, 187–88, 189,
 194, 202

Richter, Walter, 119–20

Riesen, Edmund E., 81

The Ripples, 165

River Above Renfro Dam, 74

River and Saltcedar, Colorado City, 40

River Dock at Night, 197

river gauges, 178

river-level reporting, 93, 178

River Revealed, 66

A River Runs Through It (Maclean), 77

River User's Guide (LCRA), 191

Roadrunner, 24

Roemer, Ferdinand, 27, 84, 106, 175–76,
 184

Roemer's Texas (Roemer), 27, 175–76, 184

Rolling Plains, *2,* 19, 31, *32,* 35, 51–52,
 58, *68*

Roosevelt, Franklin Delano, 104–6, 109–10

Rose, Mark, 150, 168–69

Rough Creek, 87

Roy Inks Dam, 114

Rye Valley Ranch, 79–82

salamanders, *140,* 140–41

saltcedar *(Tamarix), 40, 49*
 and the Caprock Escarpment, 6, 17
 and E. V. Spence Reservoir, 45–50
 and Lake J. B. Thomas, 33
 and oil exploration, 37–38, 39–42
 and river flow rates, 71

salt deposits, 19

San Angelo, 65

San Antonio River, 106

San Antonio Water Supply (SAWS), 189

San Bernard River, 175, 176, 183, 186, 190

sandhill cranes, 44, 181, 183, 187

sandstone, 72

San Marcos River, 29

San Saba River

confluence with the Colorado, 78, *80*
 and floods, 92, 177
 Olmsted on, 106
 and settlers, 74

San Saba Valley, 84

Sawyer, Audrey, 159

scaled quail. *See Cottontops*

Scanlan, John, 169

Schroeter, Arthur, 119–20

Scissor-tailed Flycatcher, 72

seeps, 13. *See also* springs

seep willows, 19

settlement pits, 20

settlers, 2, 22, 27, 73, 118, 186

sewage and sewage treatment, 138–39,
 149–50, 153–55

Shaws Bend, 76, 79

Shaws Bend Reservoir (proposed), *146,*
 169–71

sheep ranching, 17, 18, 22, 52, 90–91

Sheppard, Morris, 109

Shirley Shoals, 107, 108

Shoal Creek, ix, 136

Silent Spring (Carson), 136–38

silt and sedimentation, 33, 44–45, 177

singing persimmon trees, 98–99

Siren Song, 151

Sitz, David, 195–96, 202

Sitz, Marilyn, 195–97, 202

Smithwick Shale, 88

snakes
 checkered garter snakes, 36–37, *37*
 Concho water snakes, 54–57, 60
 hognose snakes, 83, 86
 rattlesnakes, 6, 7, 34, 44

soil conservation, xvi, 23, 121–23

Soil Conservation Service, 23

Solís, Gaspar Jose de, 165

Sometimes Islands, 124

Song Sparrow I & II, 12–13

source of the Colorado, 1–6, *2,* 6–8, 29

South Texas Nuclear Project, 168–69, 198
South Texas Project, 198
Spade Ranch, 181–83
Spanish explorers and settlers, 22, 106, 118
sparrows, 12, *12–13, 25*
spartina (salt grass) marshes, 202
Splash Exhibit, 139
Spotted Gar, 75
spotted gars, 64, 68, *75,* 75–76, 163
Spraberry-Dean Sandstone oil fields, 20
Spring Creek, 73
springs, 19, 52, 77, 93, 96–98
Springs of Texas (Brune), 19
St. Mary's Bayou, 198–200
Stacy Dam, 55, 60–62
Staked Plains (Llano Estacado), 1, 21–23, 29
Starcke, Max, 122
Starcke Dam, 117, 119–20, 123
steamboats, 160–61
steam-generated plants, 167
Stewart, Don, 9, 14
Stewart, Martha, 9
Stewart Ranch, *2,* 8–15
Stork's Bill Geranium, 28
stormwater drainage, 136
stream flow data, 126
strip-mining, 168
sugarcane cultivation, 179, 184
Sulphur Springs, 93, 95
Sulphur Springs Camp, 81–82, 82–95
Summer River, 144
Superfund sites, 39–41
surface waters, 60
Swinging Bridge Campground, 69–70
Syndicate Power Company, 108

temperature of river water, 159
Tennessee Valley Authority, 169
Texas Commission on Environmental Quality (TCEQ), 41
Texas Constitution, 110, 120–21

Texas Department of Health, 138
Texas Department of Transportation, 145
Texas Fish Commission, 72–73
Texas Game and Fish Commission, 138
Texas horned lizards, 44
Texas Nature Conservancy, 202
Texas Parks and Wildlife Department
 Davis S. Hall boat ramp, 190
 and Gorman Falls, 96
 and habitat restoration efforts, 42, 98
 and Mad Island Wildlife Management
 Area, 201–2
 and Montopolis Bridge access, 145
 and wetlands management, 181, 196–97
Texas Railroad Commission, 47
Texas Rangers, 75, 195
*Texas River School Canoes under Montopolis
 Bridge, 147*
Texas River School (TRS), 139–41, 146,
 147, 149–52
Texas Sugar Bowl, 184
Texas Supreme Court, 60
Texas Water Commission, 60
Texas Water Development Board (TWDB),
 79, 126, 169–71
thermal layers, 75
thermoelectric plants, 167
Thistles and Buttonbush, 62
Thomas C. Ferguson Power Plant, 116
Thornton, Okla, 50, 55–56
threatened species, 35, 54–57, 60, 163. *See
 also* endangered species
tidal marshes, 202
timber, 106–7, 121, 162
Titmouse, 82
Tobacco Creek, *2,* 6–7, 21, 24
Tom Miller Dam, 108, 117, 129–30, 134,
 135, 208n8
Town Lake, 130, 136, 138–39, 164,
 208n10. *See also* Lady Bird Lake
Town Lake Beautification Project, 138

Town Mountain granite, 118
toxic waste, 19–20, 168
trash dumping, 150–51
Travis Audubon Society, 131
Travis County, 131, 145
Triassic era, 3, 45
trilobites, 88
Trull Foundation, x
Twenty-Minute War, 195

University of Texas, 77, 159
U.S. Army Corps of Engineers, 128, 177,
 197, 200
U.S. Department of Agriculture (USDA),
 42, 49–50, 184, 189
U.S. Fish and Wildlife Service (USFWS),
 56, 116, 130–31, 197
U.S. Geological Service (USGS), 6, 178,
 207n1, 208n5
U.S. Government Soil Erosion Service, 121

*The Valley between the Colorado and the
 Pedernales, 123*
Valley Spring, 114
Vanishing Texas River Cruise, 101

Waller Creek, ix, 136
wastewater systems, xi, 149–50, 153–55, 168
water availability models (WAM), 126
waterfalls, *97*
Waterloo, 2. *See also* Austin
water quality testing, 47–48, 56–57,
 152–53. *See also* pollution
water rights, 60–65, 80–81, 82, 126
Watershed Protection Department, 152
water supplies, 33
water-use permits, 60, 62, 108, 126
weather and climate
 average rainfall rates, 124
 evaporation rates, 45
 northers, 9, 173

weather and climate (*cont.*)

 "rain bombs," 106, 123

 rainwater catchment, 23, 25–26

Webberville, 163

wells, 14, 22. *See also* irrigation

Welsh, Elisabeth, 152

Weniger, Del, 16, 21

West Texas Chamber of Commerce, 108

wetlands, 77, 175, 180, 186, 196–97

Wharton (city), 186, 193

Wharton County, 184, *194*

white bass, 95

Wilbarger, John Wesley, 155

Wilbarger Bend, 5

Wildcat Creek, 51–53

wildfire suppression, 106–7

wildflowers, 11–12, 28, 52–53, 96, 119, 164

Wildflowers of the Western Plains (Kirkpatrick), 28

wild hogs, 53, 120

Wilson Creek, 194

Winchell, 92

wind power, 104

Wirtz, Alvin, 109–10, 116, 127–28

Wolf Creek, *2*

wolves, 21

Wood Rat, 15

wood rats (pack rats), 15, *15,* 44

Yellow Bladderpod, 29

Zilker Park, 136

Other River Books

Paddling the Wild Neches, Richard M. Donovan

The San Marcos, Jim Kimmel

Freshwater Fishes of Texas, Thomas and Bonner

Flash Floods in Texas, Jonathan Burnett

Paddling the Guadalupe, Wayne H. McAlister

Texas Water Atlas, Estaville and Earl

Neches River User Guide, Gina Donovan

Living Waters of Texas, Ken W. Kramer

Exploring the Brazos River, Jim Kimmel